4-22-85

Thelma M. Norton
223 S. Federal Hwy., Apt. 30
Dania, FL 33004

 S0-BFD-557

Thelma M. Norton
223 S. Federal Hwy., Apt. 30
Dania, FL 33004

4-22-85

S0-BFD-557

THE OIL PAINTER'S
GUIDE TO PAINTING
TREES

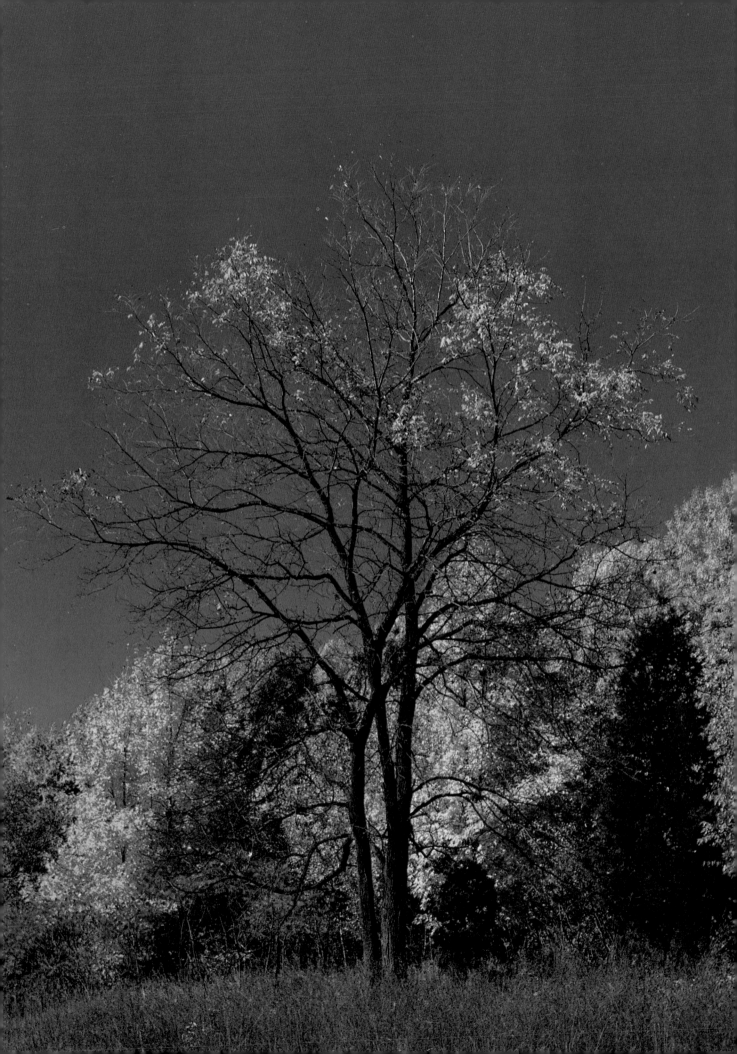

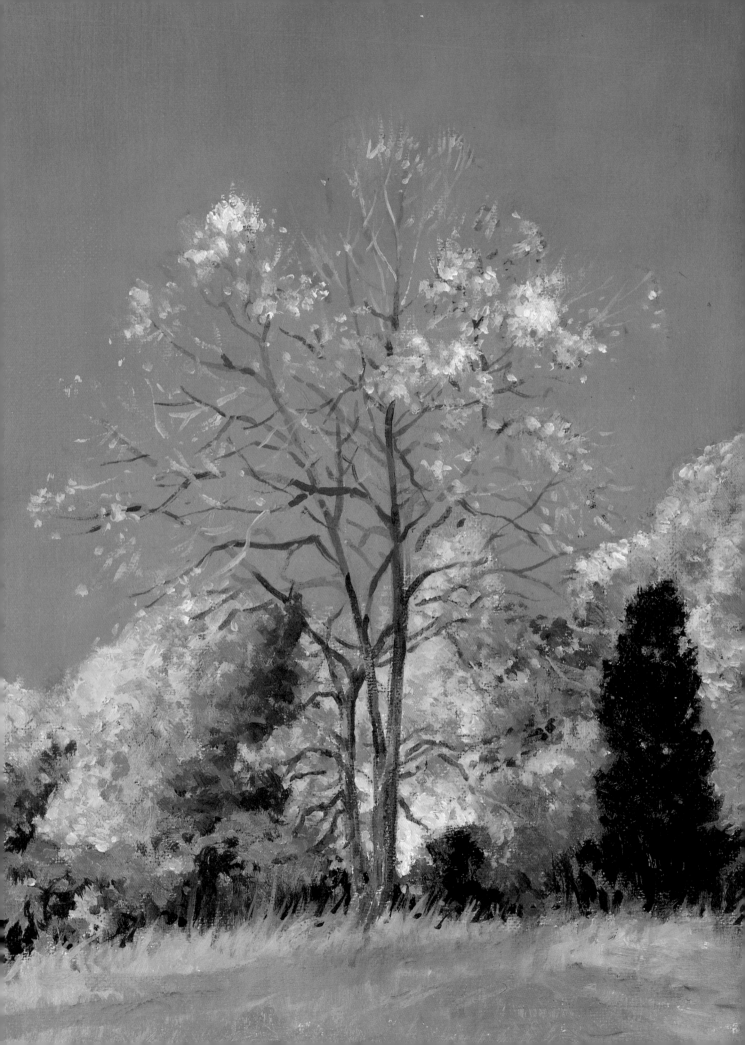

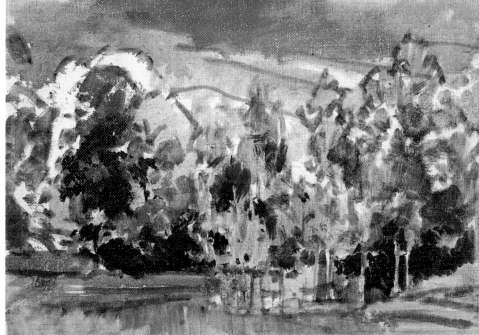

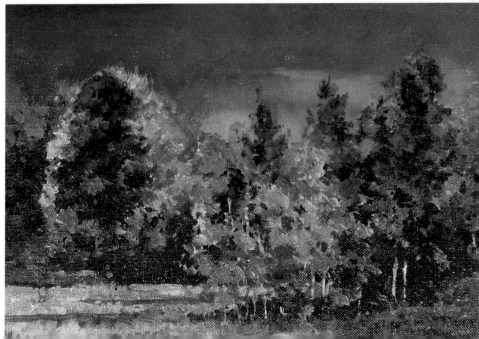

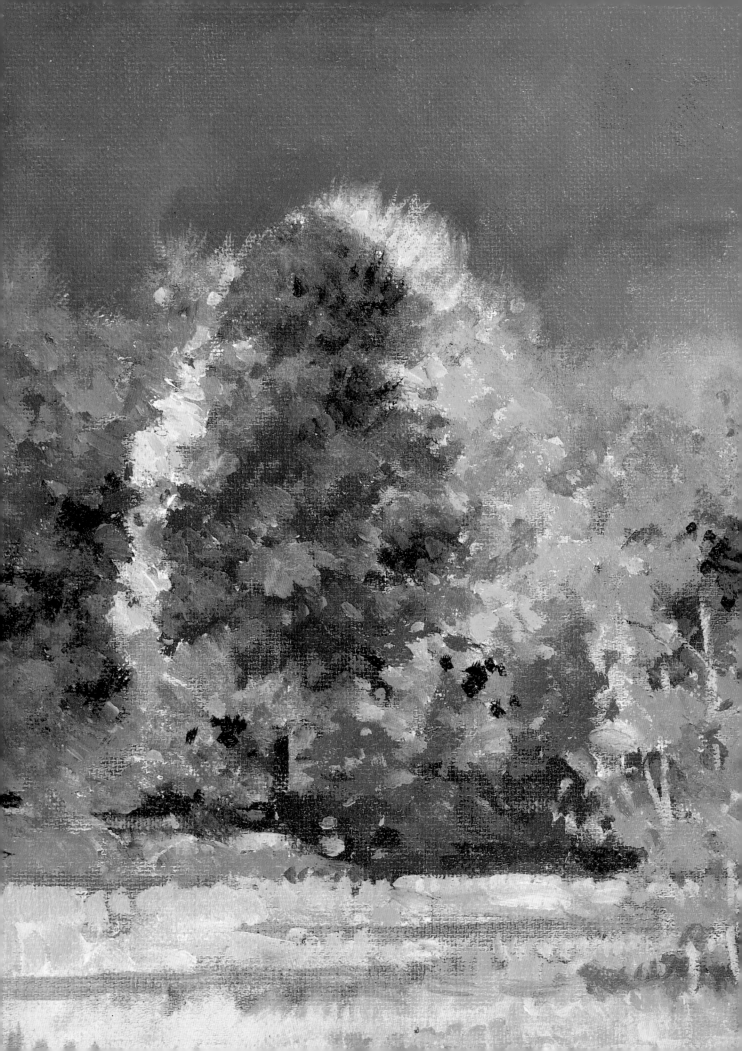

THE OIL PAINTER'S GUIDE TO PAINTING
TREES

PAINTINGS BY S. ALLYN SCHAEFFER

Photographs by John Shaw

WATSON-GUPTILL PUBLICATIONS·NEW YORK

S. ALLYN SCHAEFFER

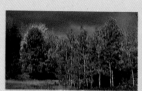

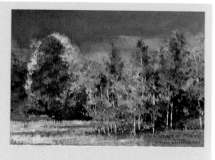

PAGES 2–3

An isolated tree gives character to autumn trees massed against a brilliant blue sky.

This painting conveys the delicate feel of the tall tree in the center without sacrificing the power of the brightly colored autumn foliage in the background or the intensity of the crisp blue sky. With all these different elements, it's hard to know where to begin. Start by painting in the sky. Its cool, vibrant blue will tell you how to key the other, warmer colors. Use a large bristle brush, then go back over the paint with a fan brush to smooth out any obvious brushstrokes.

Next, turn to the richly colored trees in the background and the scraggly, dead grass in front. For the time being, forget about the delicate tree in the middle; paint the rest of the scene as though it weren't present. To capture the mass of multicolored leaves, use dabs of cadmium orange, cadmium red, and cadmium yellow with variations in value. Add touches of green to break up the stronger, brighter colors.

Finally, you're ready for the tall, isolated tree. As you draw in its trunk and branches with paint, be true to what you see. If you aren't, you'll lose what's most important—the character of this particular tree.

PAGES 4–7

Above a mass of gloriously colored autumn trees, a darkening sky signals an approaching storm.

This autumn scene presents two challenges. First, how do you balance the brilliance of the fall trees against the dark moodiness of the sky? Second, can you distinguish the mass of brightly colored trees in the background from the delicate trees in the middle ground?

To solve the first problem, build up the color gradually, starting with very thin turp washes. To differentiate the background from the middle ground, make the distant trees denser and less de- tailed than those in front.

A preliminary drawing in charcoal sets the main forms in place. To reinforce the drawing, use a very thin wash and lightly brush in the darkest areas of the composition. Then begin to work all over the canvas—again, with thin washes of color. Remember to reserve the lightest areas—here the yellow in the tree at the left— for last. Pay attention to the value scheme, but don't agonize over color. Just aim for a close approximation of each tone.

Now it's time to start using thicker paint. Continually adjust hues and values as you work, keeping your attention on the darkest and lightest areas. Save details and accents, such as the white tree trunks near the front, for the final step. Complete your painting by adding color highlights and refining individual forms. Make sure you've captured the distinctive silhouette of each tree—that's the touch that will make your painting come alive.

First published 1985 in New York by Watson-Guptill Publications, a division of Billboard Publications, Inc., 1515 Broadway, New York, N.Y. 10036

Library of Congress Cataloguing in Publication Data

Schaeffer, S. Allyn, 1935-
 The oil painter's guide to painting trees.

 Includes index.
 1. Trees in art. 2. Paintings—Technique.
I. Shaw, John, 1944- II. Title.
ND1440.S27 1985 751.45′43 84-25736
ISBN 0-8230-3267-1

Distributed in the United Kingdom by Phaidon Press Ltd., Littlegate House, St. Ebbe's St., Oxford

All rights reserved. No part of this publication may be reproduced or used in any form or by any means—graphic, electronic, or mechanical, including photocopying, recording, taping, or information storage and retrieval systems—without written permission of the publisher.

Manufactured in Japan

First Printing, 1985
1 2 3 4 5 6 7 8 9 10/90 89 88 87 86 85

Contents

Introduction

Painting trees skillfully is one of the biggest challenges facing the landscape artist. Who doesn't want to capture the strong, vibrant greens of trees massed together in full summer foliage? Or the stark, spare feeling evoked by a lone tree on a prairie? Stop and examine landscape subject after landscape subject; you'll soon discover the important role that trees play in injecting landscapes with vigor and strength.

But nature's complexity can easily overwhelm fledgling landscape artists. All too often, they try to capture everything at once—the foliage, the sky, and the ground. As a result, their paintings lack focus. This doesn't have to be the case.

Master the art of painting trees and see how your paintings change. Find out which kinds of brushstrokes are best suited for depicting masses of foliage. Discover how to capture the brilliance of autumn leaves. Explore the ways that mist and fog alter the landscape. Using this book, you can learn all this and more. The practical, problem-solving approach that we provide will demystify the process of painting trees.

The lessons in this book show you much more than simply how to deal with conventional landscape subjects. You'll also encounter the wealth of painting material that lies in the minutiae of nature. You'll see how to move in close on details—delicate maple blossoms, golden pine cones, or a single leaf trapped under ice. And you'll learn how to deal with complex patterns, from a maze of spidery branches to an intriguing tapestry of silvery green leaves.

With the information we provide, you'll discover how to enhance your landscape paintings. More than that, you'll find there's a rich world of new painting possibilities waiting for you right outside your door.

WHO THIS BOOK IS FOR

This book is aimed at the intermediate oil painter, one who is familiar with basic oil techniques. If you are just starting to paint with oils, though, there's plenty here for you, too. Before you begin to explore these lessons and assignments, become familiar with the essentials of oil painting. Learn how to prepare a wash with turpentine, which painting medium you prefer, which brushes work best for you, and what kind of support you are most comfortable with. Then start to paint.

At first, you may be most comfortable with simple subjects—an isolated tree, for example. Gradually, though, you'll find yourself better able to analyze what you see. You'll want to move on and tackle more complicated scenes.

HOW THIS BOOK IS ORGANIZED

This book contains fifty lessons, each highlighting a problem you are likely to run into when you paint trees. First, the problem is discussed, then a working solution is outlined. Of course, many problems have more than one solution, so whenever possible, we include alternative plans of attack.

In each lesson, the painting procedure is carefully presented. In many cases, step-by-step photographs show how the painting actually develops. As you read the lessons and work with them, you'll come to understand the wealth of considerations that come into play whenever you

work with oils. Fifteen lessons include assignments that have been designed to help you apply what you've learned to your own paintings.

Choose whatever order you like in using the lessons. To get the most from the assignments, though, it helps to study the corresponding lessons first.

THE PHOTOGRAPHS

Every lesson starts with the photograph that the artist worked from as he painted. These photographs give you an advantage that few books provide—you can actually see how the artist interpreted his subject matter.

And there's another benefit: by studying the photographs, you can learn a lot about composition. As you turn to each new lesson, spend a few minutes examining how the photographer set up the scene. What angle did he shoot from? How did he frame his composition? How did he use the lighting conditions to enhance the subject? Then, when you yourself begin to choose new subjects outdoors, apply what you've learned from your study of the photographs.

THE IMPORTANCE OF DRAWING

You don't have to be an experienced draftsman to paint in oils, but it helps to understand the basics of drawing. Get in the habit of carrying a sketch pad with you and work with it for a little while each day. Don't labor over complicated subjects; instead, learn how to analyze the major lines of a composition and how to express what gives character to your subject.

When you begin an oil painting, sketch the subject on the canvas before you pick up a brush. Soft

vine charcoal is great for these preliminary drawings. It's easy to wipe away with a tissue if you make a mistake. Remember to blow off any surplus dust once you've finished; in certain situations you may also want to spray the drawing with fixative.

Sturdier charcoal pencils are ideal when a more detailed drawing is necessary. Occasionally you may want to start a painting by staining the entire surface with a dark color. When you choose this path, try using a white charcoal pencil to sketch your subject on the prepared surface.

As your painting progresses, you may lose your drawing, gradually covering it with pigment. Feel free to go back and redraw portions of your composition. Let the surface dry; then sketch the areas that need more definition, either with a brush dipped into a thin wash of color or with charcoal.

SELECTING COLORS
The paintings in this book are all done with the following twenty-two colors, although in most of the individual paintings, only six or seven colors are actually employed:

White
Cadmium yellow light
Cadmium yellow deep
Yellow ocher
Raw sienna
Cadmium orange
Cadmium red light
Cadmium red medium
Cadmium red deep
Alizarin crimson
Light red
Burnt sienna
Mars violet
Burnt umber
Raw umber
Thalo (phthalo) blue,
 or ultramarine blue
Cobalt blue
Cerulean blue
Thalo (phthalo) green,
 or viridian
Permanent green light
Thalo (phthalo) yellow-green
Black

If you have been painting for a few years, you have probably established a basic palette of ten to fifteen colors. You may, however, want to try out some of the colors mentioned here in solving a particular problem.

From time to time even experienced artists find that they are leaning too heavily on one particular color. If this happens to you, give the color up for a month or two. Explore alternative color possibilities and different combinations.

At times you may even want to substitute an entire group of colors. Getting rid of old, familiar friends is a good way to liven up your paintings and shake them loose from an all-too-comfortable feel.

Yet another way to break away from habit is to add one new, experimental color to your palette every month and look for ways to use it. You may well find that some of these experimental colors become permanent tools.

CHOOSING THE RIGHT BRUSHES
You'll need two basic kinds of brushes: bristles and sables. In general, you'll work mostly with the bristles. These relatively stiff brushes are ideal for laying in large areas of color and handy for loose, painterly strokes. The softer, more pliable sables come into play when you begin to depict small details.

Bristle brushes come in three main shapes: there are flats, filberts (oval-shaped), and rounds (with a pointed tip). Fan-shaped bristle brushes are also available; they come in handy when you want to smooth away obvious brushstrokes. Experiment with different shapes and sizes of bristle brushes to learn the range of strokes each type can produce.

Also compare the differences when you work with the whole body of the brush or just the very tip.

Good sable brushes can be expensive, especially in the larger sizes. There are, however, some good synthetic substitutes available. Moreover, for most oil painting situations, you won't need a large sable; a medium-size bristle will probably create the same effect. Choose from the smaller sables, and save them for delicate details. A flat sable is also useful in applying glazes.

MISCELLANEOUS MATERIALS
You will need a good, sturdy easel, one that is portable if you plan to work outside. To carry your materials, choose a good-sized paint box, one large enough to hold everything you'll need when you start to paint—even your palette.

In addition to your paints and brushes, basic supplies include either turpentine or mineral spirits, one or more painting mediums, plus painting and palette knives. Keep plenty of rags on hand as well.

To make their paint softer and easier to manipulate, many artists use prepared mediums like copal. You can, however, mix your own; for instance, for the paintings in this book, the artist prepared a medium using four or five parts of turpentine to one part varnish and one part stand oil. In some situations, you may want to try mediums that retard drying time or, in other instances, mediums that hasten it.

SELECTING THE RIGHT SUPPORT
Stretching your own canvases is great if you have the time and the space, and if their bulk isn't a consideration. You can choose from a variety of textures, but make sure the canvas is primed before you paint.

Beginning painters may prefer to paint on prepared canvas boards. The boards are relatively

light and take up very little space. More than that, they are ready when you are.

Unfortunately, prepared boards come in a limited number of sizes. If you want to break away from the formats that are available, you can, of course, build your own stretchers—or you can try painting on Masonite (hardboard). Masonite comes in large sheets that you can saw to any size you desire. After you have divided the sheet of Masonite into sections, prime each board with acrylic gesso before you begin painting. In addition to allowing you to select the scale you desire, Masonite is ideal for intricate subjects where the weave of canvas might get in the way of what you are depicting.

Watercolor paper is a good choice for some subjects, especially ones with a bumpy texture like that of the paper. Before you can apply your oils to the paper, though, you'll have to size it with an acrylic mat medium. Thinned white shellac is another possible sealing agent. If you work directly on the watercolor paper, the oil will bleed outward and eventually attack the structure of the paper itself.

CHOOSING A SUBJECT
Complex landscapes, packed with intricate detail, are the downfall of many artists. These scenes are fascinating to look at but awfully difficult to paint. There's no easier way to become discouraged than to take on a project that lies beyond your grasp.

Start with simple, focused subjects. Instead of painting an entire forest, concentrate on just one tree. Learn to solve the problems it presents before you move on to a scene made up of two or three trees. Gradually, you'll become comfortable with more and more complicated subjects.

DEVELOPING YOUR OWN STYLE
As you explore the lessons in this book, it's likely that you'll think of different solutions to the problems we present. If you approach the lessons with an open, curious mind, you're bound to.

Try this. Every time you turn to a new lesson, spend a few minutes looking at the photograph before you read the text. Which aspect seems most difficult to you? Is it the lighting that will be hard to capture? Or is it the anatomy of a particular tree? How would you handle this problem?

After you've studied the photograph, turn to the text and find out how the painting was done. If your approach makes more sense to you, go ahead and follow your instincts. You'll soon discover techniques and approaches that suit your own particular view of the land. Armed with that knowledge, you'll have the confidence you need to create what you want—strong, vigorous landscape paintings.

Accentuating a Lone Tree against a Dramatic Sky

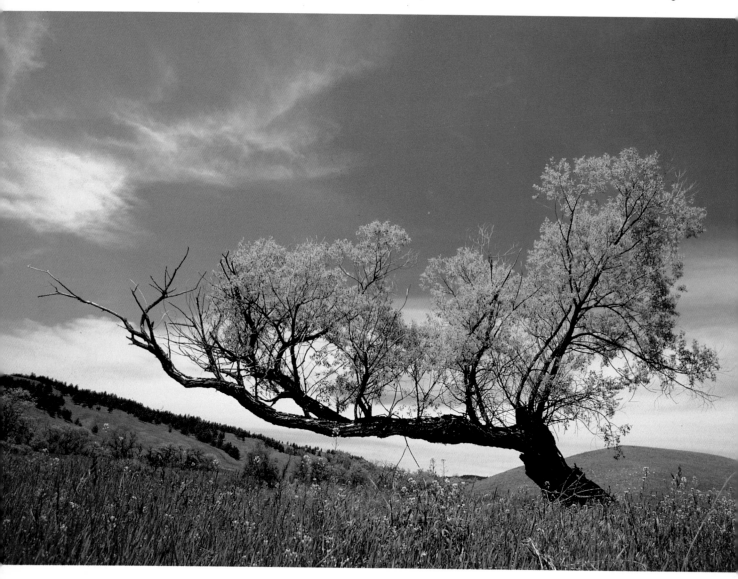

PROBLEM
The cloud-swept sky is so dramatic that it might easily become the center of the painting. If it does, the tree will seem insignificant.

SOLUTION
Emphasize the tree as much as possible by giving it a strong, definite silhouette. At the same time, play down the sweep of the sky.

On a prairie in the Midwest, an old willow tree bends gracefully toward the ground.

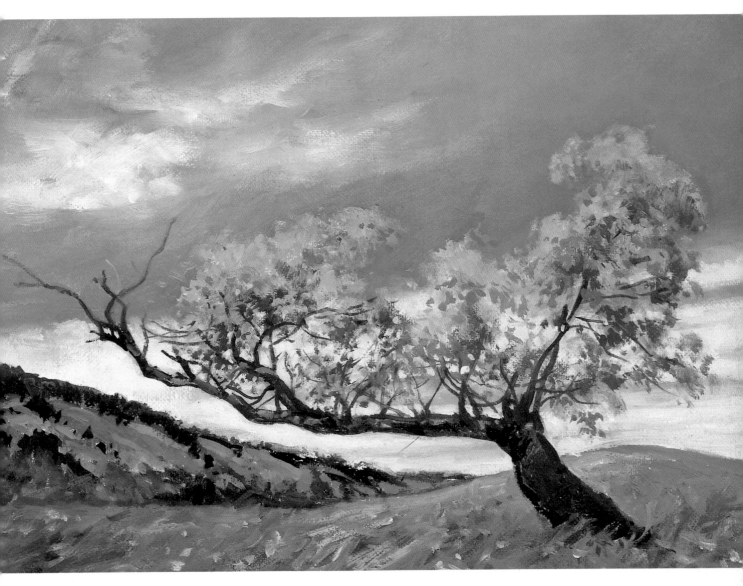

☐ In your preliminary charcoal sketch, pay careful attention to the shape of the tree. Analyze the way its main branch reaches across the ground. Next, using a wash of a dark, neutral color, go over the lines of your drawing with a brush. Don't worry about details. Concentrate on the tree's essential rhythm.

Begin laying in thin areas of color all over the surface. Start by establishing the darkest value —here the tree trunk and branches—and leave the area with the lightest value—the clouds—white. But think ahead.

How will you keep the intense white of the clouds from dominating the painting? By adding touches of yellow ocher to the clouds, you'll tone down their brilliance and, at the same time, achieve a more realistic depiction.

Once you've gotten down the basic color and value schemes, begin to work with stronger color, in thicker pigment. You may be tempted to use greens straight out of the tube. Don't. Your painting will be a lot more interesting if you temper the greens with other colors. Here the green foreground is broken up with

strokes of yellow ocher, blue, and even a mixture of black and yellow, which produces a lively silvery green.

Finally, step back and evaluate your painting critically. If some areas seem lackluster, bring them to life with touches of another color. Here flecks of dark green break up the masses of light and medium green in the tree's foliage. Dots of slightly greened yellow add highlights. Final touches like these help you achieve what you set out to do— they draw attention to the tree and make it stand out against the expanse of sky.

Creating a Convincing Sense of Space

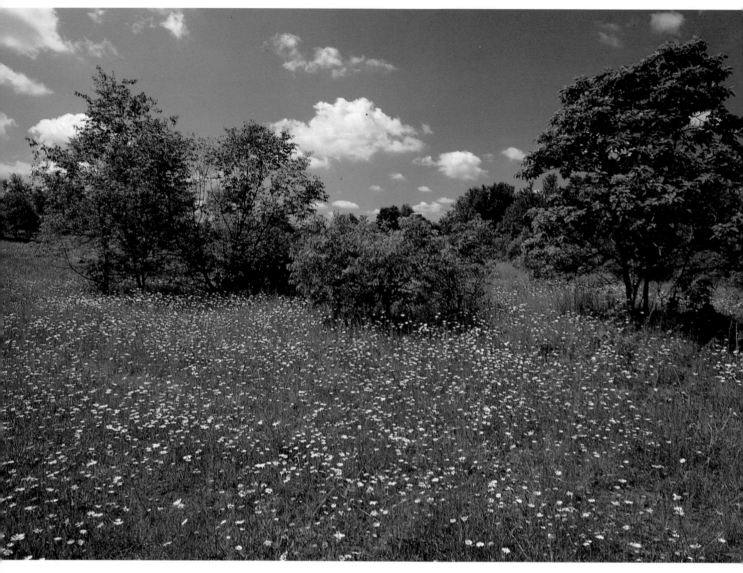

PROBLEM
All of the action in this scene occurs in the middle ground. There is nothing in the foreground to focus in on.

SOLUTION
After you have painted the entire scene, search for patterns in the foreground. Here you'll find them in the flowers that punctuate the grass.

Ox-eye daisies carpet a field, highlighting the vibrant greens of early summer.

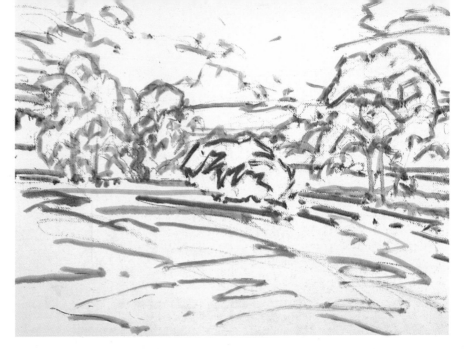

STEP ONE

With charcoal, sketch in the main forms that you see, even subtle ones, like the planes of the foreground. Then go over the lines of your drawing with thin washes. Use these washes to set the overall color mood of the painting by choosing two or three dominant tones—here blue for the shapes in the sky and greenish and brownish hues for the trees and grass.

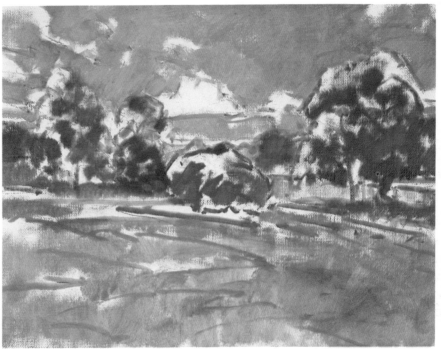

STEP TWO

Work from dark to light to bring out the tonal structure of the painting. The darkest areas are in the trees. Try mixing alizarin crimson with Thalo green for a deep, rich color. Keep your paint fluid at this stage by wetting your brush with turpentine. Next, lightly lay in the dark passages that run through the sky. A blend of cerulean and cobalt blue will give you the dynamic shade you see here. Loosely brush in the color patterns in the foreground with yellow ocher, raw sienna, permanent green light, and cadmium yellow.

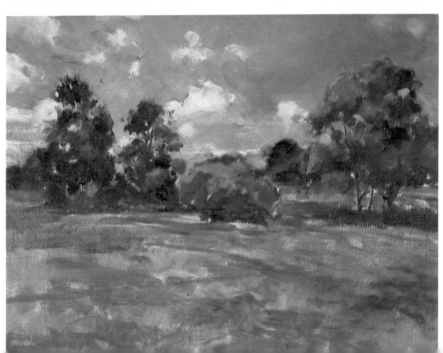

STEP THREE

Switch now to more opaque color as you begin to build up the trees. Once they are done, check the sky; you may have to adjust the blue to clarify its relationship with the trees' green. Be sure that the silhouettes of the trees stand out clearly against the sky. And don't forget the foreground; continue to define the contours of the field.

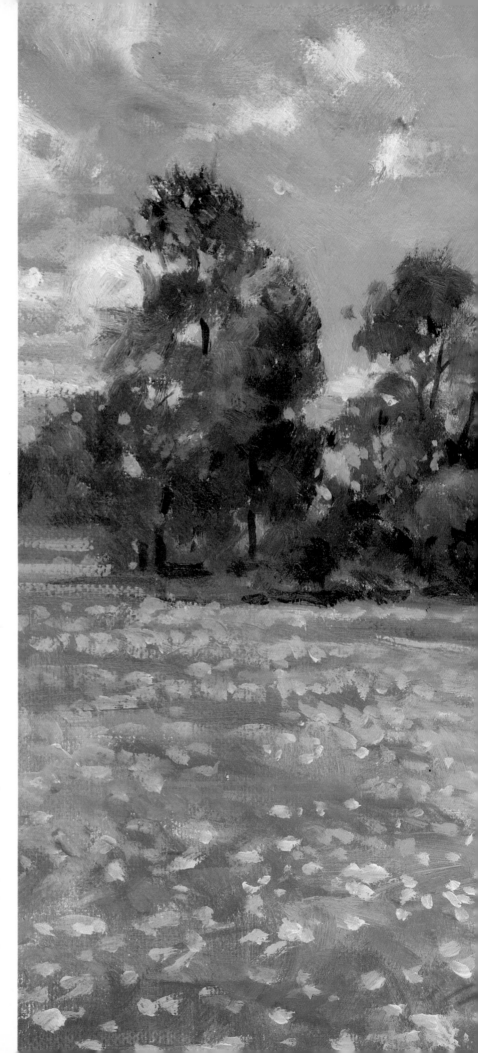

FINISHED PAINTING

Now refine what you've done. Start by sculpting out the shapes of the clouds by adding touches of yellow, gray, and purple. Then turn to the foreground. Using quick, light strokes, paint in the flowers that spill over the grass. What you are doing here is actually composing the foreground, creating stronger patterns than those that really exist. With dots of light color, you can lead the eye back to the darker trees—thus activating a strong sense of space.

ASSIGNMENT

In many landscapes, the focus lies in the middle distance, or even farther back in the picture plane. It's often tempting to concentrate on the scene's focal point, neglecting the rest of the subject. But if you do, you'll eventually run into trouble. Use your preliminary drawing as a tool to plan the design of the entire composition. In your sketch, lay in the contours that define the foreground and even the patterns that the clouds trace across the sky. Flip through the pages of this book and study the preliminary drawings. Note how directional lines are established right away, and how the major lines of the composition are clearly sketched in before painting actually begins.

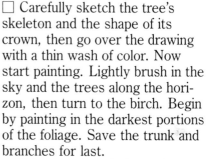

WHITE BIRCH

Capturing the Individuality of a Particular Tree

PROBLEM

A scene like this one—a handsome tree set against a clear blue sky—can be found almost anywhere. The challenge for the painter is how to make this tree unique.

SOLUTION

Pay attention to those things that give this particular tree its character. Make sure that your sketch captures the silhouette of the tree and the way its trunk and branches work together.

☐ Carefully sketch the tree's skeleton and the shape of its crown, then go over the drawing with a thin wash of color. Now start painting. Lightly brush in the sky and the trees along the horizon, then turn to the birch. Begin by painting in the darkest portions of the foliage. Save the trunk and branches for last.

Using heavier, darker color, continue to build up the tree and the sky. Work on both simultaneously, balancing the values of the blue and the greens. To break up the masses in the tree's crown and give a sense of the play of light, use a variety of colors to mix your greens.

Next, develop the foreground. Strong, vertical strokes will suggest the way the grass grows. To complete your work, paint the tree trunk. Capture the shadows that fall over its surface by experimenting with cool grays, blues, and purples. They will make the white areas much more exciting.

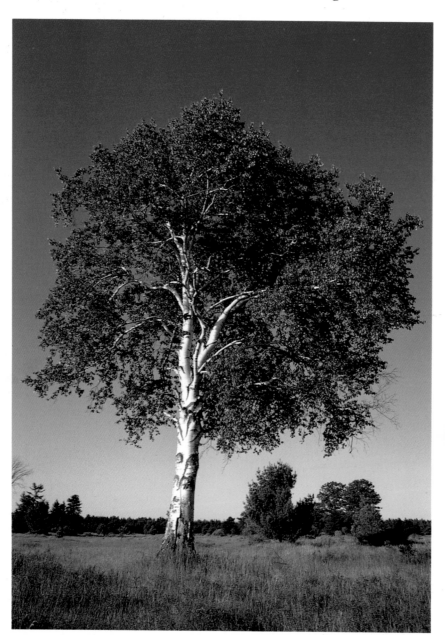

In late summer a majestic white birch stands against a deep blue sky.

ASSIGNMENT

Next time you go out scouting locations for your paintings, take along a sketchbook, pencils, and charcoal. Select a variety of trees to draw; search for stately conifers, delicate trees with lacy foliage, and handsome oaks and maples with dense, rounded crowns. As you sketch, pay careful attention to what makes each tree individual—how its trunk branches out, how the leaves are attached to the branches, and the pattern the foliage forms against the sky. Too many artists fall into the habit of drawing or painting an approximation of a tree. Instead of looking, they rely on an image they carry about with them, made up of all the trees they have seen in their lives—there's no greater obstacle to creating fresh, interesting paintings.

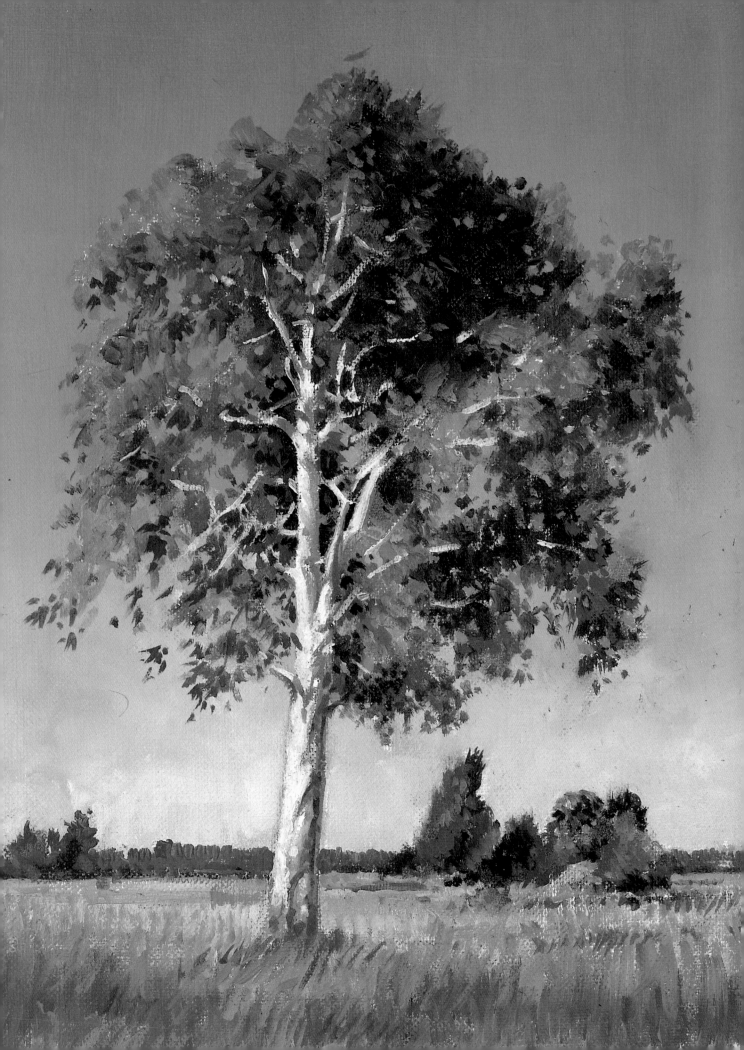

Stimulating Interest through Detail

PROBLEM

The myriad branches and twigs of this sycamore are almost lost against the brilliance of the blue sky. It's going to be hard to make them stand out clearly.

SOLUTION

A careful, detailed drawing is the secret to coping with such a complex pattern of lines. In it you can depict as many nuances as you like; then, when you start to paint, you can check specific reference points if you lose your way.

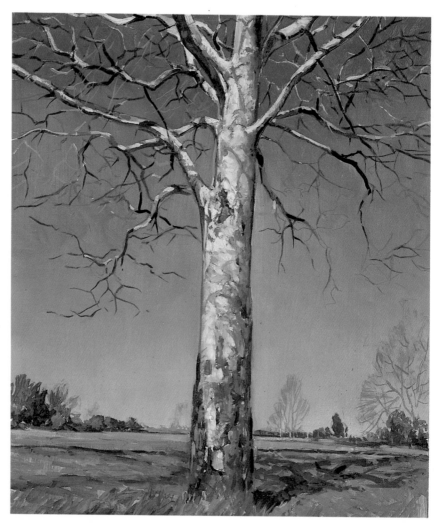

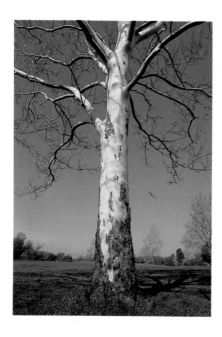

In May the twisting branches of an American sycamore create an intricate maze against the sky.

☐ Ask yourself: What kind of surface is best suited to this subject? The smooth white bark of the sycamore suggests a support like Masonite. Its smooth surface will help you convey the feel of the sycamore, whereas the texture of canvas might interfere with what you are trying to show.

Take your time with your charcoal drawing. Be sure to get the major branches down accurately; note where they bend and how they curve.

As you start to paint, use very thin washes—you want your drawing to remain visible. Lay in the sky all the way down to the horizon, then go back and pick out the whites of the branches

with a clean brush.

Now focus on the tree, working back and forth between lights and darks. By attending to the play of light on the trunk and branches, you can enhance the pattern of the tree against the sky. Search for colors that form the shadows on the trunk. They aren't just gray, but flecked with tints of blue and yellow.

Now enliven the grass with strong brushstrokes of varying greens and carefully render the dark shadows that run across the ground. Finally, paint the green trees along the horizon; then, using an almost dry brush, sketch in the delicate golden trees in front of them.

Unifying a Complex Maze of Branches

PROBLEM

There's order in this tangle of branches and twigs, but it's difficult to see at first. Unless you are careful, your painting will lack unity.

SOLUTION

Concentrate on the major branches and their extensions. In your drawing, work out the underlying pattern of lines. Then, with paint, focus on the play of light and dark.

Brilliant spring sunshine picks out the tracery of a sycamore, highlighting its graceful lines.

☐ Once again, use Masonite for your support. Don't force this strongly vertical subject onto a standard-size board; instead, pick one that is tall and narrow. With soft vine charcoal, outline the twists and turns of the tree's skeleton. After fixing your drawing, you're ready to paint.

Cover the entire surface with transparent layers of blue paint, but don't lose your drawing. Now turn to the tree. For the darkest branches, try mixing cobalt blue and burnt sienna. The blue will soften the brown and relate the tree to the sky.

When the strong darks and lights have been established, concentrate on the transitions between them. Touches of yellow ocher and alizarin crimson relate the darker areas here to the creamy and pinkish whites. Add dabs of blue and yellow to convey the flicker of light shadows across the bark. It's these subtle color variations that take your painting beyond drawing.

You can't paint every little twig—if you do, your painting will be too busy. Instead, use a dry brush and feathery strokes for the twigs at the branches' tips. Here touches of raw sienna get across their spidery feel.

23

Working with Strong Contrasts

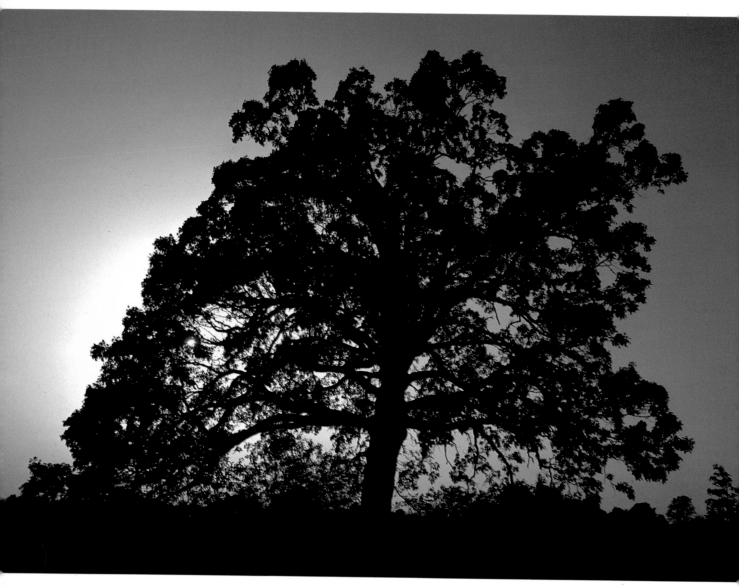

PROBLEM

When the contrast between a tree and the sky is this strong, it's easy to overlook the subtle points that make this dramatic scene arresting.

SOLUTION

Pretend at first that the tree isn't present. Start by trying to capture the beauty of the evening sky.

☐ In your preliminary charcoal sketch, aim at getting three things down: the tree trunk, the shape of the tree's crown, and the horizon line. Now reinforce your drawing with paint. Mix a bit of pigment with a good amount of turpentine and brush the mixture over the charcoal drawing. Once this thin wash is dry, turn to the sky. At first, use a bristle brush. Later, you can even out your strokes with a fan brush.

Work from the horizon line up toward the top of the canvas.

In the haze of summer, an old oak is silhouetted against a pale blue and gold sunset.

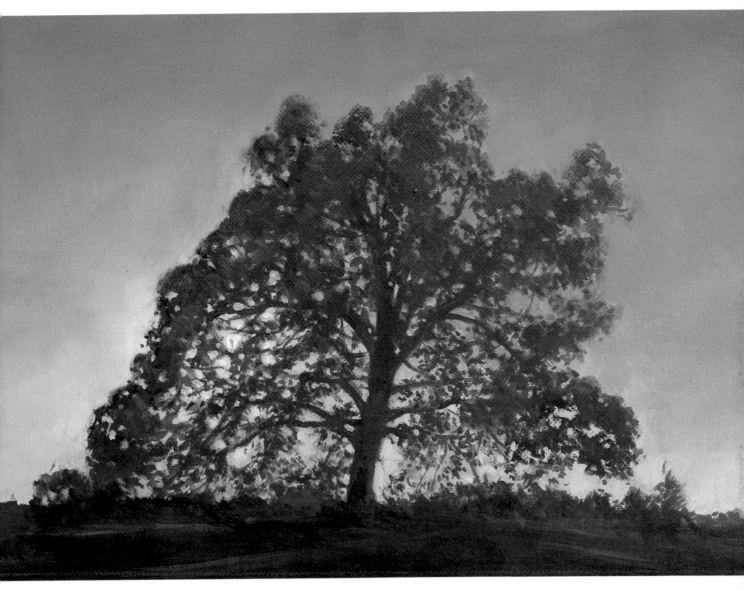

Near the horizon, use pale shades of yellow and cadmium orange. Gradually add a hint of crimson, then begin to blend in your blues. Make them strongest near the very top.

Let the sky dry for a bit, then turn to the tree. Its beauty stems, in large part, from the lacy delicacy of its foliage. Instead of using a broad bristle brush, try a small, pointed sable. With it, you'll be able to dab the paint on, gradually building up the masses of leaves that are silhouetted against the evening sky.

Don't use straight black for the tree. Even though it's very dark, there's a lot of hidden color in it. Mixing blue with brown will give you an interesting dark color, with a slightly purple cast. Also look for the areas of deep green.

At some point, you'll probably find that you need to add touches of sky where the darker strokes have become too dense. Work back and forth, striving constantly for a convincing illusion without worrying about detailed accuracy.

Finally, paint in the foreground with a bristle brush. Right along the horizon, take your sable brush again and dab paint onto the surface to break up what could become a monotonous stretch of flat land. In the finished painting, the tree's silhouette stands out clearly. Its branches and leaves have character, yet they retain the delicacy that makes this scene so appealing.

Grasping a Complicated Silhouette

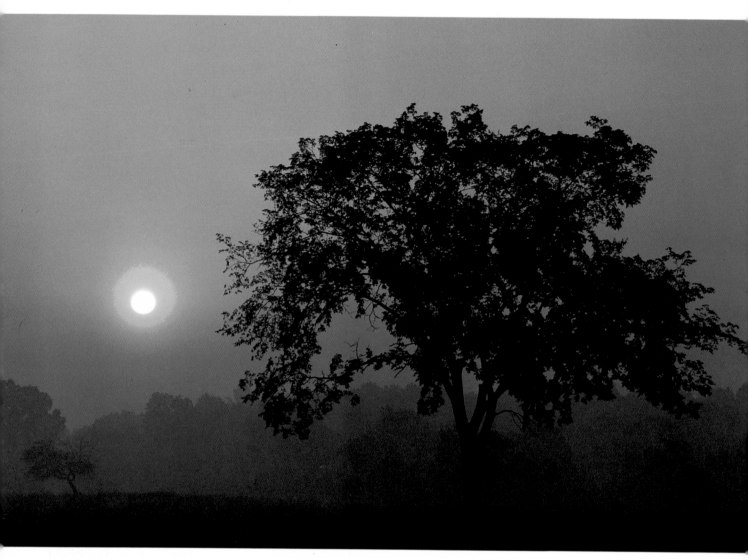

PROBLEM

This tree's silhouette is fairly complicated—it's made up of masses of tiny leaves. They have to be strong enough to convey the feel of this particular tree, but not so strong that the scene looks artificial.

SOLUTION

Paint the sky first. When you add the tree, follow what you see as carefully as possible, rendering the leaves with a small sable brush. Finally, soften the edges with dabs of lighter paint.

As the sun begins to rise, an American elm is set off by a rich, warm orange sky.

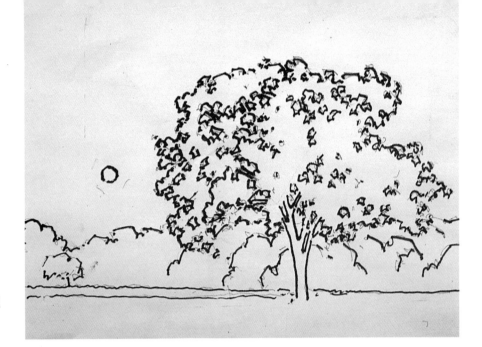

On a separate piece of paper, draw in the tree, the horizon line, and the sun. Outline the major masses of leaves and the clumps of foliage along the horizon. You'll refer back to this drawing once you've laid in the sky.

STEP TWO

On your canvas, use soft charcoal to sketch in the horizon line, background shrubbery, and the sun. Now, with very thin washes of pale yellow, lay in the sky. By introducing a little orange, you can begin to hint at the warm glow surrounding the sun. Continuing to use thin washes, suggest the planes of the foreground and the shapes of the distant trees.

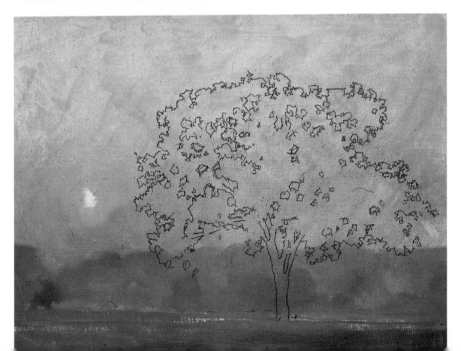

STEP THREE

Once the paint has dried, take your original drawing and copy the tree onto the canvas with charcoal. Softly blow any loose dust off the surface, then begin to paint. First, step up the brilliance of the orange surrounding the sun.

FINISHED PAINTING

To paint the tree, take a small, round, sable brush and dab the paint on gently, coaxing it onto the canvas. Don't use pure black; it will look heavy and dead. Instead, mix one of your browns with some alizarin crimson. At the very end, add a little white to your brown and crimson paints and scumble this mixture into the sky. Finally, with a dry brush, drag some of this mixture over the tree's crown to soften its edges.

The pale sky mixture dragged over the tips of the branches softens the harshness of the tree's silhouette and makes the entire scene seem more natural and convincing.

The sky can't be too light if it is to set off the yellowish-white color of the sun. The bright halo of orange accentuates this focal point, but the orange gradually diffuses as one moves away from the sun.

Painted simply and without much detail, the ground anchors the tree and establishes a strong middle value. Its rich reddish brown warms the sky and heightens its drama.

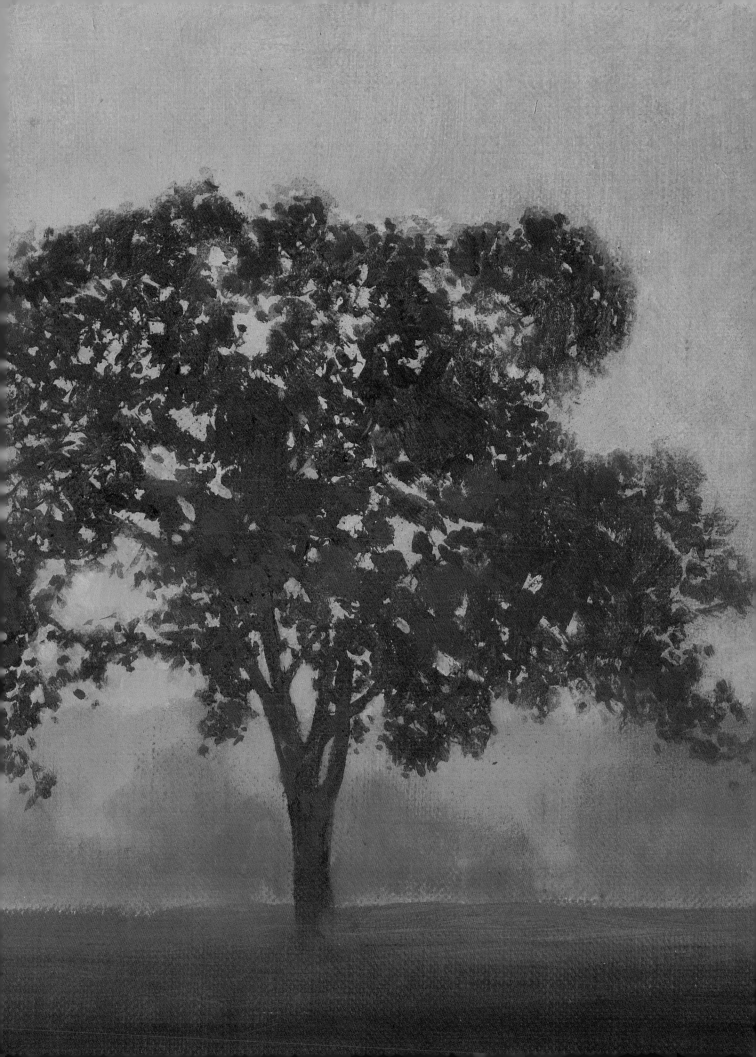

Translating a Tree's Skeleton at Sunset

PROBLEM

This handsome elm tree has countless branches and twigs, all thrown into sharp relief by the golden-orange sky. Don't be tempted to depict each and every one—you'll become lost in the maze, and your painting will look confusing and lack unity.

SOLUTION

Once the sky is established, focus on the main elements of the tree—its trunk and the largest branches. As you work, be faithful to what you see. When it comes time to add the small, wispy branches, make sure that they have the same feel as the rest of the tree.

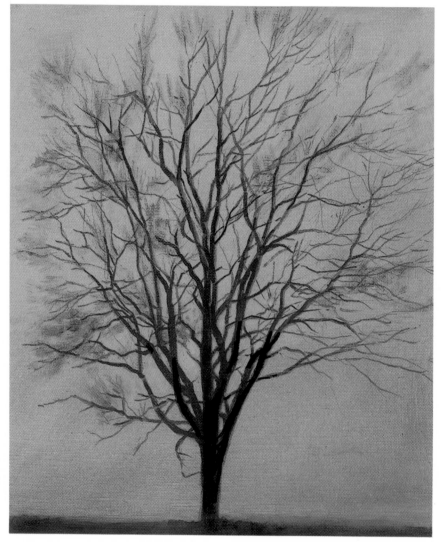

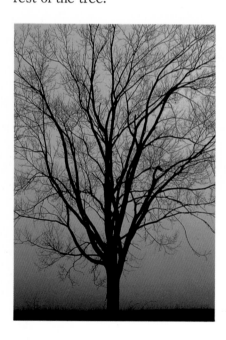

At sunset the branches of an American elm etch an elaborate network of lines in a pumpkin sky.

☐ Paint the deep orange sky first, with no thought of the tree, using full-strength paint right from the tube. Here the sky is colored by cadmium orange, cadmium yellow, cadmium red, and a touch of alizarin crimson. Painting the entire sky first is a handy approach whenever the sky serves as a fairly flat backdrop, without much detail, for a fairly complicated tree. It would be almost impossible to work back and forth between the tree and sky, picking out the bits of sky that appear between the branches.

Once the yellows, oranges, and reds are down on the canvas, smooth them together with a fan brush and let them dry. Then draw in the major lines of the tree with soft vine charcoal. To paint the tree, choose a small, long-haired, pointed brush and make your pigment wet enough to glide effortlessly onto the canvas.

Here the tree is painted primarily with a warm brown mixed from violet and blue. Occasional strokes of ocher complement and accent the interweaving of the darker lines. The fine, feathery twigs are indicated in the very last step.

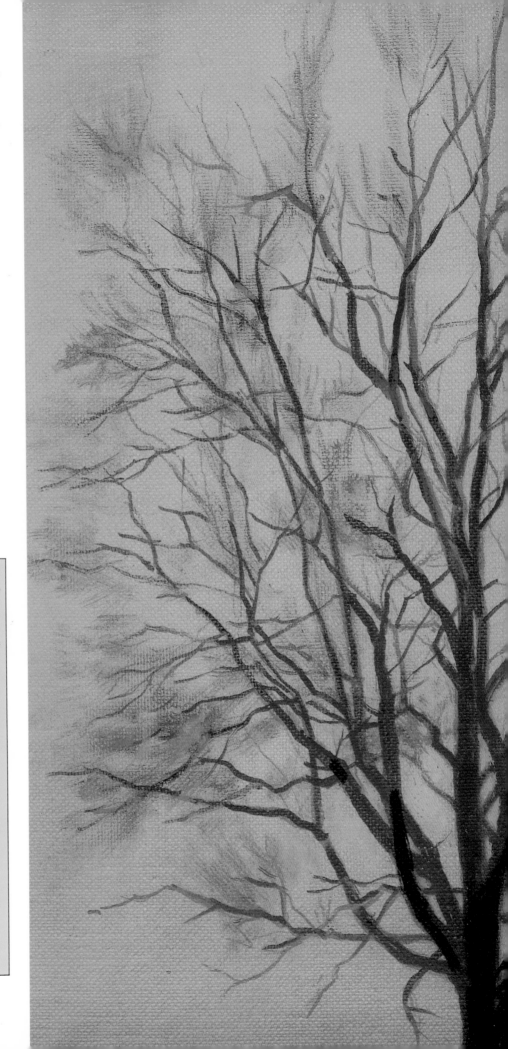

DETAIL
To suggest the wispy twigs at the tips of the branches, use a dry-brush technique. Just barely moisten your brush with pigment, then drag it quickly across the surface. The result will be a soft blur of color, giving a convincing sense of how the myriad twigs blend together visually.

ASSIGNMENT
A drybrush technique is invaluable for depicting masses of distant foliage and for painting thin, terminal twigs. Here's how it's done.

Take a bristle brush and dab it onto your palette, then wipe the brush off on a rag. You want it to be barely moistened with pigment. Now, with a very light hand, quickly drag the brush over the canvas. Once you are comfortable with the technique, apply it to an actual painting.

Choose a subject with a mass of trees in the distance, along the horizon line. Sketch the scene, build up the surface with thin washes of color, then paint everything but the distant trees. As soon as the sky dries, lay in the trees with a very dry brush. Quickly drag the brush up over the sky. The thin, uneven strokes will get across the feeling of trees that are far away.

Balancing Strong and Delicate Elements

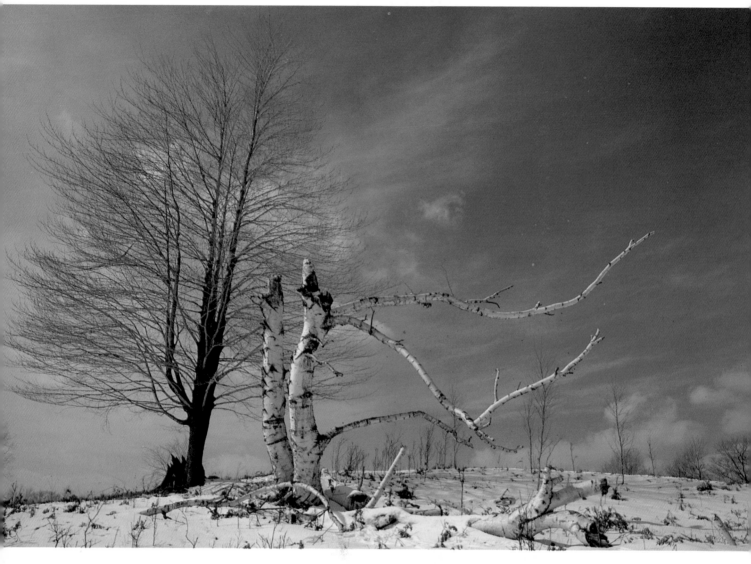

PROBLEM

The dramatic sweep of the clouds overshadows the stable trees below. To further complicate matters, the two trees are very different. The dark maple, with the upward surge of its trunk and delicate web of branches, seems far removed from the broken and bent white birch in the foreground.

SOLUTION

Capture the essence of the trees right away with a clear, loose drawing. Work up the sky gradually, starting with thin washes. As you begin to add opaque color, do so carefully, never letting it become so thick or intense that it steals attention from the trees.

On a chilly March afternoon, a cloud-swept sky forms the backdrop for a graceful maple and the remains of an old birch tree.

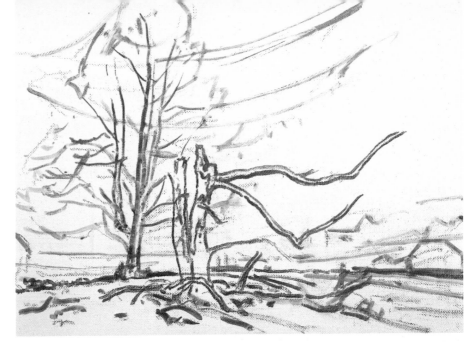

STEP ONE

In your preliminary charcoal sketch, free your hand to follow the major directional lines that rush through the scene. Try to convey the movement of the clouds as well as the flow of the trees. Now, with a pointed brush, go over the lines of your drawing with thin washes. Don't pick just any hue for these washes; select one or two that will set the color mood of the scene.

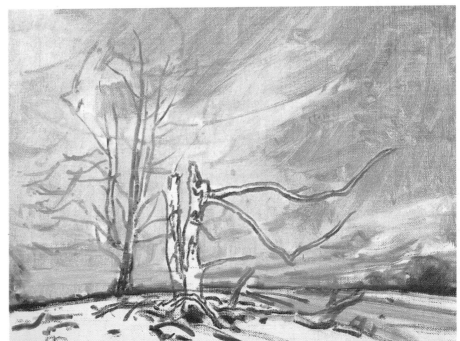

STEP TWO

Begin to develop the sky. Once again, you should use very thin washes—washes so thin, in fact, that they simply stain the canvas. Work expressively, sweeping your brush in rhythm with the race of clouds across the sky.

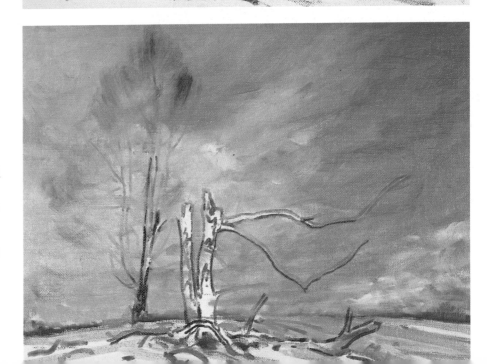

STEP THREE

Now it's time to start working with thicker pigment. Using the washes you laid down in step two as a guide, continue to build up the sky. Here most of it is colored in cobalt and cerulean blue, with touches of white and even alizarin crimson. Once the sky is down, set the character of the maple by using a drybrush technique for its feathered edges. Also start on the foreground.

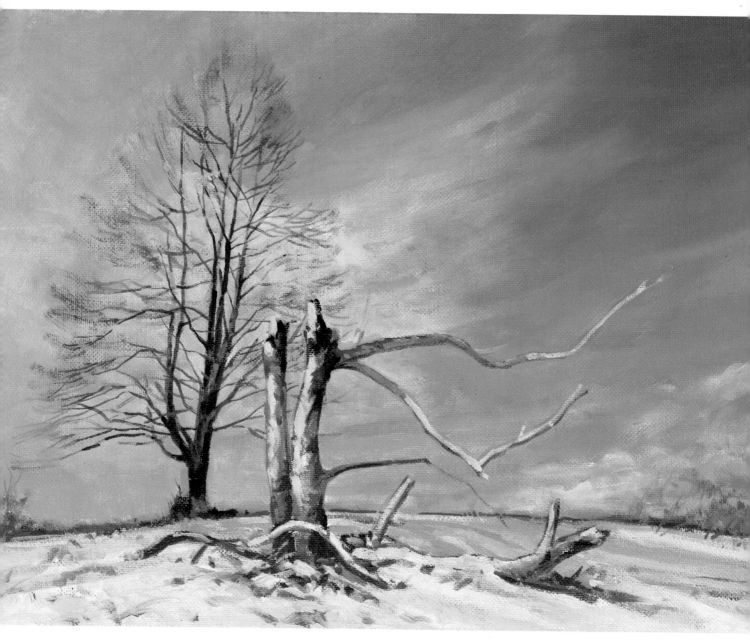

FINISHED PAINTING

With the sky completed, it's easy
to gauge how dark you want the
trees to be. You'll also see how to
work in their contrasting ele-
ments. A rich, warm brown will
distinguish the maple's elegance
against the cool drama of the sky.
To bring out the birch in front,
play the shadows that define its
volume against the areas of spar-
kling white. As a final step, mix
together a very pale shade of
whitish blue to lay in the rest of
the foreground.

ASSIGNMENT

Working effectively with turp washes calls for a free touch. If they are
laid in too rigidly, they will stiffen your paintings and become an obstacle
rather than a help.

To become comfortable with them, select a subject, sketch it with
charcoal, then begin to paint. Mix your pigment with a fair amount of
turpentine or mineral spirits, then load a large bristle brush with the
mixture. Don't be too fussy about exact hues or values; just aim at an
approximation of the color you eventually want. Sweep the brush over
the surface, using your drawing as a general guide. Don't be alarmed if
the wash starts to run—when you start working with thicker pigment,
you can paint over anything that doesn't work.

You may find that unexpected drips and splatters suggest new
avenues of approach. If they do, try playing with them rather than
avoiding them. Finally, don't let your drawing get in the way of the
painting process. It's tempting to stay within the lines of your drawing,
but if you do, the chances are that your finished work will look more like
a colored drawing than a painting in oil.

DETAIL

The broken birch stems in the foreground are painted with thick, rich pigment, which brings them into focus and makes them stand out from all the other elements in the painting. Yet the maple in the background has its own power. With its trunk warmed by a rich, dark brown, the tree is clearly silhouetted against the cloud-swept sky.

DETAIL

Snow may at first seem pure white, but when you stop and analyze it, you'll find that it's full of nuances of color. Here, for example, touches of blue, brown, and even alizarin crimson temper the harshness of pure white. These hints of color not only soften the white; they also relate the snow to the painting's overall color scheme.

Exploring Color Veiled by Fog

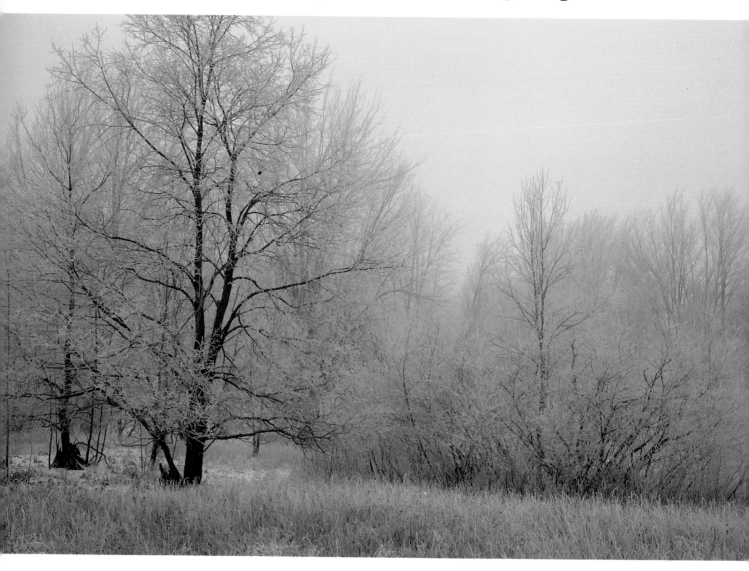

PROBLEM

Fog affects how we see objects. Their edges blur and their colors are muted; even a lively, variegated scene seems still and monochromatic. Working within this limited range of values can be difficult.

SOLUTION

Develop your painting very slowly, working from thin washes of color to slightly thicker, more opaque ones. Set the color mood from the very beginning; when you reinforce your charcoal drawing with diluted paint, choose a cool blue.

A frosty fog shrouds a stand of oaks in layers of ice.

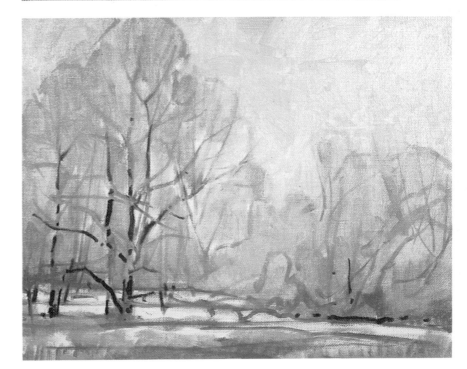

STEP ONE
In your drawing, aim for the overall silhouettes of the trees, not every twig and branch. Try, too, to indicate the ridges that separate the ground into distinct areas. Now go over your charcoal drawing with a thin blue wash.

STEP TWO
Let the paint dry, then introduce somewhat thicker layers of paint. Tone the simple shapes formed by the masses of trees and let the white of the canvas indicate where snow lies on the ground. Add the darkest value, too—the deep brown of the tree trunks.

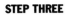

STEP THREE
To capture the shimmering, icy effect you are after, work wet into wet as you begin to use thicker pigment. Brush in a bit of the sky, then move to the branches of the trees. Work back and forth between these two major areas, avoiding sharp boundaries. Start to develop the foreground, too.

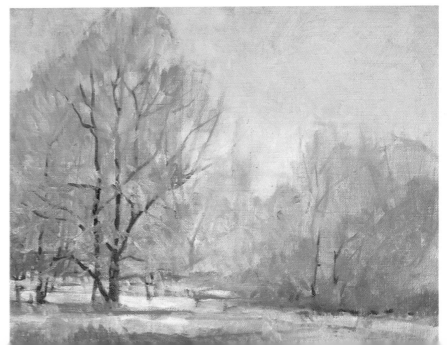

FINISHED PAINTING

Much of what gives this painting its strength occurs in the final steps. It's then that definite touches specify the misty atmosphere and clarify spatial relationships. The delicate lines of the tree trunks and branches are brought out by a fine, pointed brush that has barely been moistened. Quick, bolder strokes in the foreground give it a strong, rhythmic sense. Finally, pale yellow is scumbled into the sky and the spaces between the trees. The soft yellow warms up the cool colors that dominate the composition and makes the painting seem livelier and more realistic.

ASSIGNMENT

When you go outdoors looking for landscape subjects, bring a camera along so that you can augment the sketches you make with good, clear photographs. Photographs can help you in several ways. First, when you are working on a painting that will take you a while to complete, it's not always practical to work entirely outdoors. More than that, sometimes at night, or even early in the morning, you'll figure out a way to break through a particular problem you have been facing. Referring to photographs taken on site can refresh your memory about specific details. Finally, photographs can be an immense help when it's just too cold to work outside. Scenes like the one featured in this lesson are incredibly appealing, but all too often they are neglected because of the difficulties involved in working outside when the temperature is below freezing.

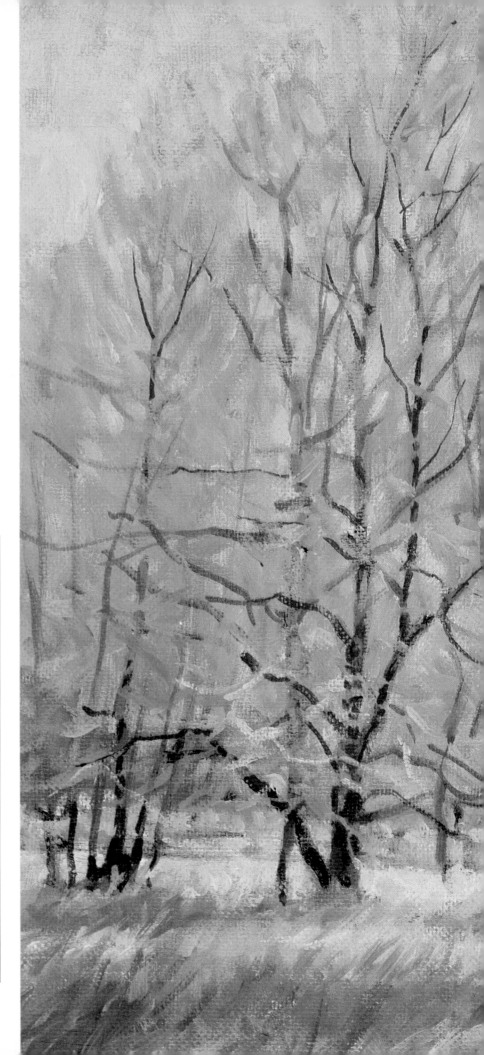

Painting a Difficult Subject on a Small Scale

PROBLEM

No matter how straightforward this scene appears at first, visually it is very confusing. It will be difficult to get across the feel of ice and to suggest that the leaf lies trapped in frozen water.

SOLUTION

Don't add to your troubles by working on a huge surface. Instead, choose a life-size scale for what you see. To capture the luminous quality of the ice, build up the entire surface gradually with transparent layers of color.

☐ Select the surface you want to work on carefully. Masonite is a good choice; its smooth surface will make it easier for you to layer your paint. Pick a piece just about the size of your subject. Then, as you start to draw, don't be misled by the seeming simplicity of the subject. Subtle points mean everything when you move in, close up, on something as "ordinary" as this leaf.

Throughout the entire painting process, use a fair amount of turpentine with your paint. You want your washes to be thin and almost transparent. Begin with the icy background, slowly building up layers of cobalt blue and green. Now turn to the leaf. To catch the sense of reflected light, continue with transparent washes. Yellow ocher dominates much of the leaf, with raw umber bringing out the details.

Once you've laid down the basic anatomy of the leaf—its veins, highlights, and shadows—begin to introduce opaque color. With a small, round brush, work over the entire surface of the leaf, adding touches of pure yellow ocher and modulations of ocher with raw umber. For a lively feel, dab on some of the blues and greens of the water.

The hardest part comes toward the end—painting the thin, dark ridge that outlines the leaf and suggests the ice. Work with a shade of greenish blue darker than the water itself and keep your touch light. A hint of purple conveys the deeper shadows. Then, to enhance the dark ridge, work around it in pale bluish greens. Spatters of white paint all about the leaf complete your work.

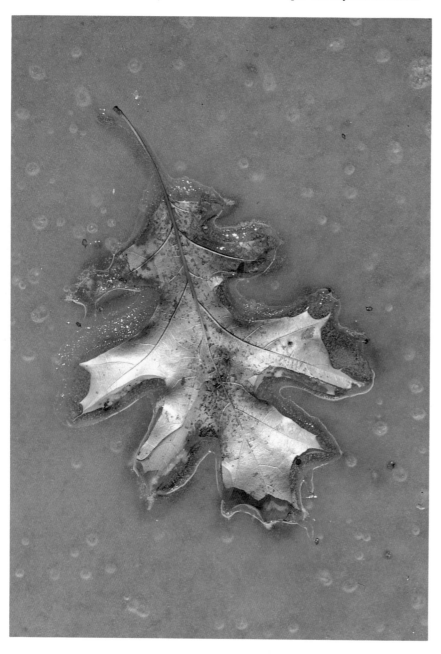

In early winter, a golden oak leaf lies frozen beneath a thin layer of ice.

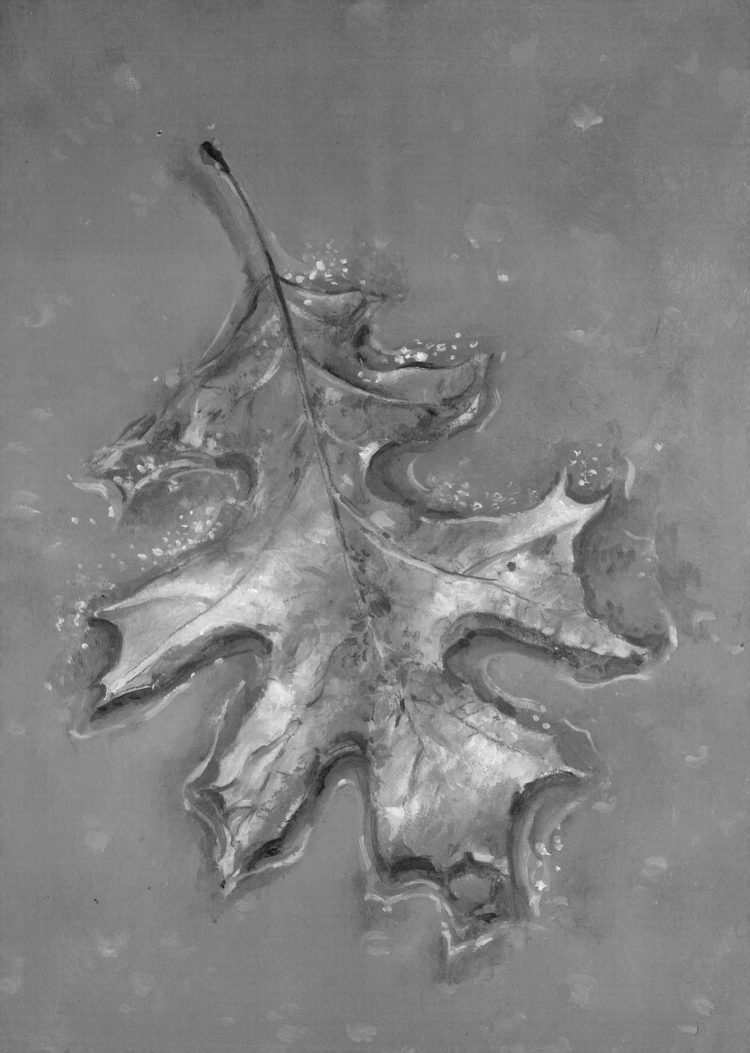

Suggesting the Feel of Ice

PROBLEM

What you are really looking at here is a complicated still life. The needles themselves are fairly intricate; covered with ice, they become even more difficult to decipher.

SOLUTION

Subjects like this call for a clear, strong drawing. Without one, you could easily lose your way in a tangle of details.

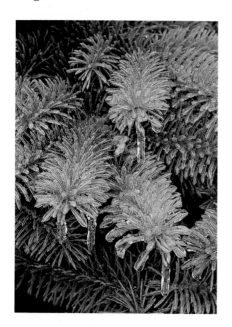

A thick layer of ice encases the living green needles of a spruce tree.

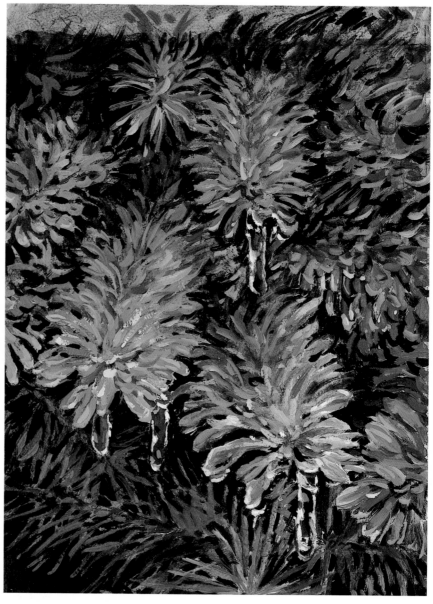

☐ Execute a very careful charcoal drawing—picking out each mass of spruce needles and giving the feel of the individual needles, too. With such a complex subject, work on Masonite so you don't have to contend with the texture of the canvas. When your drawing is complete, spray it with fixative before you start to paint.

First cover the entire surface with a middle-value green. This overall coat of green will give you something to react to; you'll be able to judge how dark your darks are and how light your lights are. With all the detail in this closeup, you'll want to keep your paint fairly fluid. If it's too thick, it won't glide easily over the surface.

On your palette, mix a deep, dark green to use for the background and several lighter greens for the individual needles. As you mix the light colors, keep an eye on the subject. When you look carefully, you can see that the

needles aren't just green; they have a lot of blue in them, too.

With a medium-size round sable, work back and forth between the lights and the darks. Use the strokes of your brush to give the sense of individual needles. When you feel that you are nearing the end, stop and evaluate your painting. Are there enough light passages to suggest the brilliance of the ice? If not, go back and add small touches of pure white to set off the surrounding greens.

DETAIL

The dripping icicles are crucial in conveying the feeling of ice. Observe how the irregular contour of the icicle is brought out here by the contrast of the white with the dark blues and greens around it. At times the white is straight from the tube. The white is also applied more thickly than the other colors so that it springs forcefully into focus.

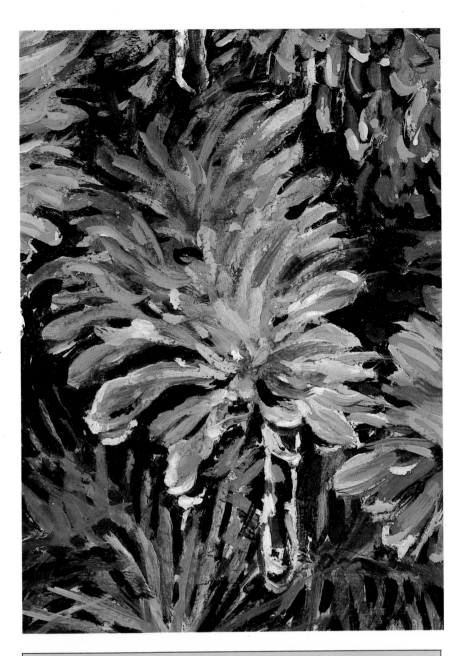

ASSIGNMENT

In addition to exploring your tube greens, learn how to mix greens from the other colors on your palette. Experiment with as broad a palette as possible to avoid relying on two or three tried-and-true formulas. Discovering a variety of greens will add freshness to your paintings.

Start with black and one of your yellows. Lay dabs of both colors a few inches apart on your palette. Drag one into the other gradually to see the range of hues they can produce. When black combines with yellow, you'll find that the result is generally a grayed olive-green tone. Follow the same procedure with cerulean blue, cobalt blue, and ultramarine blue. To each blue, add your yellows one at a time. Don't stop with straightforward yellows; continue your experiments with yellow ocher and cadmium orange.

When you begin to apply the results of your experiments to your paintings, don't mix a huge amount of any one green. Instead, repeatedly mix small amounts of the color you want. You'll find that from batch to batch small, subtle differences occur. These differences may not be obvious at first glance, but cumulatively they can make your paintings more vigorous and exciting.

Narrowing in on Texture

PROBLEM

The problem here is clearly the complicated structure of the peeling bark. Its cracks, tears, and bumps weave an incredibly intricate pattern, one that's difficult to depict.

SOLUTION

Work on primed watercolor paper, which mimics the texture of the trunk, and rely on watercolor techniques. Start with your lights, then gradually introduce stronger, darker colors.

☐ When you work with oils on watercolor paper, you have to size the paper first. If you don't, the paint will be absorbed by the paper and you'll end up with very little pigment to work with. Coat the paper with an acrylic medium —matt was used here—then let the medium dry.

Now sketch in the main patterns with a graphite pencil—it's easier to control than charcoal, and you'll find that it's ideal for subjects that are mostly dark. Your paint will cover most of the pencil drawing, and what the paint doesn't cover will add structure to the finished work.

Start painting with your lightest colors, here mostly yellow ocher and pale washes of brown. In this wet stage, the very lightest areas can be picked out with a dry brush or even blotted with a bit of paper toweling to show the white paper beneath. Gradually introduce darker colors, keeping them translucent, diluted with a lot of turpentine. Continue, too, to pick out the white of the paper with a dry brush or toweling.

As you build up the paint, try scumbling light and dark colors over each other, enhancing the texture of the watercolor paper. Here light colors were mostly dragged over deeper, darker ones. The broken color that results, combined with the roughness of the paper, will emphasize the textured quality of your subject.

As a final step, take a painting knife and scratch thin highlights into the paper. The knife reaches down beneath the pigment and isolates patches of clear white. These thin slashes of white animate the entire surface, breaking up large areas of dark color with slivers of light. They also highlight the rich layering of the tree's bark and convey the feel of cracks and tears.

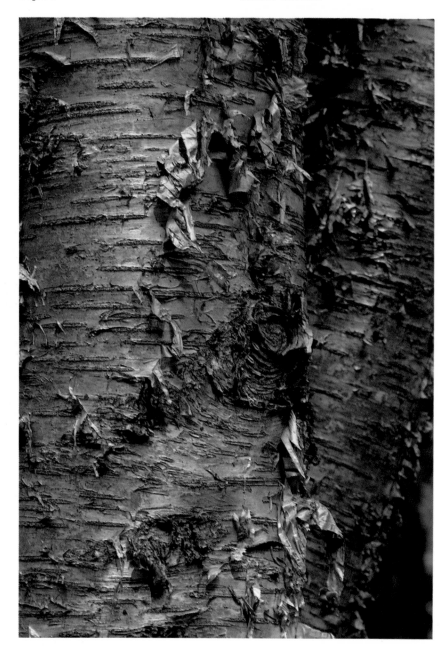

The papery bark of a yellow birch separates into strips, revealing different layers.

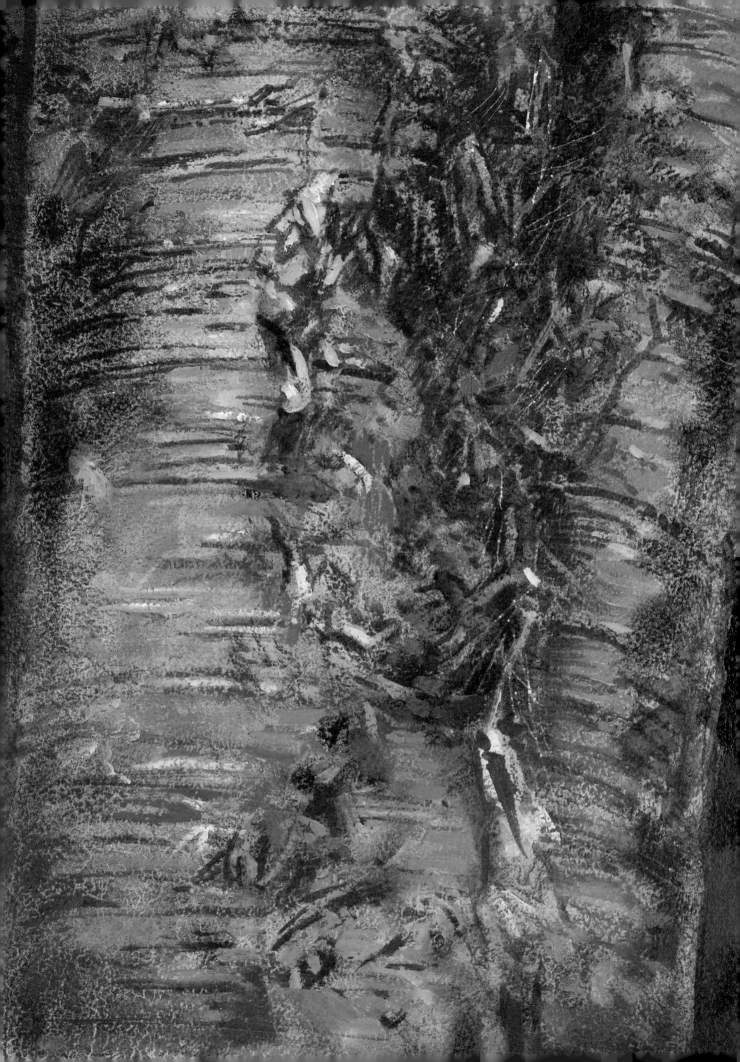

Emphasizing What's Important

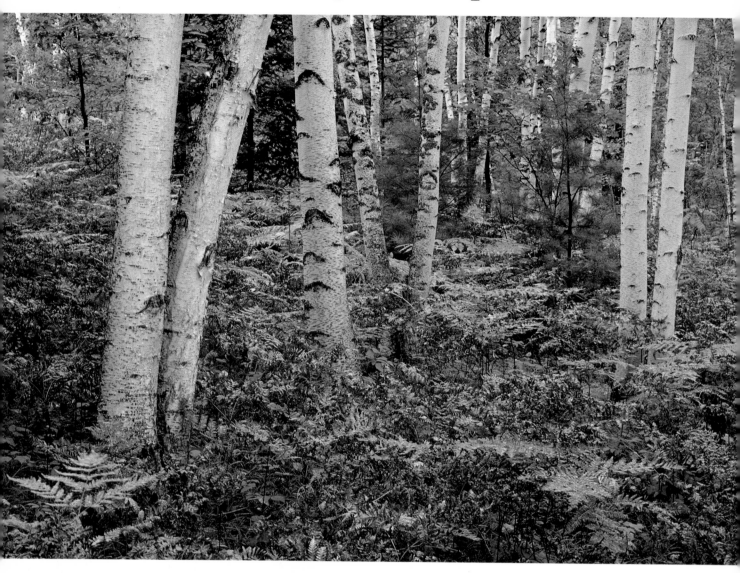

PROBLEM

There's lots going on here. The tree trunks set up a lively pattern and the richly colored ferns scatter an intricate tangle on the forest floor. But you can't emphasize everything; you have to select a focus for your painting.

SOLUTION

Look at the scene carefully and figure out what draws you to it. What makes it hang together? What gives it life and vitality? Once you've decided which element means the most to you, concentrate on it. Here the tree trunks become the focus of the painting.

In a grove of white birch trees, golden ferns nestle on the ground, proclaiming the approach of autumn.

46

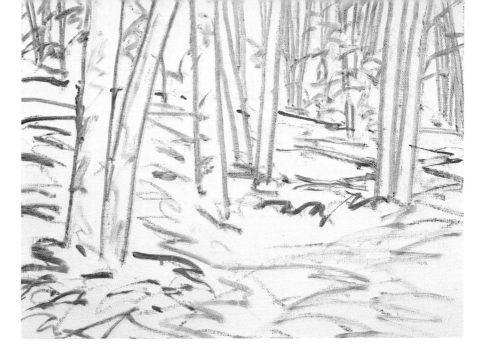

STEP ONE
Using vine charcoal, sketch in the scene, concentrating on the trunks of the trees. Lightly blow away any charcoal that might muddy your painting. Next, go over the lines of your drawing with a warm color diluted with turpentine. Here a rich brown sets the overall mood of the painting; it's dark enough to stand out against the white canvas, but it won't be difficult to work over later.

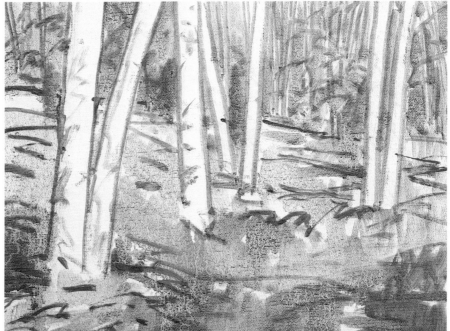

STEP TWO
As you develop the surface with thin washes, leave the tree trunks pure white. Concentrate on the varied greens and ochers that fill the background and spill over the forest floor. At this point your drawing is still quite visible and easy to work with.

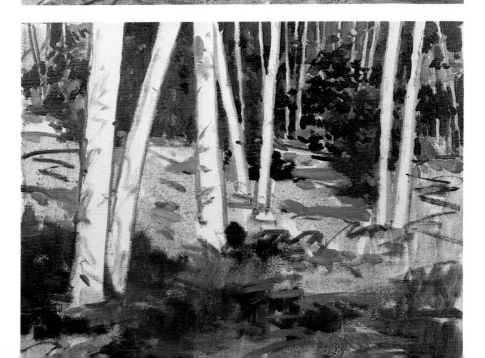

STEP THREE
Start to build the rich green foliage in the background and the golden ochers with hints of green that cover the forest floor. Pay attention to the play of light and dark. In the foreground try short, broken strokes to suggest the texture of the dry, brittle ferns.

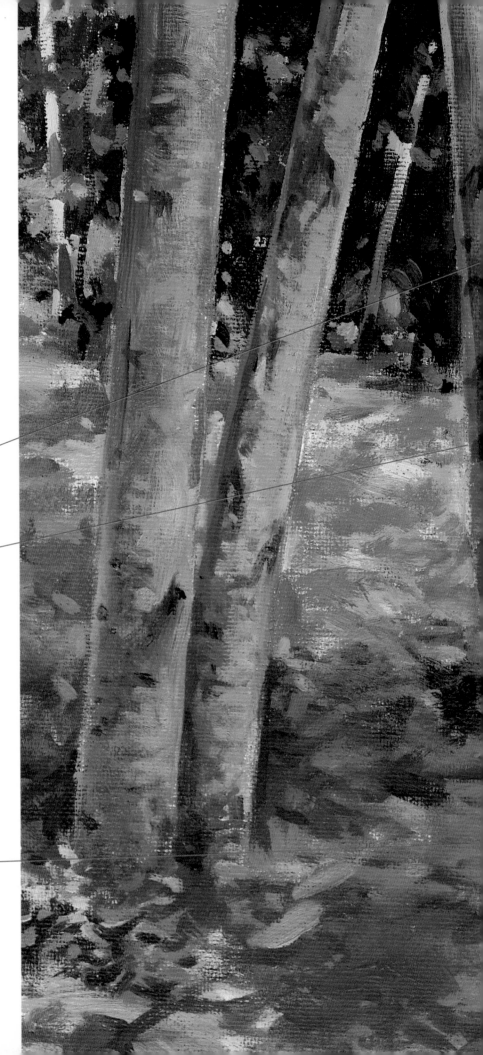

FINISHED PAINTING

A lot happens in the final polishing. First, bring out the highlights in the background trees with touches of bright yellowish-green paint. Now turn to the tree trunks. Make them the center of attention by using quick, bold strokes. Don't worry about a lot of detail; here even the shadows and bits of dark bark are laid in with rapid strokes. Finally, complete the forest floor. Continue to use short, broken strokes, bringing out the subtle variations in tone that establish the drift of sunlight. To create a sense of recession into space, keep the middle ground less developed than the foreground. Less detail almost always means less attention.

The deep, rich greens that make up the background are rendered with loose, free strokes. Highlights are picked out in the final stages with dabs of bright yellowish green.

In the finished painting, these birch trunks are clearly what matters the most. Painted with smooth, decisive brushstrokes, they sweep boldly upward. Their strong verticals form a rhythmic pattern across the surface of the canvas.

Stripped of most of their detail and depicted with brisk strokes, the golden ferns become an important accent. Without their flickering layers of color and the flurry of their brushstrokes, the tree trunks would be less dynamic. By simplifying one part of the composition, you can make the entire painting come alive.

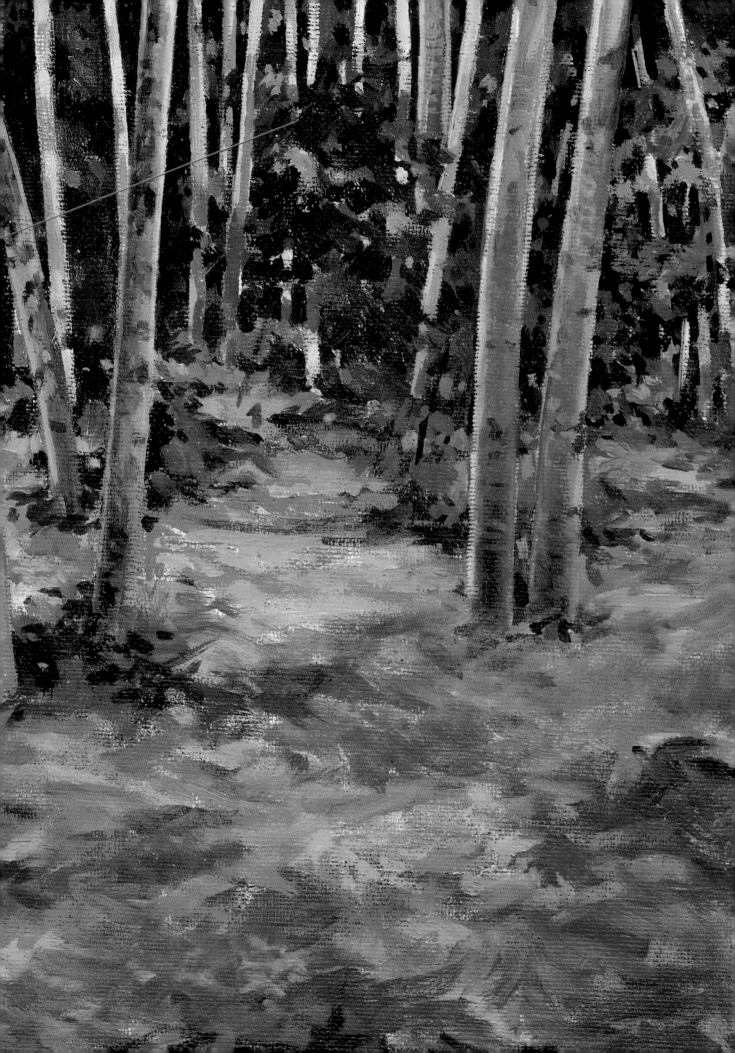

Experimenting with a Variety of Greens

PROBLEM

There's beauty in the minute details of a segment of a tree, but it takes a special kind of vision to capture the abstract patterns that make the part seem greater than the whole.

SOLUTION

A complicated subject like this one deserves a careful drawing as an anchor for the entire painting. When you start to paint, use a variety of greens to indicate the pattern of lights and darks that makes the foliage so interesting.

☐ In your charcoal drawing, don't try to delineate every twig. Concentrate, instead, on the tree's trunk and the major branches. When they are established, you can start to paint. Working with oils, you'll soon discover that it's often easiest to build from dark to light. Once the darks are down, you can bring them to life with touches of lighter, brighter color.

Using thin washes, lay in the large patches of dark green and then the lighter areas. Now introduce thicker paint. First, render the tree trunk and the main branches; then return to the foliage. Mix two basic greens—one very dark, one a medium value. With these, begin to firm up the play between dark and light indicated by your washes.

From this point on, you'll need to move back and forth between the darks and lights, with an eye to how each affects the other. Don't worry about painting over the branches at this point; you'll go back to them later. What you want to do is make the mass of green foliage lively. Try introducing subtle variations in color throughout the painting. Mix touches of orange, ocher, and deep blue with your basic shades of green.

As soon as the entire surface is fairly well developed, redefine the branches and their shadows. With quick, thin strokes, you can create a web of lines that gives the feel of numerous branchings without detailing every one.

Now refine the light and dark patterns you've created. Mix a bright yellow-green for the lightest bits of foliage. Again, you will need to work back and forth, adding touches of the darker greens to break up the lights. By looking for the variations in the green you see, you'll create a center of interest and convey the wonder of sunlight in this view.

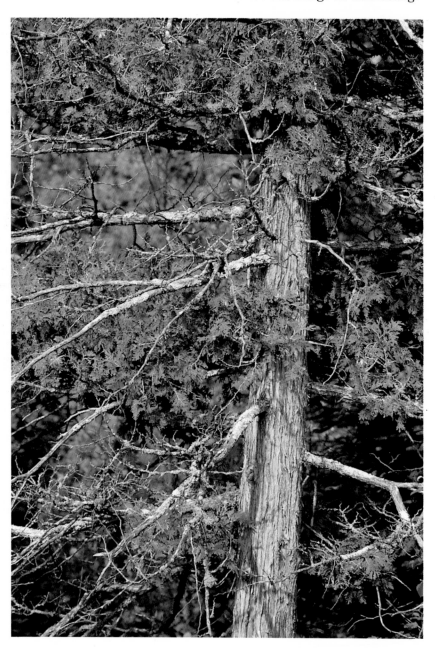

Sturdy branches reach out from the trunk of a northern white cedar.

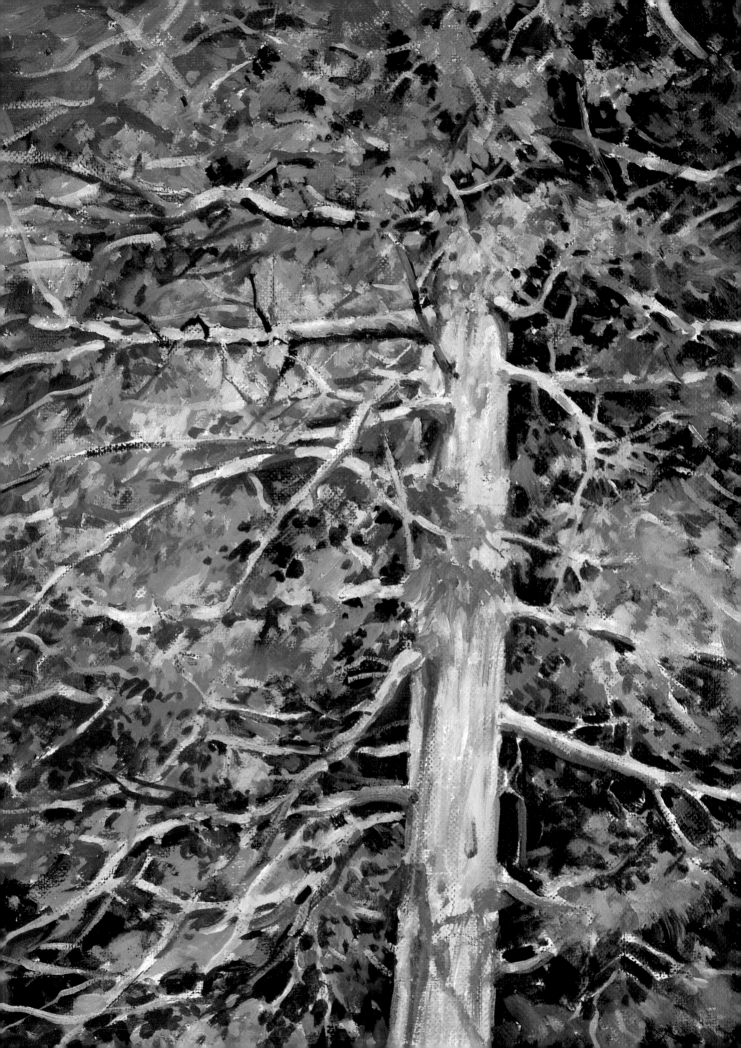

Using Brushstrokes to Break up Masses of Foliage

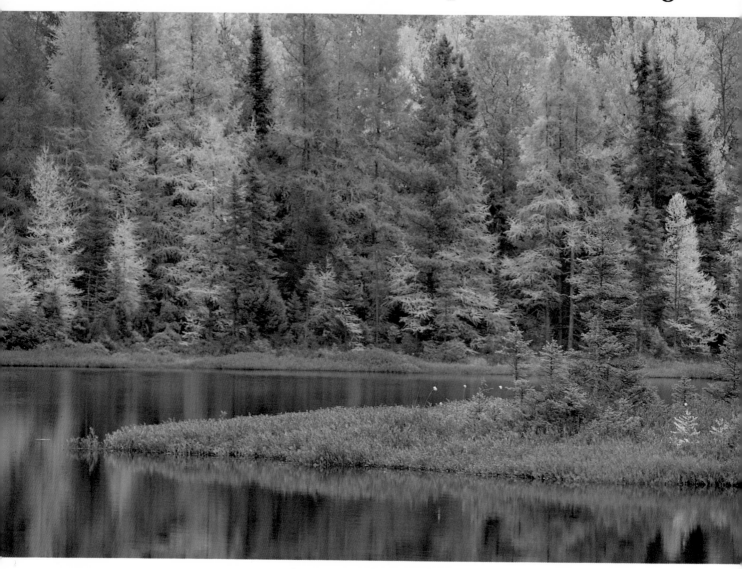

PROBLEM
It's just what makes this scene so arresting that makes it so difficult to paint. Clustered together, the trees lose their individuality in a veil of golden-green color.

SOLUTION
Don't just rely on color to pull apart individual trees; use your brushstrokes as well. With bold, powerful gestures, you can suggest the feel of the trees—how the branches spread out and the trees soar upward.

Stately larches crowd the peat-filled banks of a bog lake.

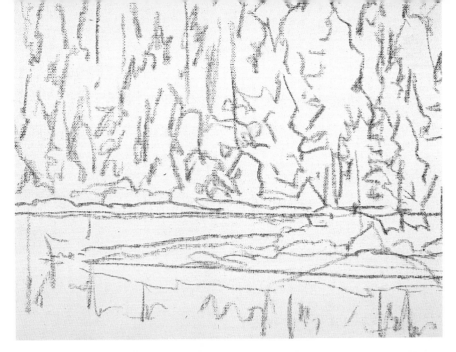

STEP ONE

Since your eventual goal is a strong, painterly effect, a bold drawing is important. Look for the overall shapes of the trees; then, using charcoal, sketch them in with quick, expressive lines. Don't dust your drawing down—you'll want all its strength to guide you as you begin to paint.

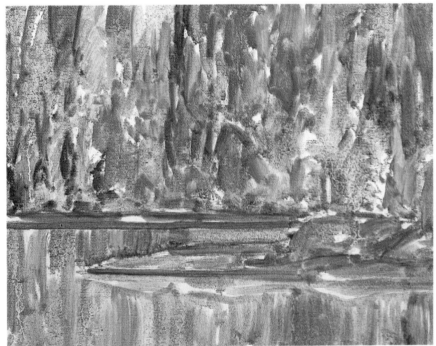

STEP TWO

Even in a crowded, problematic scene like this one, thin washes can help you structure the bones of your painting. Lay in areas of local color, but don't be too fussy. What you want at this point is a basic plan. Add some definite strokes to suggest the character of individual trees. Note how some strokes move toward the left while others sweep to the right. Nothing is static—everything is full of life.

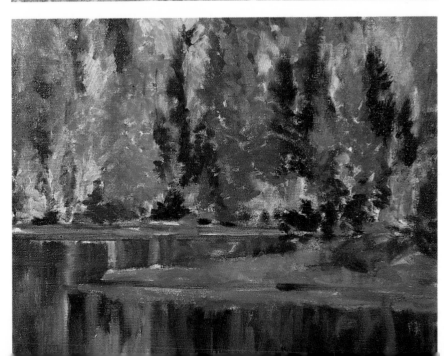

STEP THREE

Now it's time for thicker pigment. Before you take up your brush, though, study each tree's shape. Once you're conscious of how the trees fit together, transfer what you see onto your canvas, using short, rapid strokes of varied yellows, oranges, and greens. To capture the reflections in the water, use a different technique: work wet into wet with long, fluid strokes.

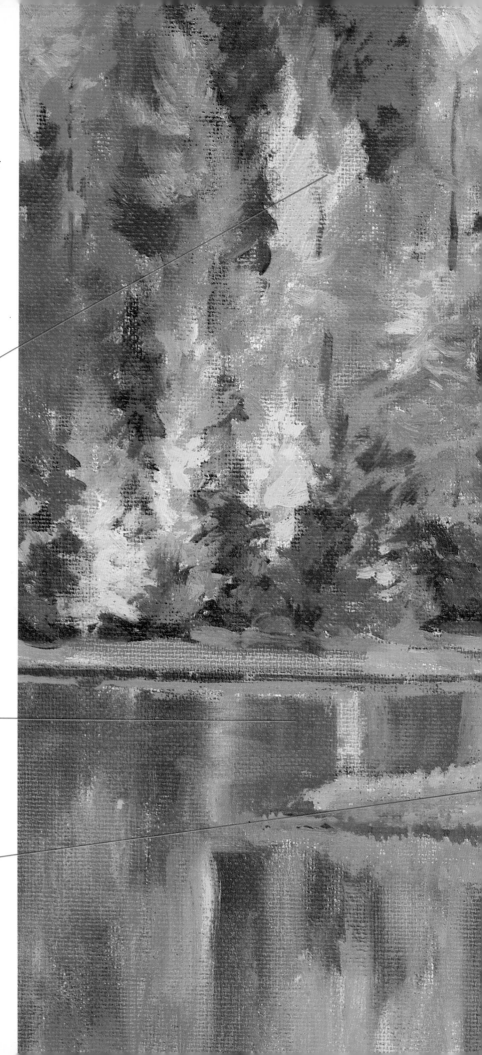

FINISHED PAINTING

Although by now your painting probably has a lot of life, it may lack definition. Do you have a sense of where one tree starts and where it stops? If not, pick out its shape by clarifying its color and distinguishing its brushwork. For accents, look for the places where a touch of a different hue will add life to the colors you already have. Here, for example, the bit of land that juts out into the lake becomes more definite and interesting as purplish pinks temper the blue-greens and siennas that had already been laid in.

The brighter, bolder golden-yellow trees stand out clearly against the trees in the background. It isn't just color that makes them so crisp. The yellow paint has been applied with quick, energetic brushstrokes.

Worked wet into wet, the fluid paint of the reflections in the water contrasts with the thicker pigment in other areas. The yellows, ochers, and greens blend together easily, setting the lake off from the bolder, staccato strokes of the trees.

The purplish-pink tones added at the very end also help to separate land from water. More than that, they sound a lively color note that complements the rest of the painting.

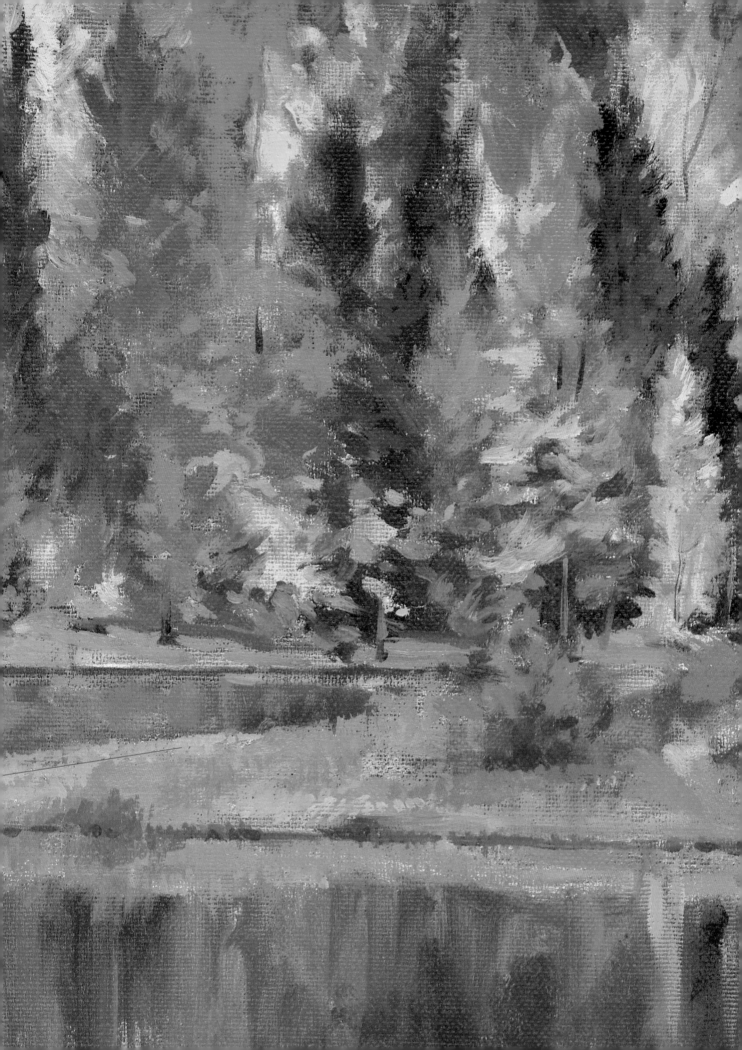

Deciphering a Multifaceted Subject

PROBLEM

Several things are happening all at once here. The background is closed in by a dense mass of woodland foliage, while in front the trees look lacy and delicate. The brilliant gold of the larch in the center adds to the confusion.

SOLUTION

Key your painting to the yellow of the center tree. After a careful preliminary drawing, cover the entire canvas with a light yellow tone. Establish the darks, then refine the light colors.

☐ In your charcoal sketch, pick out the definite lines of the golden larch and the spindly trees around it. Keep the drawing of the background trees loose.

Since touches of gold appear not only in the larch but also in the foreground and background, stain the entire surface with a deep yellow wash. If you've fixed your charcoal drawing, it will stay crisp and clearly visible beneath the thin yellow paint. Another approach is to stain the canvas first, but then allow the surface time to dry before you draw.

Now lay in the darkest tones, the deep greens that run through the background. Once they're down, you'll have established the darkest and lightest areas in your painting. Knowing the extremes ahead of time makes it easier to gauge the middle values.

When you're confronted by a lacy tree like this larch, it's a good idea to work back and forth between the darks and the lights. Here the effect of brilliant gold is created by combinations of cadmium yellow and yellow ocher applied densely, with short, rapid strokes. Then touches of green are introduced to break up the masses of gold. If your green strokes start to take over, go back and paint over them with your yellows. Keep moving back and forth, sculpting out the center tree, until you are happy with the effect you achieve. Now, blend a little green into your yellows and use the mixture to render the golden larches that stand behind the center one.

In the final stages of your painting, quickly indicate the thin, dark trunks and branches that spill into the foreground, then add a splash of bright red to the forest floor. Don't try to pick out every detail here—there's already enough action between the golds and greens.

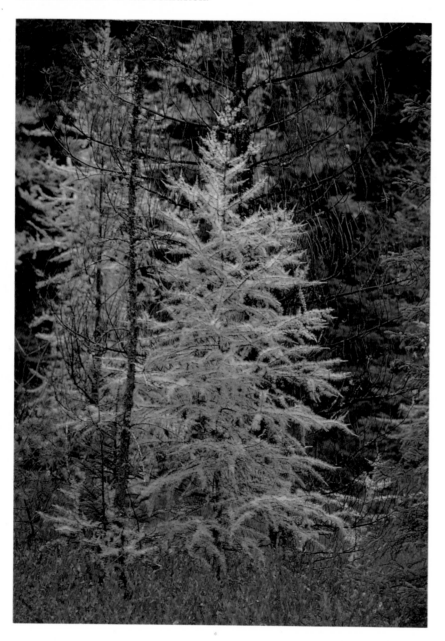

In early autumn, just before a larch begins to shed its needles, the needles turn a brilliant golden yellow.

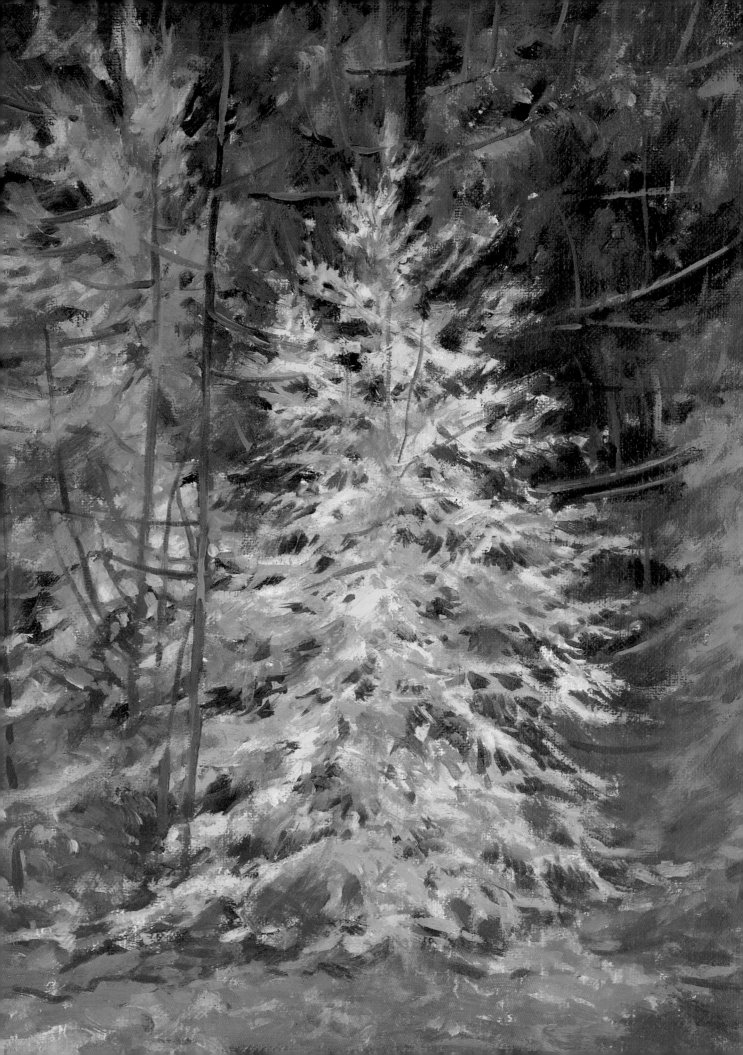

Establishing a Focus

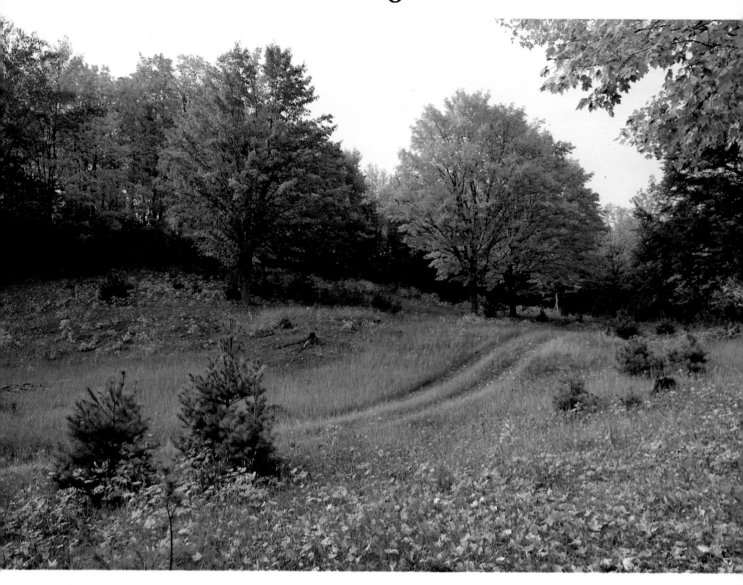

PROBLEM
Even though this scene seems simple at first glance, a lot is going on. There's a detailed foreground, a path moving strongly into space, and a mass of colorful autumn trees in the background. How are you going to simplify the complexity that you see?

SOLUTION
When you encounter a complicated scene like this one, decide which area is most important right away. If you don't, you'll end up with a painting that is unfocused. Here the emphasis is on the background, with its boldly colored autumn foliage.

A country path meanders toward the horizon on a crisp autumn day.

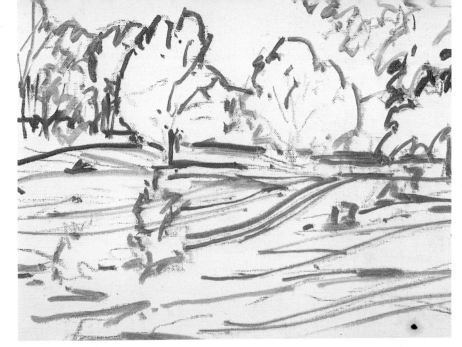

STEP ONE
Since there are so many diverse elements in this scene, it's important to get a feeling for the overall color scheme at the very start. Sketch in the composition with charcoal, then dust down your drawing. Next establish the major local colors by retracing the lines of your drawing in thin washes of the appropriate hues.

STEP TWO
Immediately concentrate on the area you've chosen to emphasize—here the background. Working with washes, briefly indicate the small evergreens that grow alongside the path, then turn to the trees in the background. Establish the base hue of each tree; some are primarily green, others mostly a golden yellow.

STEP THREE
Continue to build up the background. With short, definite strokes, begin to shape the structure of each tree. Pay attention to the way the light is shining. Here, for example, the left side of each tree's crown is lighter and brighter than the right side, showing how the bright midday light falls across the scene. When you're happy with what you've done, move on to the foreground. Start by suggesting the litter of bright leaves coloring the ground.

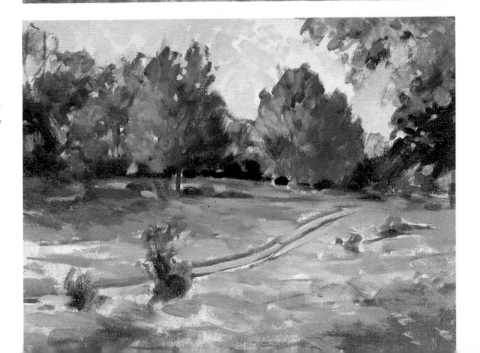

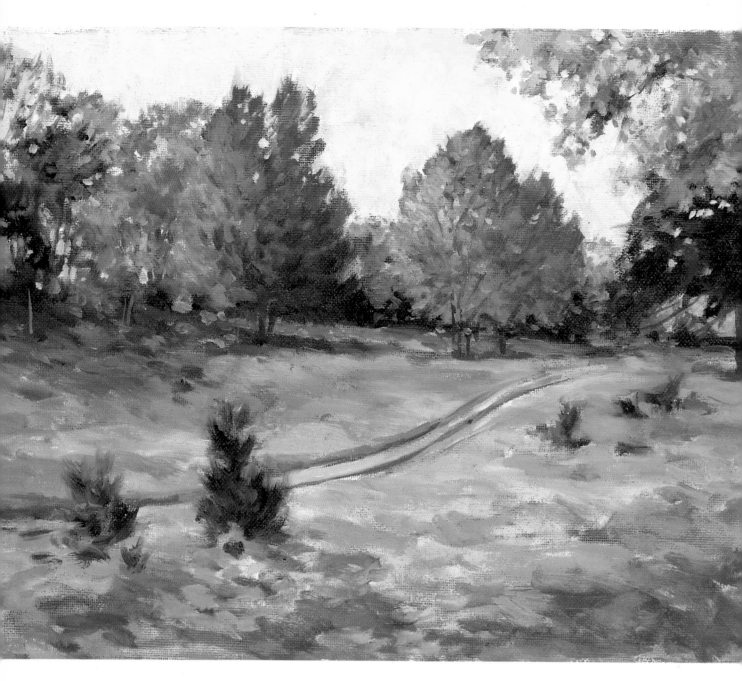

FINISHED PAINTING

All along you've been trying to make the background trees stand out as dramatic and powerful, so don't ruin what you've done now. It's hard to make the things that are closest to you seem soft and out of focus—that's not how the eye sees. But you need to downplay the foreground if you're going to highlight elements that are actually farther away.

Choose a broad brush to lay in the foreground and take a soft approach, using gentle, overlapping strokes. Don't let the colors get too brilliant; if they do, they

will command more attention than the trees farther back.

Finally, return to the focus of the scene. With a small bristle brush, sharpen the definition of the background trees. Short, vigorous strokes of color will help to draw the eye to this area.

ASSIGNMENT

Try to imagine how the scene featured here would look at different times of the year. In winter, the bare branches of the trees would appear thin and spidery. In spring, the trees would perhaps be heavy with blossoms. In summer, they would form a mass of rich greens.

As a long-term project, select a scene near your home—one that you see frequently and have come to know—then draw and paint it at different times of the year. Because the scene is familiar, composition will mostly take care of itself, leaving you free to concentrate on how the changing seasons transform a familiar subject.

DETAIL
When the sky is this pale and even, save it till the very end. To paint it, squeeze some white onto your palette, then mix in a touch of the color that dominates your painting. Here a dab of yellow tempers the intensity of white and brings the sky into harmony with the rest of the painting.

DETAIL
Everything in the foreground is soft and muted, allowing attention to focus on the brightly colored background. Note how the diagonal brushstrokes lead the eye back and at the same time give a sense of drifting fallen leaves.

Mastering an All-over Pattern

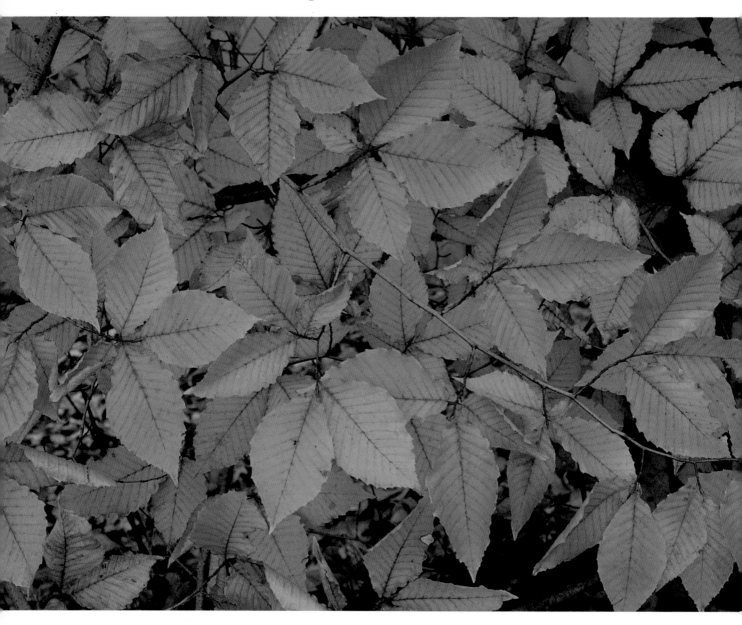

PROBLEM

Intricate closeups such as this one seem almost like abstract constructions at first. It's hard to figure out what holds the subject together.

SOLUTION

Start by working generally—lay in the overall patterns that you see. Once you've established them concentrate on the specifics. You can't hope to depict every detail, so aim at capturing the spirit of what you see.

☐ You'll need to start with a careful drawing. Instead of soft vine charcoal, try a charcoal pencil; you'll find that it's easier to manipulate than vine charcoal when you're depicting fine details. As soon as you have finished your drawing, spray it with fixative.

Using thin washes, now cover the entire surface with the approximate colors and values that you want in your finished painting. If you keep your washes thin, you won't lose your drawing, not even with the darkest hues you use.

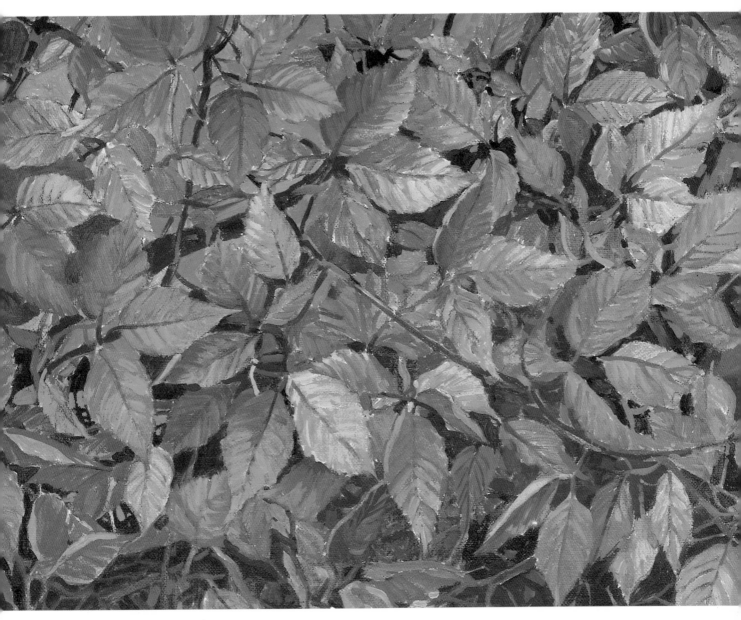

When you're ready for thicker pigment, begin by laying in the areas where the sky shines through. Here the sky is painted with a mixture of cerulean blue and white, warmed with just a touch of red. Next, select a few groups of leaves and concentrate on them. As you paint, remember that you'll never be able to follow every detail. Instead, keep your eye on the overall patterns you are creating on the canvas.

Two things are important at this point. First, all the leaves have to connect in a logical way. Second, you need to capture the subtle changes in color that occur from leaf to leaf, as well as the shadows that fall across the leaves. Start by mixing one basic brownish-gold tone; then, as you paint the leaves, add a little more yellow or brown, or even a touch of red to your basic color.

When you feel that you are almost finished, step back and look at what you've done. Is one section of the painting more prominent than the others? If so, you may want to temper its strength a bit. Do all the leaves look exactly the same? If so, try to vary them by introducing touches of other colors—darker browns, brighter ochers, an occasional blush of red. Finally, do the leaves connect in a natural way? If they don't, turn to the trouble spots and analyze what's wrong. With oils, it's easy to rework any portion of the painting.

Simplifying the Pattern of Fallen Leaves

PROBLEM

Two things catch the eye here: the strong lines formed by the massive roots and the lively pattern of autumn leaves on the ground. The danger is that one will compete with the other.

SOLUTION

Emphasize just one aspect of the subject. Here the trunk and roots are clearly the focus of the painting. The leaves are treated much more generally.

☐ Sketch the tree's roots with soft vine charcoal, then reinforce your drawing with a wash of burnt umber. Continue using thin washes to build up your painting. Try developing the incidental elements first. Here the fallen leaves that carpet the ground are given a wash of raw sienna and raw umber. Next, with raw umber and ivory black, begin to indicate the shadows that fall across the leaves. Now turn to the brighter greens. Sweep a wash of permanent green light and ocher across the canvas with a small bristle brush. Then pick out the shadows with Thalo green and a bit of alizarin crimson. Finally, for the tree's trunk, choose a basic mixture of ocher and white, with just a touch of black.

At this point the canvas should be completely covered with washes of paint. The task now is to indicate the detail of the forest floor and to build up the trunks and roots. Texture is what matters here. Don't get overly involved with minute detail; the important thing is to capture the overall feel of the scene.

Begin by sculpting out the shadowed hollows between the roots. For this, select a fine brush; if your strokes are too broad, you'll lose the realistic touch you're aiming for. To convey the texture of the leaves on the ground, use a small bristle brush and short, light strokes, one drifting into the other.

Once you've built up the entire surface of your painting, spend some time looking at what you've done. Does your painting still need a little punch? Here the dark bluish-green areas at the base of the tree were the final touch. They clarify the roots' structure and give the entire painting a crisp, focused look.

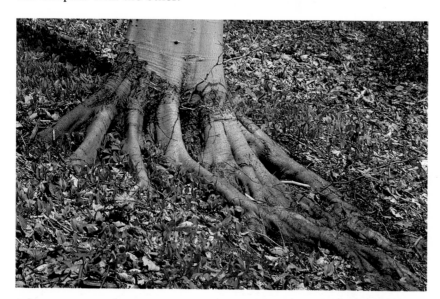

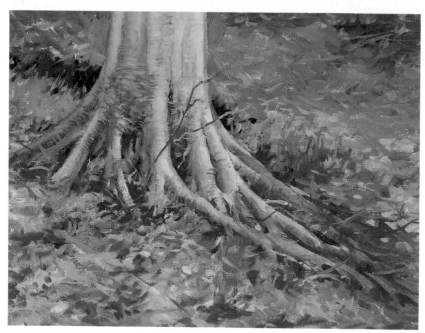

In early autumn, thick roots stretch out from the base of an old beech tree.

Working with Oil on Paper

PROBLEM

With a tree surface like this one, what stands out is the abstract configuration of shapes and lines. To make this closeup work as a painting requires something more than simply copying what you see.

SOLUTION

Subtle variations in texture are crucial when you are rendering bark, so don't let the weave of canvas or the smoothness of Masonite interfere with the quality you want to convey. Work instead on watercolor paper; its rough surface will mimic that of the tree trunk.

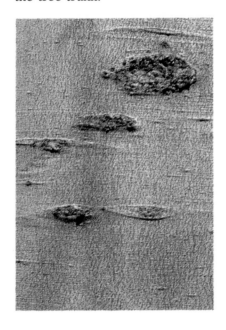

Stark, abstract patterns lie hidden in the smooth bark of a beech tree.

☐ Size the paper with a solution of acrylic medium. While you let the medium dry, figure out your approach. Oil paint need not always be applied thickly. Mixed with turpentine it handles almost like watercolor, and that can be an advantage when you want to paint a delicate subject like this one.

To start out, sketch the subject in pencil, then pour a little turpentine on your palette and add just a touch of brown pigment. Quickly apply this fluid wash to the paper. Next, use a slightly darker, brownish-gray wash to pick out surface details—the cracks and fissures in the bark. While the paper is still wet, hold it up and let the dark pigment run up and down, backward and forward. You'll be amazed at how much control you actually have over the flow. Once a satisfactory pattern is achieved, use a dry brush to lift the wash off the paper in places, thus establishing your lights.

Wait for the paper to dry, then repeat these steps as often as needed until the image looks realistic. Toward the end, you may want to use a fine sable brush dipped into a brown wash to refine bits of the trunk. As a final step, take a sharp blade and scratch off some of the dark paint. Used sparingly, this technique can enhance the textural effect.

DETAIL
The varied techniques used in this painting can all be seen in this detail. First, note the bumpy texture of the watercolor paper and how the pale brown washes have settled into the paper's depressions, leaving interesting patterns as they dry. The darker washes are soft and indistinct, the result of allowing the washes to flow naturally into each other. A few small details stand out crisp and clear because they were painted with a small brush after the surface was dry. Finally, the pale, horizontal lines were made by scraping the paper with a sharp blade.

ASSIGNMENT
As you've discovered in this lesson, there are times when watercolor paper provides an ideal support for the oil painter. Use it when its bumpy, irregular surface imitates the surface of the subject you are painting. It's perfect, for example, when you are rendering the rough, irregular bark of a tree.

Priming the paper is essential if your painting is going to work. If you skip this step, you'll discover that the oil seeps through the fiber of the paper. This isn't just unsightly—it will make your painting less permanent as well. Try priming several sheets of watercolor paper, then start to experiment. You'll discover that thin washes of color float easily over the paper; laid on in successive layers, they slowly build to create a powerful effect.

Making Bright Colors Bold

PROBLEM
The strong, crisp colors of this hickory tree are going to be hard to depict. It's easy to add too much white and to lose the brilliance of the tree's foliage.

SOLUTION
You'll be better able to gauge your bright tones accurately if you keep your darks really dark. Set against dark passages of paint, strong, bright colors seem even brighter.

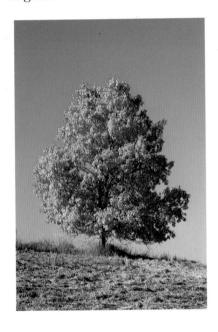

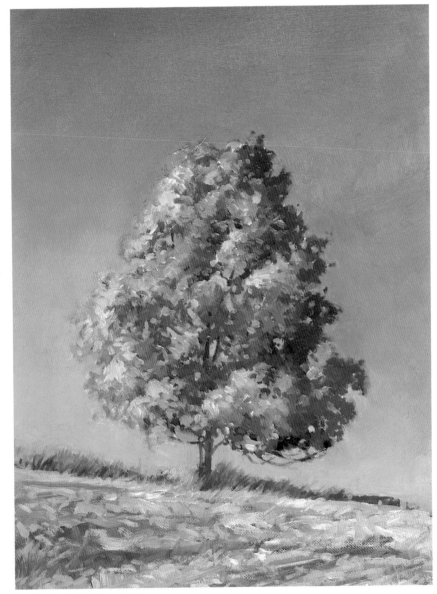

In autumn a handsome hickory asserts its golden shape against an azure sky.

☐ After reinforcing your sketch with a brush, lay in the tree's shadowy masses. Make them really dark to set off the brilliant leaves. Wash the rest of the tree in cadmium yellow and the ground in ocher, then turn to the sky.

Using a large bristle brush, start at the top with cobalt blue and alizarin crimson, but quickly eliminate the crimson. About halfway down, shift to cerulean blue, Thalo green, and a touch of white. Finally, smooth everything with a fan brush.

Now return to the foliage. With a small bristle brush and broken strokes, apply a mixture of cadmium yellow, cadmium orange, and a mere touch of white to the crown. Don't use too much white, or your colors will look washed out. Continue with just the yellow and orange. Also add dark accents of Mars violet and cobalt blue to sculpt the tree's volume.

If you paint the foreground the same color as the tree, the tree will lose its drama. Choose a mix of yellow ocher and raw sienna. At the end, enliven the ground with quick, rough strokes.

Downplaying a Potentially Dramatic Element

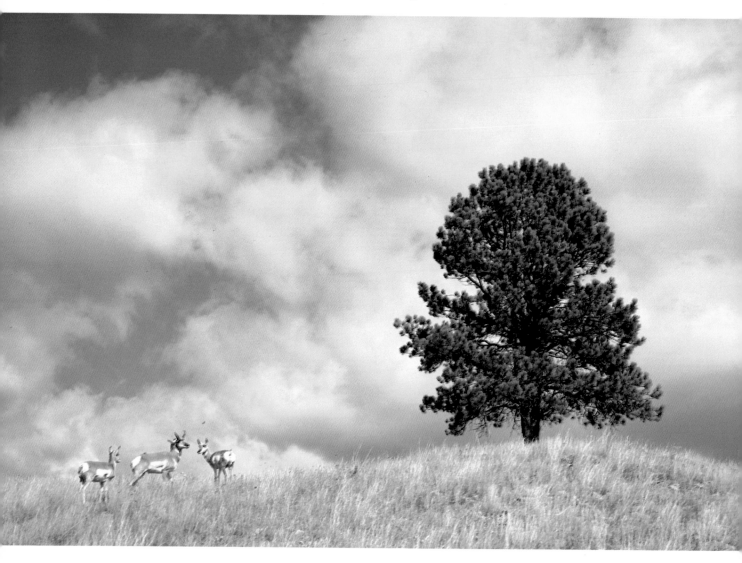

PROBLEM
Whenever an animal appears in a painting, you can bet it's going to become the center of attention. But sometimes that's not what you want. Here, for example, the pronghorns seem almost incidental; it's the dramatic sky and the tree's handsome profile that define the view.

SOLUTION
Paint the entire scene before you develop the pronghorns. Make the tree even bolder than it really is and play up the excitement of the sky. When it comes time to paint in the animals, just suggest their shapes; don't pick out every detail.

*Three pronghorns pause briefly
near a ponderosa pine.*

STEP ONE
Simple subjects like this one don't require complicated sketches. Just lay in the main lines of the composition with vine charcoal. As you sketch, remember to pay attention to the shapes of the clouds as well as the tree, animals, and ground.

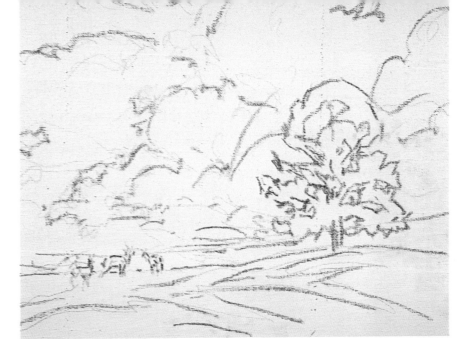

STEP TWO
Loosely brush in the dark greens of the tree, then, with a fine brush, indicate the animals and the horizon line. Next, turn to the sky. Working with thin washes, establish the blue of the sky, then use a grayish wash to show the shadowed areas of the clouds. For the time being, let the white of the canvas represent the brightest, lightest portions of the composition. Finally, lay in the grass that sweeps across the foreground with a yellow ocher wash.

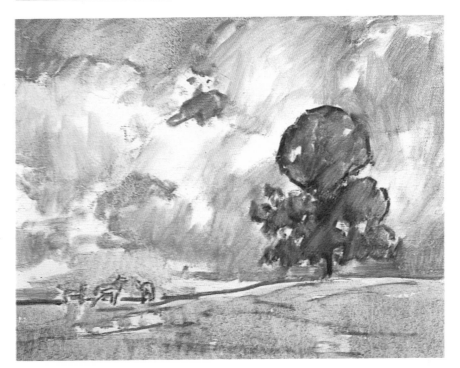

STEP THREE
Using opaque pigment, start with the sky since it is so much lighter than the tree. Work wet into wet to capture its soft, fluid quality. The grayish shadows that you indicated earlier will serve as guides now. Try working around them with a mixture of white and yellow ocher—even the brightest areas in a cloud are rarely pure white. Then develop the tree, applying your paint with a small bristle brush. Choose just one basic green here; for the shadows, add a little brown to the green; for the highlights, mix in a dab of white.

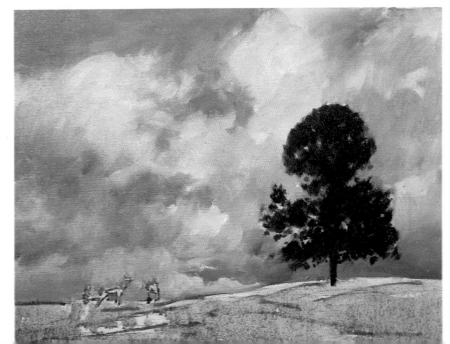

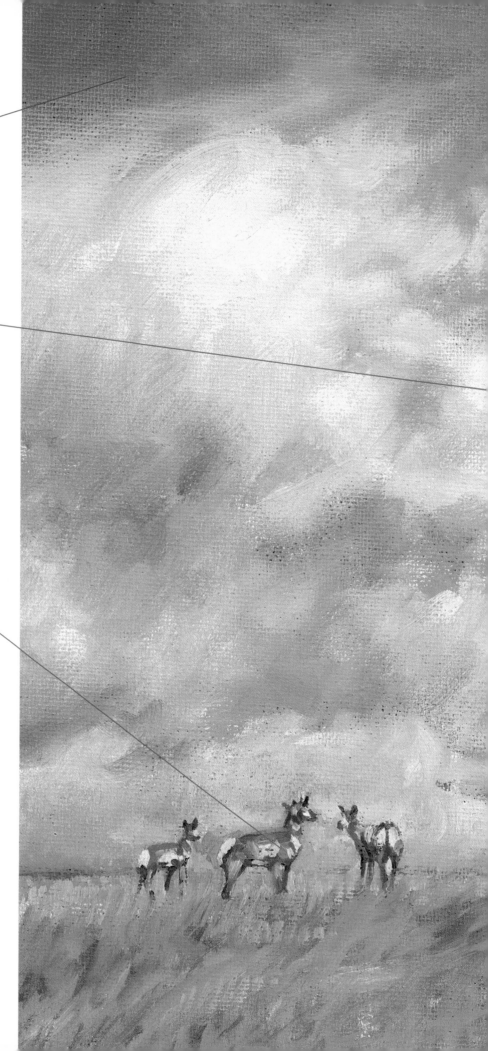

Most of the sky is painted with cerulean blue, but here a touch of ultramarine has been mixed in. This dark wedge of color at the edge directs the eye in, toward the center of the painting.

The ponderosa pine's silhouette stands out forcefully against the cloudy sky. When you are working with such a dramatic backdrop, be sure to keep the other elements in your painting simple yet strong. If this tree were overly fussy, its impact against the sky would disappear in the trivia of detail and the whole painting would lose its focus.

Painted simply at the very end, the pronghorns blend easily into the rest of the picture. Note the fine brush-strokes that were used to delineate their basic form; it seems almost as though the animals were drawn, not painted.

FINISHED PAINTING

Paint the grassy foreground with yellow ocher. Use short, calligraphic strokes to break up the surface and to pull the foreground out to the front of the picture plane. Now, with a fine sable brush, complete the animals; remember: don't go into too much detail here. Finally, examine your whole painting critically, gauging how well the different parts work together. Here the clouds seemed just a little on the dark side. Adding some bright white passages to them made the whole painting spring to life.

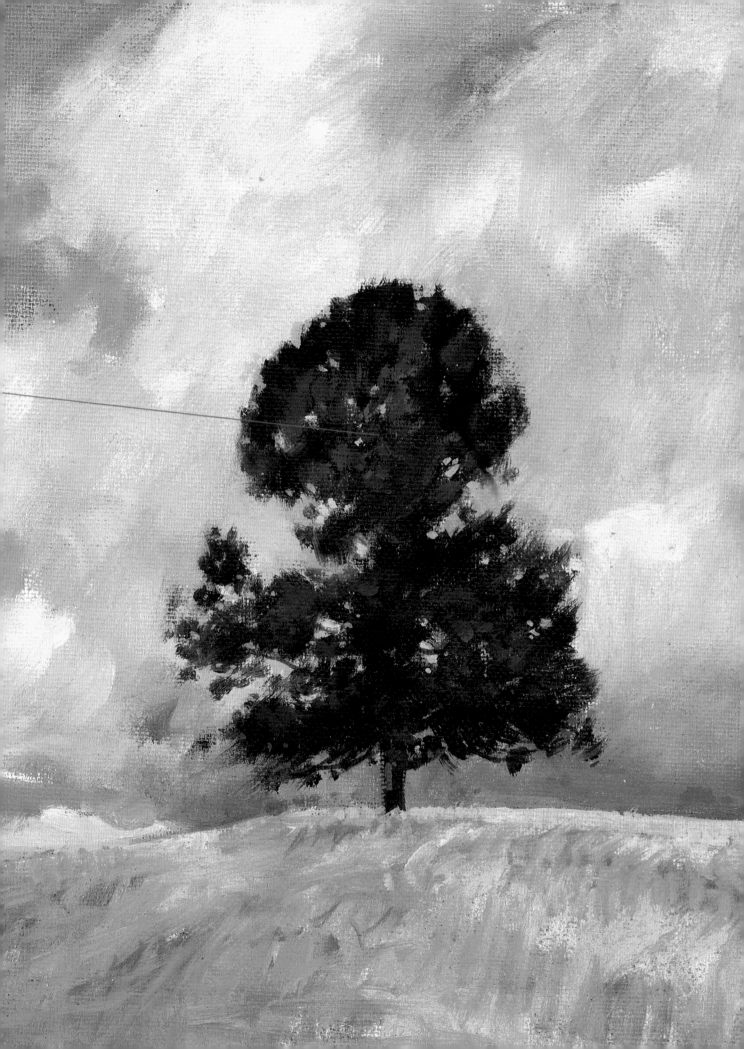

Experimenting with Fog

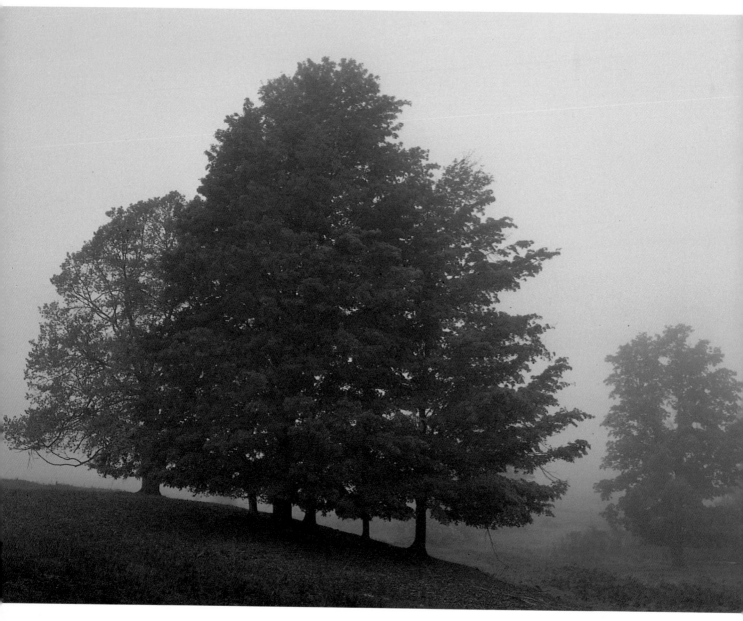

PROBLEM

A foggy scene can be hard to paint. Fog softens the edges of everything it envelops and tends to narrow the range of values.

SOLUTION

Don't be too literal in your interpretation. If you stick too closely to what you see, you may lose the sense of space. Make the tree in the foreground slightly darker than it really is to clarify its position in the landscape.

*Fog rolls in over a gentle hillside,
shrouding a grove of maples.*

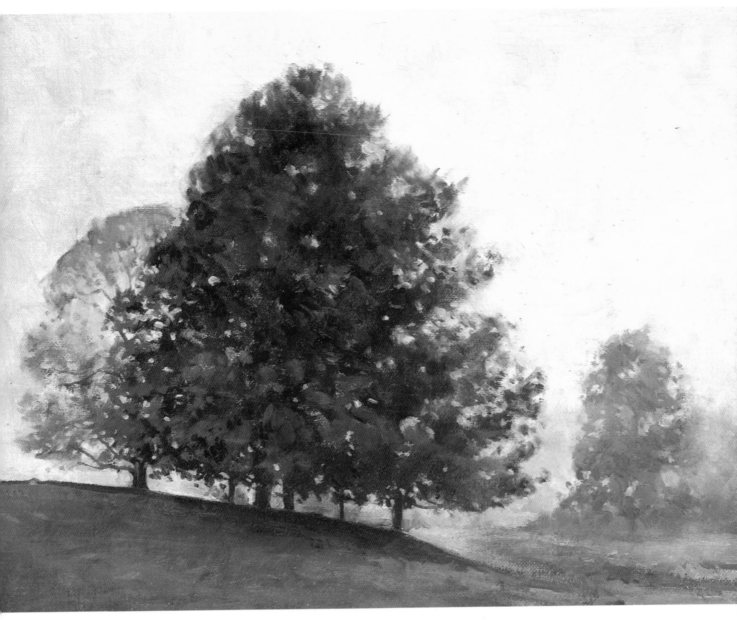

☐ With charcoal, define the major shapes in the composition and then dust your drawing down. Now redraw the scene with a small brush dipped into a pale wash. In preparing these preliminary washes, look for the colors that dominate in this scene. Here bluish and reddish purples came into play.

Still working with thin washes, establish the dark trees in front. Introduce opaque pigment as you turn to the sky. Rendered with a mixture of yellow ocher, perma-

nent green light, and white, the sky has a luminous quality that suggests how the sun diffuses through the fog.

Now go back and build up the trees. To capture the soft atmosphere that bathes the entire scene, work wet into wet as you paint the trees. Gently blend their edges into the sky to avoid sharp, definite transitions. For the trees closest to you, use a blend of cadmium red, cobalt blue, Mars violet, and white. As you move to the trees in the distance, de-

crease the amount of red in your mixture and add a touch more white. The blue will help make the trees in the distance recede, while the red will make those in the foreground jump forward.

Now lay in the hillside with a large bristle brush. By using the same colors found in the trees, you'll create a pleasing sense of color harmony. As a final note, emphasize the nearest tree by building up its texture with short, vigorous strokes of thick paint.

Bringing out Early Autumn Color

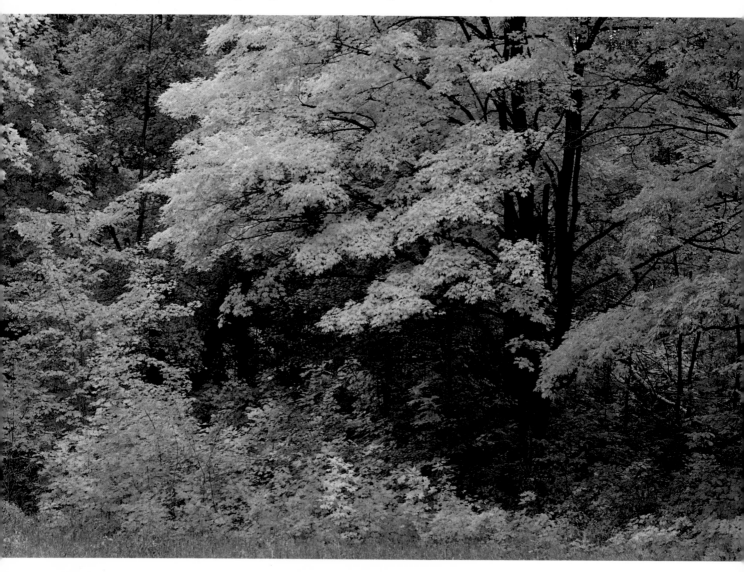

PROBLEM
Packed together, thick, colorful foliage is exciting to look at but awfully hard to paint. Somehow you have to capture how the color relates to the individual trees or your painting won't make sense.

SOLUTION
Use your brushstrokes to convey the rhythmic buildup of color. Short, deft strokes with a bristle brush give the sense of many separate leaves joining together. This painterly approach will enliven the surface of your painting and help make the individual colors sing.

Autumn maples cluster together in a flourish of rich greenish golds and oranges.

STEP ONE

Before you sketch the scene, spend a little time studying it. There's nothing tangible to hang onto here; instead, you are dealing with amorphous masses of color. Figure out where the main hues start and stop, then indicate those places with charcoal. Next, sketch in the major directional lines with thin washes of ocher and green.

STEP TWO

Mix washes of your major colors—golden oranges, ochers, and greens—then rapidly cover the entire surface, working from dark to light. Don't try to portray exact hues; instead, concentrate on values and the patterns of light and dark you are creating.

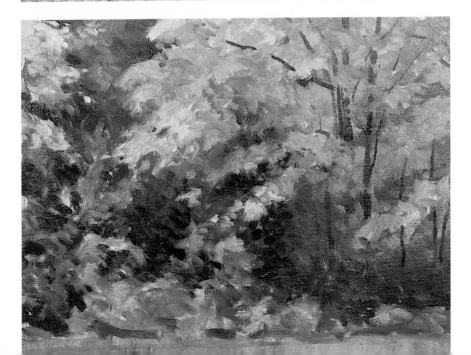

STEP THREE

To capture the feel of dense, overlapping leaves, use short, broken strokes as you begin to work with opaque pigment. Let the colors you laid down with your washes act as a guide. At this stage work wet into wet and, again, move from dark to light. Your focus is still on defining large blocks of color, though you can begin to break these areas up with touches of lighter or darker color.

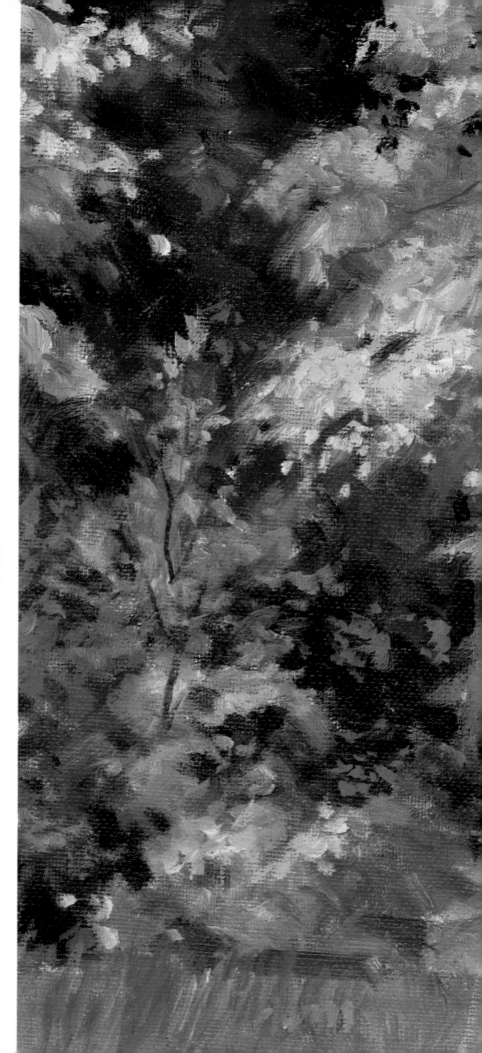

FINISHED PAINTING

Once the major color areas are clearly defined, shift your attention to the range within the areas. You want to show the rich mix of color that makes this scene exciting. In particular, observe how the light strikes the leaves; capturing the direction of the light can help to unify your painting.

At this stage, the needs of the painting take over. Look at it and figure out what has to be done if it's going to be convincing. Here the masses of color were still too broad and general. They needed more variety and distinction to suggest the wealth of foliage. If that's the effect you want, accent the dashes of color with short, broken strokes. Keep your eye on the subject so the direction of your strokes will suggest the way the leaves hang on the trees.

ASSIGNMENT

Brushes come in a such a huge array of sizes and shapes that choosing them may, at first, seem bewildering. Don't let all the choices you face make you fall into the trap of using the same types every time you paint.

Bristle brushes may be flat, almond-shaped (called "filberts"), or round; in addition, they may be long- or short-haired. Each type produces a brushstroke with a visibly different edge. To learn what each kind of brush can do for you, experiment with the three basic types: a flat, a round, and a filbert. Load each brush with pigment, then drag it across a piece of canvas. Note the different effects you achieve. Next, try dabbing paint onto the canvas with each brush. You'll find that the filberts produce a gently curving stroke, one that's perfect for depicting masses of foliage. The flat brush has its own uses—it's great when you are trying to lay in washes quickly at the beginning.

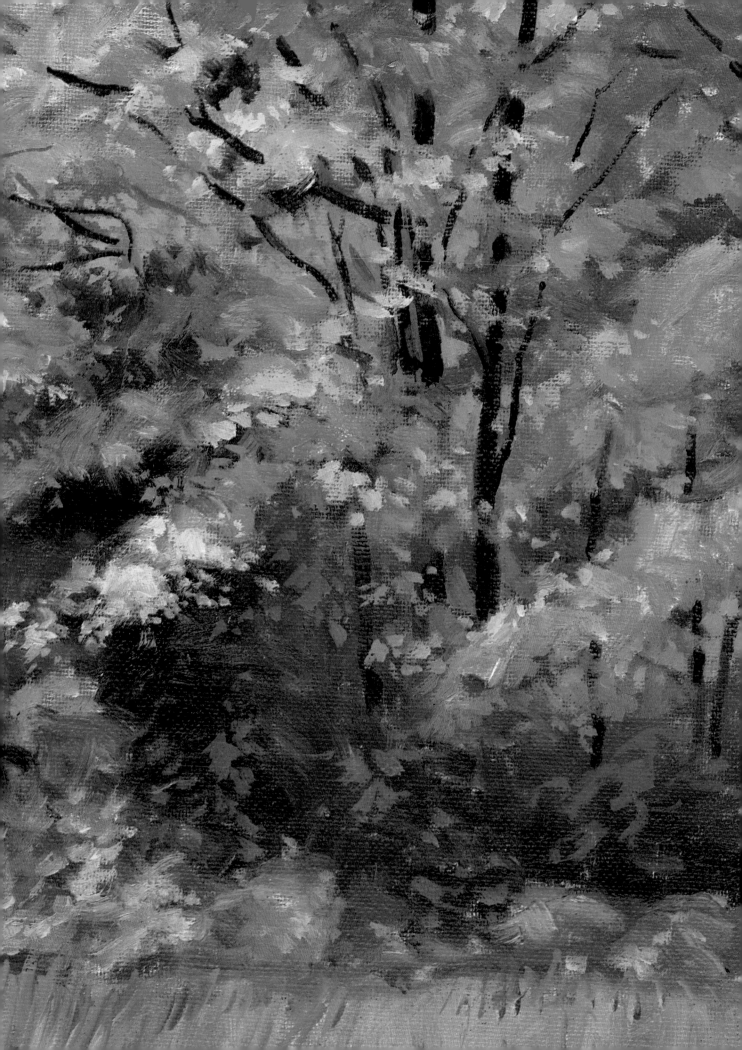

Creating the Feel of Backlighting

PROBLEM

Backlit scenes are among the most difficult to paint. They can easily become unconvincing if the contrasts between light and shadow are too emphatic, or if you ignore subtle changes in color.

SOLUTION

After you've finished your preliminary sketch, establish the brightest tone by laying a light yellow wash over the entire surface. For the darkest value, don't choose pure black. Instead, mix a deep, rich tone from your browns and reds or blues.

☐ Your charcoal sketch should be simple. Draw the trunk and the powerful branches that soar up from it; also lightly indicate the darkest masses of foliage. Now cover your drawing with a burnt umber wash. Then, to infuse your subject with a golden glow, bathe the canvas in a wash of cadmium yellow light. But first protect what you've done by sealing the surface with a coat of varnish.

As you turn to thicker paint, study how clusters of leaves look when they are lit from behind. Instead of forming bold areas of color, they break up into small patches of light and shade. To capture this sensation, work with a small bristle brush and short, broken strokes. First develop the dark patches; next turn to the lighter areas; then move back and forth. Note how just one dark stroke can change the entire feel of the painting. Don't worry: you can always go back and readjust the other lights and darks.

Now return to the trunks and branches. What color should you use? You may be tempted to try pure black; after all, the trunk is very dark compared with the leaves. But pure black will make the transition between the leaves and bark too harsh. Instead, take a burnt umber and temper it with a touch of red.

Once you've established the trunk and branches, let the painting tell you what to do. Assess the patterns of dark and light that run through the foliage. If some passages seem too dark or too light, readjust your value scheme. You may also want to introduce touches of pure color—here dabs of brilliant cadmium yellow reinforce the wash that was laid down earlier.

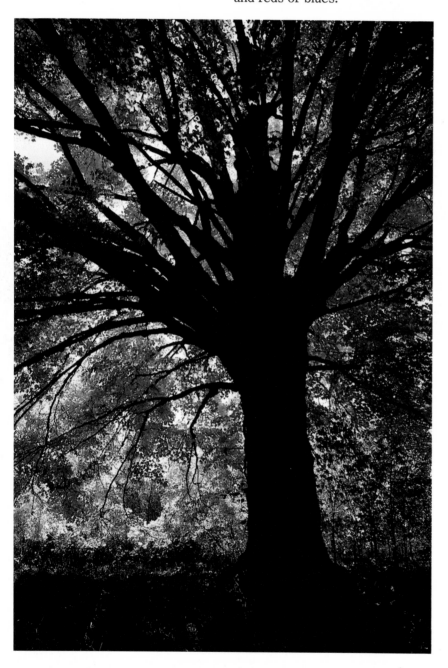

The strong trunk of a maple stands boldly silhouetted against a riot of autumn foliage.

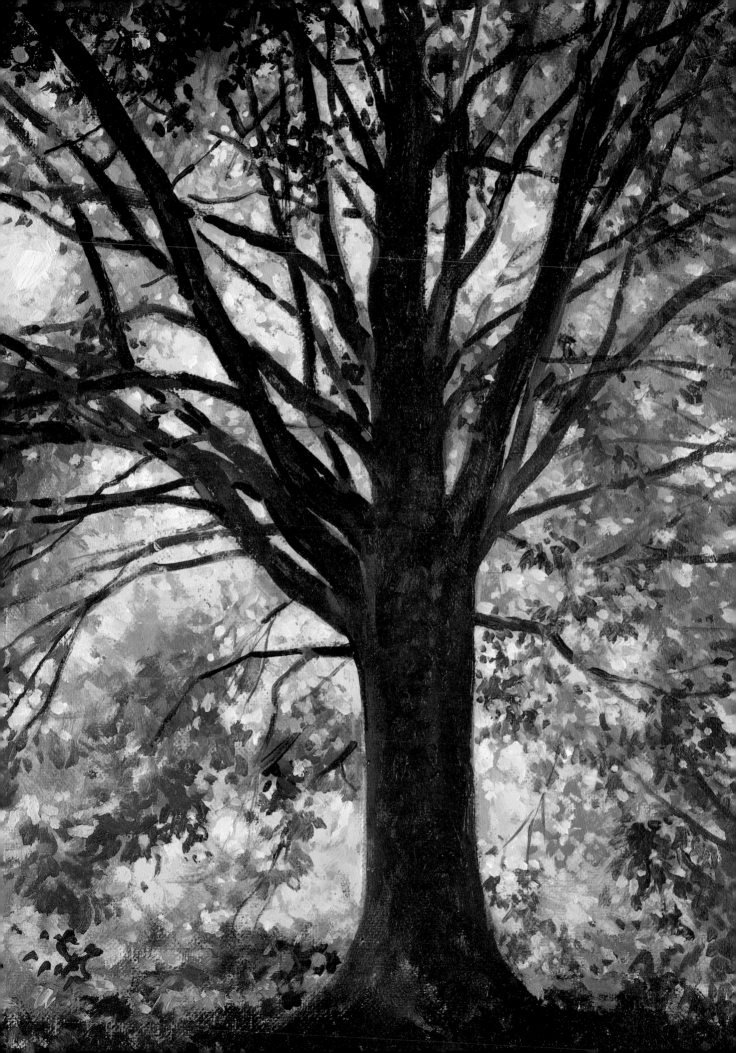

Handling a Painting Knife

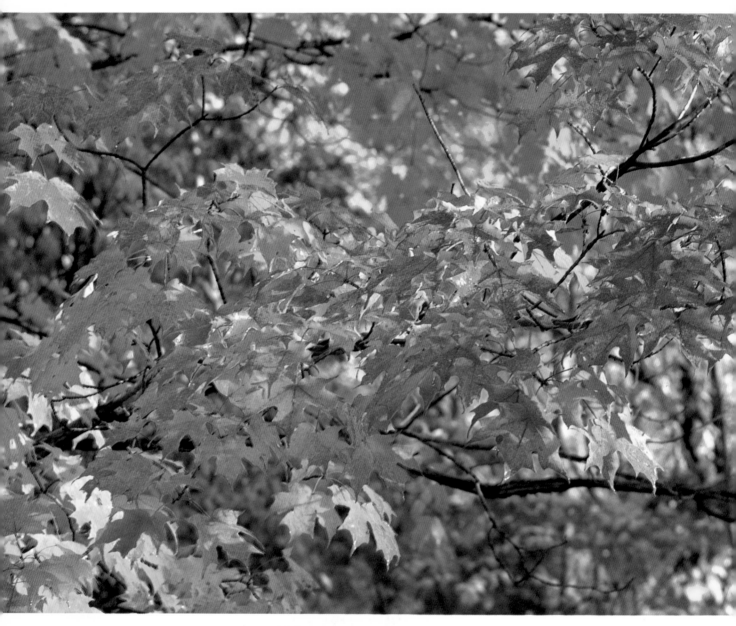

PROBLEM
Bright reds, yellows, and oranges tend to bleed together visually, making it difficult to get a sense of individual leaves.

SOLUTION
Don't rely on color alone to punctuate the surface of the painting. Once you've set up the overall composition with thin washes, use a painting knife to apply the paint.

☐ In your drawing, concentrate on just one thing: the patterns formed by the dominant red leaves. Then redraw them with a small brush and a thin wash of red to further separate them from the background. When you've indicated the hottest, boldest areas, turn to the dark greens that lie in the background. This step helps you establish the overall design of the painting—as you lay in the darks, you have to figure out which areas should spring forward and which are less important.

It's at this point that many beginners want to add the branches, which they hope will structure their work. But if you put the branches down now, it's all too tempting to hang clumps of leaves on them—and nothing could make a scene look more unnatural. In views like this one, the branches are relatively unimportant. What you want to capture is the impact of the brilliant leaves. Forget the branches until the very end and concentrate on color.

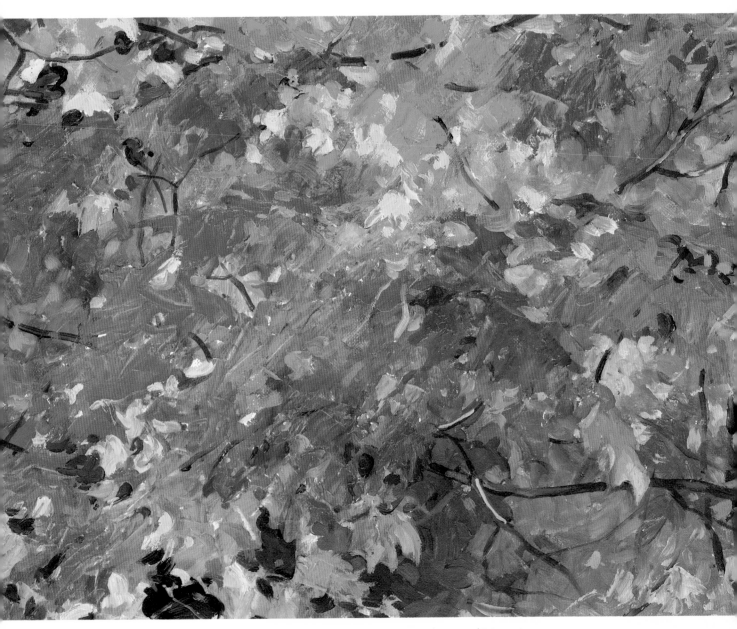

The glorious colors of maple leaves in autumn rush together in a dazzling pattern.

Start using thick paint now, applying your pigment with a painting knife. Working with a painting knife is faster than laying in color with a brush, and that can be an advantage in cases like this one where texture is critical. You can quickly build up a rich impasto that suggests the actual texture of the leaves. If you're wondering about drying time with such thick paint, it's true that the drying process can take longer. But if you add a gel medium to your pigment—one that speeds up dry-ing time—you'll find that thick paint dries almost as quickly as thin layers of paint.

Now that you've established the major areas of color, refine them with a brush. Use a bristle brush to coax the paint about, sharpening the edges of each mass of color. At the same time, pay attention to the background, building up the greens that you first laid in with thin washes. You'll need to work back and forth between the leaves and the back-ground, adjusting values and clar-ifying shapes.

It's at this point that the branches should be added. As you draw them in with a small sable brush, don't try to be exact. If you get caught up in detail now, you'll lose the rich, painterly feel you've already achieved. Finally, mix a little cerulean blue and white; then, with a bristle brush, roughly indicate the patches of sky that peek through the leaves. In the end, you'll have a blaze of color, flaming so vigorously that it almost seems to pulsate.

Playing Sharp against Soft Focus

PROBLEM

This knot of flowers is packed with detail—so much detail, in fact, that it will be hard to capture and present clearly.

SOLUTION

First, choose a small support, one only a little larger than the actual cluster of flowers. It's also a good idea to use Masonite. Concentrate on the flowers closest to you; just suggest those in back.

☐ When detail matters as much as it does here, a careful drawing is a must. Instead of charcoal, try a carbon pencil; you'll find it has a crisper, more definite edge. After fixing your drawing, you're ready to lay in color. But where do you begin with so much intricate detail?

What you want to do is to take advantage of the soft blur of the background flowers to bring out the sharp focus in front. A good way to start is by laying in the general patterns of dark and light. Apply washes of pink and red to indicate the main highlights and shadows of the blossoms, then gradually add a few definite shapes. Don't forget about the background; develop it, too, with thin washes of green. Since your drawing will still be visible through the transparent washes of color, use it as a guide to help you separate one area from another.

Now turn to opaque pigment. If you paint portions of the flower clearly, with sharp detail, the rest will be carried along; the eye will fill in the details that are glossed over in the painting process. Start with the pale pinks—they'll set the stage for the darker pinks and reds. Use your medium-value pinks to depict the parts of the flower closest to the viewer; then sharpen up the details you've chosen to accentuate with deep, rich red.

The white tips of the blossoms, as well as the green leaves and stems, are set down at the very end. By scattering dabs of white over the surface of the painting, you'll create a lively rhythm. The greens will temper the brilliance of the pinks and reds and, at the same time, help convey the feel of living flowers.

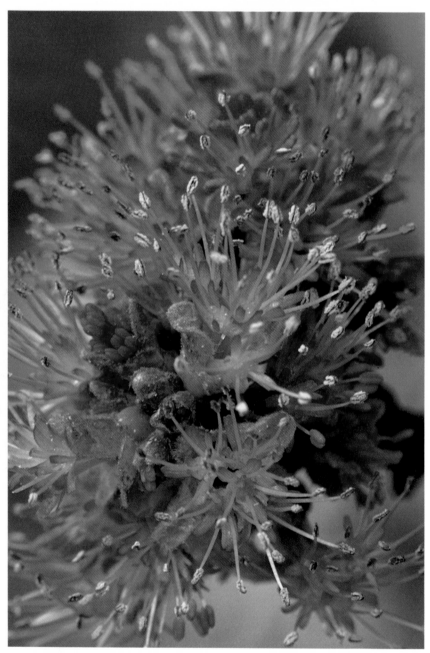

In early spring, just as the chill of winter dies away, a cluster of flowers bursts out on a red maple.

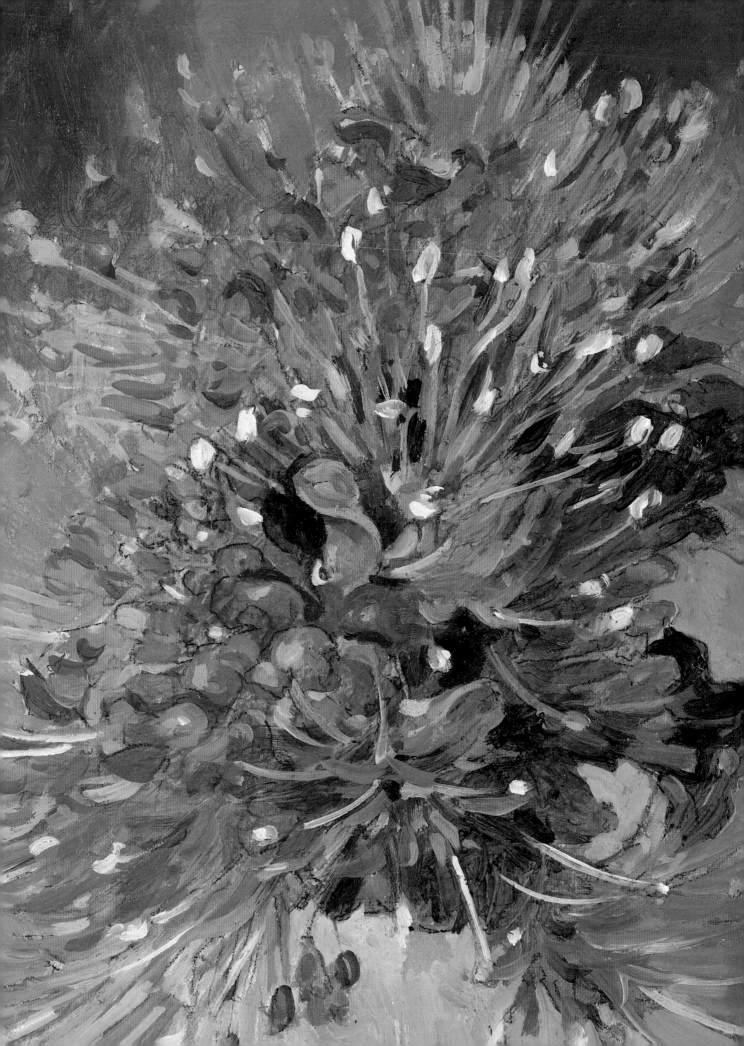

Balancing Two Competing Colors

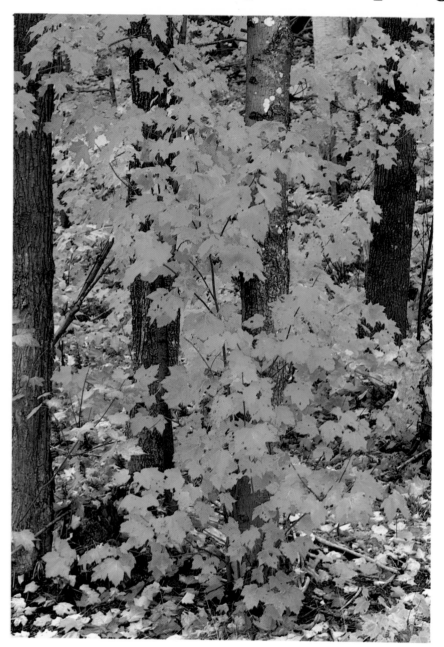

PROBLEM
The colors in both the foreground and the middle ground are strong and bright. If you make them equally vivid, you may lose a clear sense of space.

SOLUTION
Exaggerate the contrast between the reds and the oranges so that one color—red—stands out clearly.

STEP ONE
In your preliminary drawing, concentrate on the vertical tree trunks and the overall pattern of the leaves. Detail isn't important here. Search instead for the rhythm that the clusters of leaves set up. Then, redraw the scene with a thin red wash, outlining the masses of bright red leaves. For the time being, ignore the orange leaves; it's important to emphasize just one color.

Partially hidden by a maze of brilliant red and orange autumn leaves, tall maple trunks sweep upward.

STEP TWO
To further distinguish the red leaves from the rest of the composition, cover the background with a thin, dull wash of ocher and raw sienna. At the same time, bathe the tree trunks with a brownish wash to clearly establish their shapes. Continue to let the white of the canvas represent the red leaves.

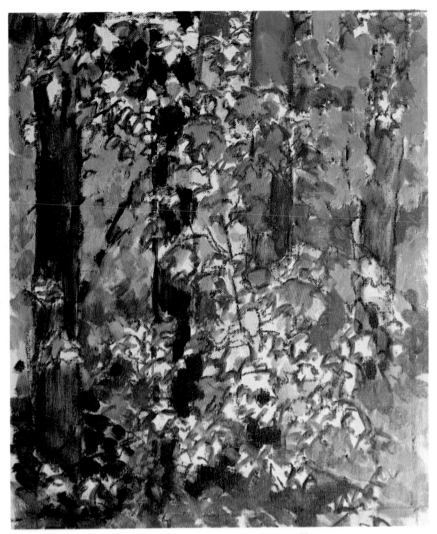

STEP THREE
Now begin to work with thicker pigment. To make the reds really stand out, use a painting knife. In this way you can lay in bold, dramatic masses of paint and build a tangible surface texture. After you've piled on the red pigment with your painting knife, refine the contours of the red leaves with a small bristle brush.

FINISHED PAINTING (*overleaf*)
Almost everything that makes this painting special happens in the final stages—the colors are intensified, the texture becomes more dramatic, and the forms are defined. First, go back to the dark tree trunks, working around the red leaves you've already established. Now turn to the red and orange leaves. On your palette prepare good-sized dabs of red and a bright yellow-orange, then mix portions of the two colors together to get a strong reddish orange. To all three colors, add gel medium to hasten drying time.

Moving all over the canvas, apply dabs of color with a painting knife. Get the yellow-oranges down first and keep them thin. For the reds and red-oranges, use

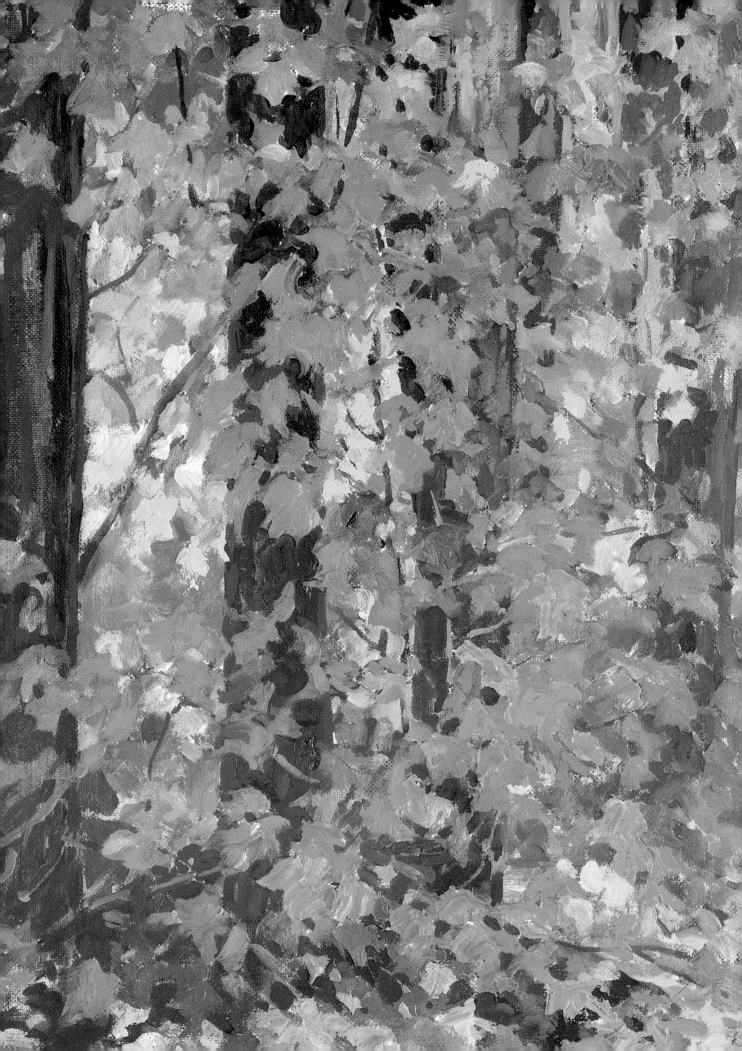

more paint so their texture will literally make them stand out.

Once you're satisfied with the overall pattern, introduce a few bright color accents with cadmium yellow. Finally, while the paint is still wet, take a small bristle brush and refine the strokes laid in with the painting knife. In some places you'll want to soften the edges; in others you may want to add still more pigment to enhance the three-dimensional effect.

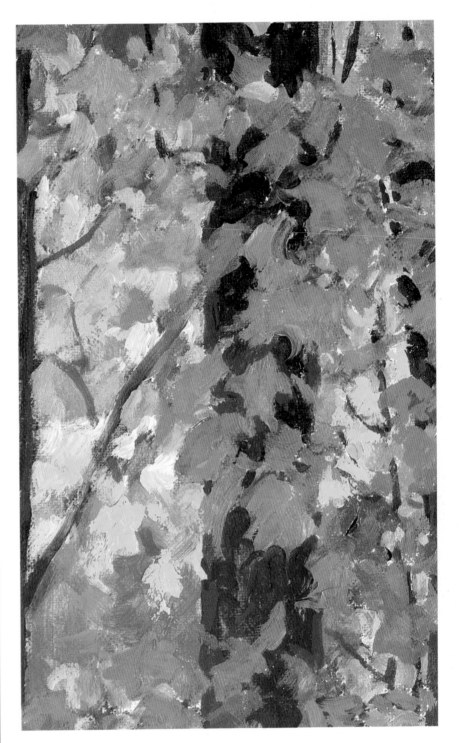

ASSIGNMENT
Learn the difference between painting knives and palette knives. Palette knives are stiff and used mostly to scrape dried paint off the palette. In contrast, painting knives are flexible, with a definite spring to them. They come in an extraordinary variety of shapes and sizes.

To explore their different effects, choose a scene made up of large masses of color. After you've sketched the scene and laid in the basic color scheme with washes, load a painting knife with thick pigment. Quickly put down the clumps of color that you see. Try a fat knife and a thin one, or a long one and a short one. Remember that when you're done, the thick paint will still be fluid, so you can take a brush and smooth out any edges that don't seem to work.

DETAIL
When you lay touches of bright yellow on top of your reds and oranges, what you are doing is setting up a lively sense of space. Like the reds, the intense yellows spring forward, giving your painting a sense of immediacy. More than that, they break up and thus activate the pattern of the reds—which is important when the reds are as strong as they are in this scene.

Finding the Details That Count

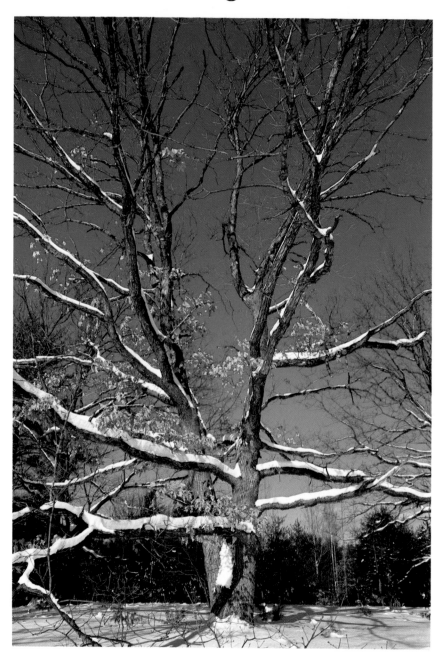

PROBLEM

Although this scene looks straightforward at first, once you start to analyze it, you'll find it's quite complex. The intertwining branches of the oak, with their snowy covering and dried-out leaves, make for detail—detail that has to be captured if your painting is to convey the tree's essence.

SOLUTION

Make sure you establish the basic lines of the oak in a good, clear drawing. Paint the strong blue sky first, however. Once it's down, you'll be able to focus on the details of the tree that give it character.

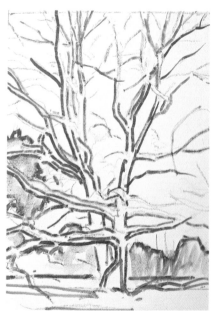

STEP ONE

Capture the structure of the tree with a strong charcoal drawing, then reinforce it with diluted color. Also use thin washes to lay in the incidental elements of the scene—here the trees that hover on the horizon.

In early February snow lays heavily on the sturdy branches of an old oak tree.

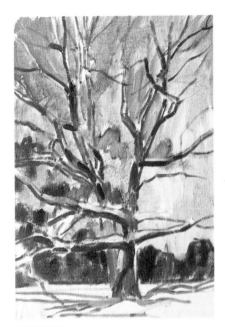

STEP TWO

Now's the time to establish your overall color scheme. Still working with thin washes, get down the blue of the sky. As you turn to the tree and its leaves, let the white of the canvas represent the snow weighing down its branches. Then build up the dark hues that define the background.

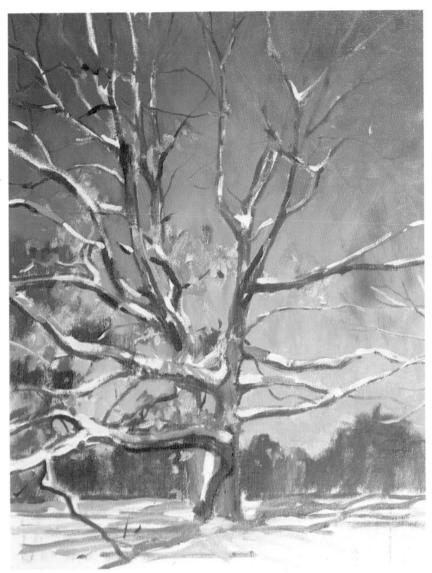

STEP THREE

In winter scenes, the warmth or coolness of the sky does a lot to establish the mood of a painting. Here the sky is a warm, radiant blue. As soon as you start to work with opaque pigment, get the value and warmth of the sky down. Once it's done, you can concentrate on the tree. After reasserting the lines of the tree, begin to build its lights and darks with different browns. It's time, too, to render the snow—use a small sable brush and pure white paint, plus white mixed with a touch of blue. Next turn to the snow in the foreground. Get the bluish shadows down first.

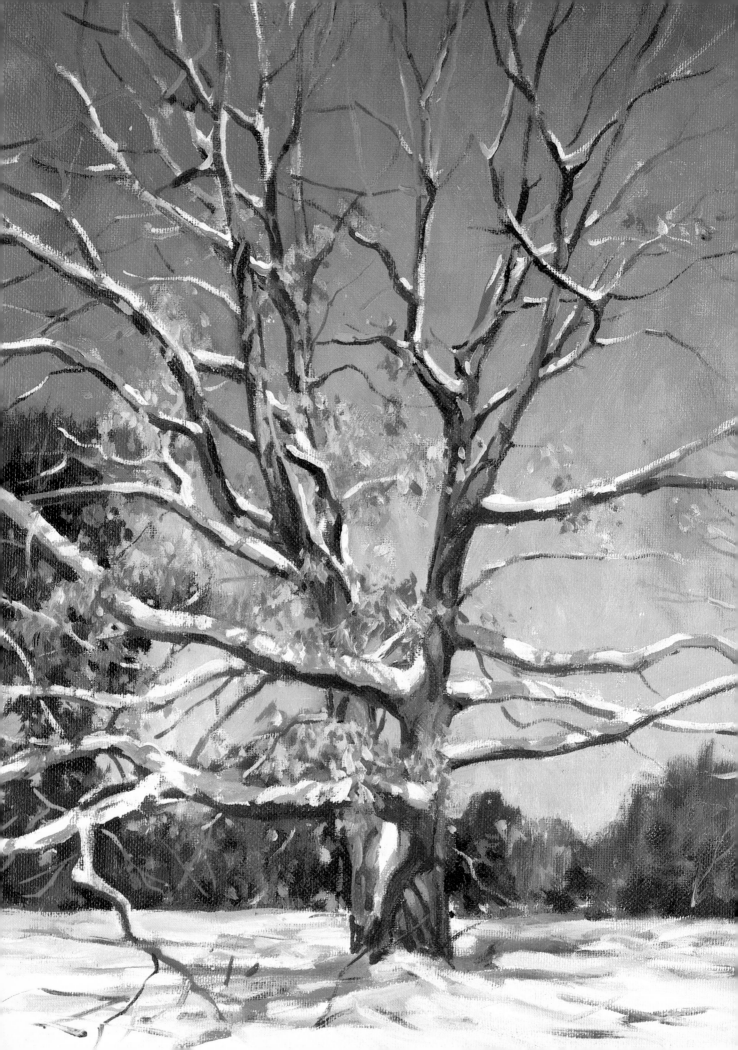

FINISHED PAINTING

In the final stages, bring out the leaves that cling to the tree. Working with your browns and yellow ocher, gently dab the leaves in with a small sable brush. The point is to make the leaves look dry and fragile; with heavy, unbroken pigment, you'd lose the feel of winter. At times you may need to work back and forth between the leaves and the sky, adding touches of blue to break up the golden-brown tones, or vice versa.

Next, complete the foreground. To tie the ground to the tree, add touches of yellow ocher and brown to the snow beneath the tree. Finally, turn a critical eye toward the tree. Is its structure clear? Here it was necessary to redraw portions with a small sable brush moistened with dark pigment. At the very end, paint in the shadows that weave over the trunk.

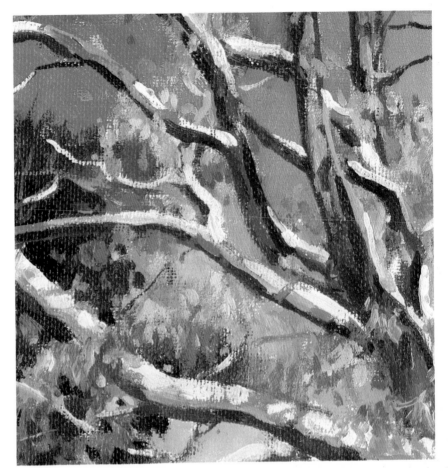

DETAIL *(above)*

Seen up close, the variety of colors used to render the snow-covered tree and its dried leaves becomes apparent. Bits of blue key some snowy passages to the color of the sky. Also notice how the broken strokes let the brown of the branches show through. The gentle dabs of yellow-browns in the leaves strike a different, more delicate note.

DETAIL *(right)*

There's a lot going on in the background; thick trees hug the horizon and the snow-covered ground is covered with deep shadows. In the finished painting, the background remains important, yet it is rendered with much less detail than the oak. If it were developed more fully, it would steal attention from the oak—the focus of the painting.

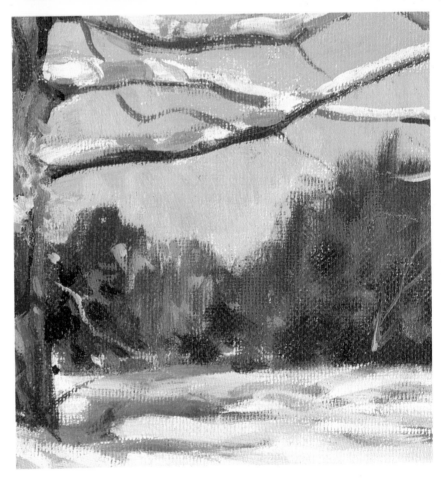

Using Value to Clarify an Intricate Pattern

PROBLEM

When you move in close on a scene, it can become extraordinarily complex. Here the branches form a spidery web interrupted only by the dead leaves. Making sense out of this jumble will be difficult.

SOLUTION

Establish your middle value right away. Once it's down, you won't have to struggle with the value scheme. You can easily gauge the strength of your darks and lights as you concentrate on what matters here—pattern.

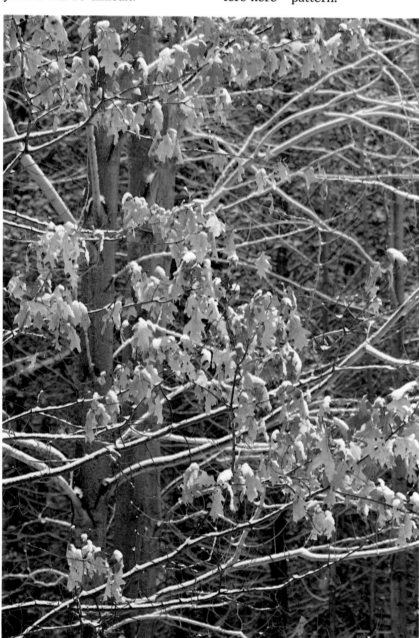

Clusters of dead leaves cling to the branches of an oak tree already coated with thick, wet snow.

☐ Use your preliminary sketch to delineate the major branches of the tree and the overall pattern of its foliage. You'll be staining the canvas with a middle-value wash, so fix your drawing before you proceed. When the fixative has dried, go over the lines of your drawing with thinned yellow ocher—the color you'll rely on when you paint the leaves.

Now tone the entire canvas with a cool bluish gray—the color that dominates the background. Mix a small amount of pigment on your palette, then add a good amount of turpentine. Sweep the mixture over the entire canvas with a large brush, or even a rag. Then take a small, dry brush and "erase" the areas of snow.

When you are confronted with a scene as complex as this one, work all over the canvas as soon as you begin to paint. Lay all the colors you'll need on your palette. As you work back and forth between the leaves, the branches, and the background, you'll see that each stroke you lay down influences those around it. First, get down major shapes— the tangle of branches, the tree trunks in the rear, and the overall configuration of the leaves. Next, tighten up the painting's structure by refining details. To make the leaves stand out, darken the areas that surround them and break up their masses.

Finally, with a light shade of bluish gray, paint the thin, delicate branches. Add the snow using a drybrush technique; slowly pull a barely moistened brush along the canvas, letting touches of the gray-brown break through the white. When you think your painting is finished, leave it alone for a while. When you come back to it, look to see if the overall pattern is clear, and if the lights and darks stand out from the grayish middle tone.

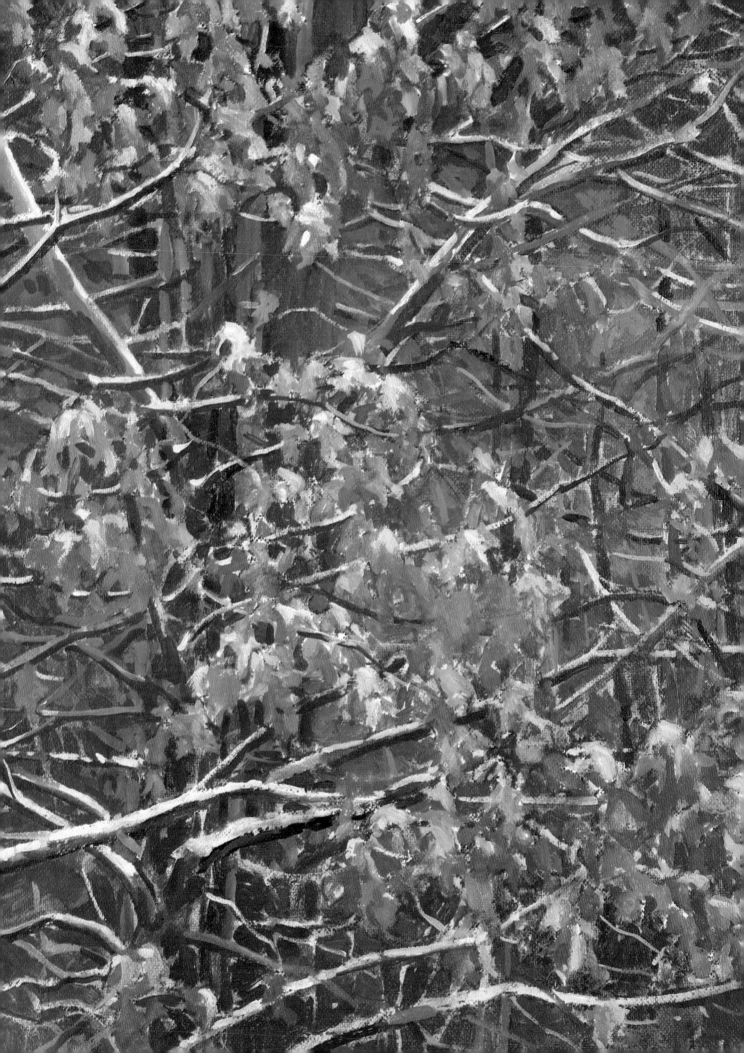

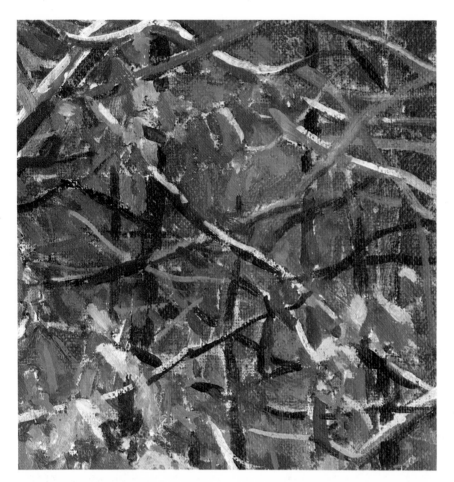

DETAIL
The delicate, snow-covered branches are subtly rendered with a drybrush technique. In places the white pigment covers only portions of the grayish-brown branches, re-creating the irregular patterning of snow. Observe how the blue-grays of the background enhance the cold, wintry feel of this scene.

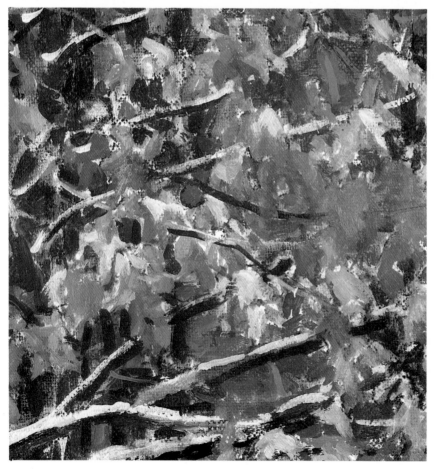

DETAIL
Painted with overlapping strokes of blues, grays, yellow ocher, browns, and white, the leaves of the oak tree develop a three-dimensional feel. The strokes that were laid down last seem to lie in front of those that were painted first. Note, for example, how the dabs of white stand out against the darker hues, and how they link the leaves to the snowy branches.

Distinguishing Spidery Branches against a Pale Sky

PROBLEM

The branches of this oak tree are thin and spidery. Set against a pale sky, they are very hard to see. Unless you take care, they will lose their delicacy and look harsh and unrealistic.

SOLUTION

Paint the sky before you tackle the tree. Then reestablish your preliminary drawing. With something as delicate as these branches, you may have to pause several times while painting to redo your drawing. If you let the drawing fade away, you'll never capture the branches' spidery quality.

☐ With charcoal, sketch the tree and go over your drawing with thinned burnt umber. As soon as your color drawing has dried, turn to the sky. Load a large bristle brush with cobalt and cerulean blue lightened with a touch of white. To indicate the clouds that soften the sky, gently coax white pigment onto the blue ground. For a more realistic look, add touches of yellow ocher and even gray to the white.

If your drawing has become lost as you laid in the sky, reestablish it with thin color. Then, with thicker paint, build up the trunk and the major branches. To make your brownish hue more interesting, try adding a touch of cobalt blue to your burnt umber. Next, brush in the line of distant trees and the basic planes of the foreground. For the time being, let the white of the canvas represent the snow.

Once the darks of the tree are down, you may want to adjust the strength of the sky. While the sky is still wet, lightly brush in the tree's delicate, spidery branches with a thin sable brush; the brown will become soft and fuzzy as it blends with the colors of the sky.

To complete your painting, add thin strokes of white to suggest the snow on the branches; then build up the grass in the foreground. You'll want to render the grass boldly, with rapid, calligraphic strokes, to give the tree a solid base.

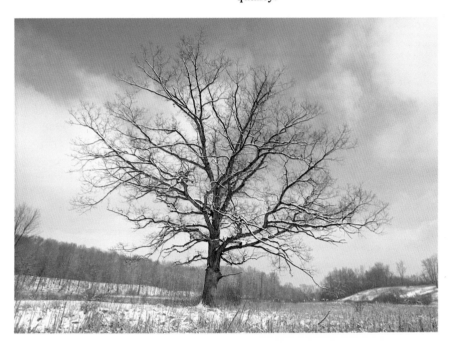

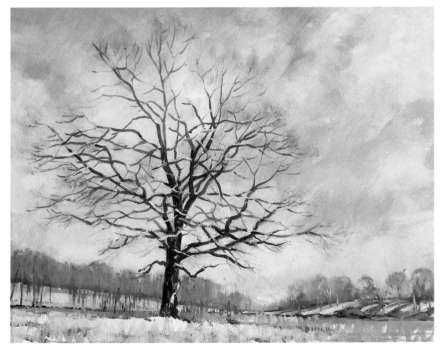

The barren branches of a white oak reach out across a cool winter sky.

95

Capturing the Sparkle of Frost

PROBLEM

What's unusual about this subject is the sparkle of frost that adorns the leaves. But if you concentrate on just that, you'll lose the overall sense of the composition.

SOLUTION

Before you turn to the frost, carefully analyze the pattern of lights and darks running through the leaves. Only when you've finished everything else, add the slivers of white that cling to the edges of the leaves.

☐ Carefully draw the leaves, then cover your drawing with thinned color. Here the view has been extended beyond the photograph on the right side. Feel free to alter what you see if it will improve your composition.

When you start to paint, establish the darks right away. Moisten your brush slightly with pigment, then stroke the paint over the surface to indicate the shadowy portions of the leaves. As soon as they are down, capture the hazy, indistinct background by scrubbing color onto the canvas with a barely moistened brush. Use the same colors that you intend to use for the leaves.

In painting the shadowy areas, you had to gauge their values against the white of the canvas. Now that the background is painted, you'll probably find that the shadows are too light. Deepen their color, then let the surface dry.

To build up the leaves, work with glazes—mixing your pigment with a medium to create a transparent veil of color. Because the color is transparent, the shadows you've established are never lost. Instead, they shine through the lighter, brighter colors laid down on top of them. Don't try this technique with turp washes because the turpentine will stir up the paint already on the canvas.

As you apply successive glazes, work from dark to light. Only when you are completely satisfied with the pattern of darks and lights should you think about the frost. Take a small sable brush; dip it into white pigment; then gently dab the white around each leaf. As a final step, mix a dull grayish tone to temper some of the dots of white. Not only will this suggest the shadows that fall across the frost, but it will also bring out the sparkle of the pure white.

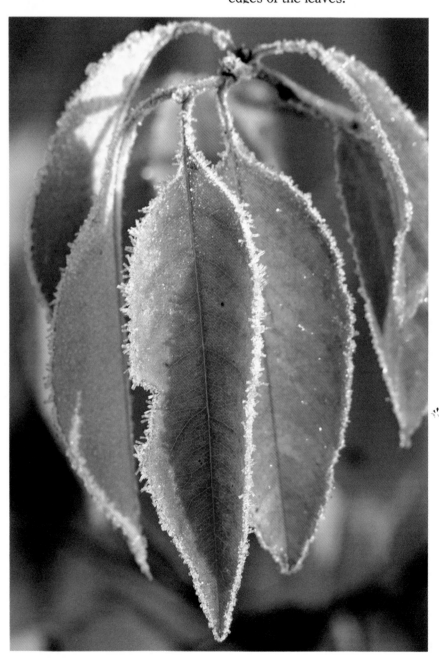

An early frost decorates the long, thin leaves of a cherry tree.

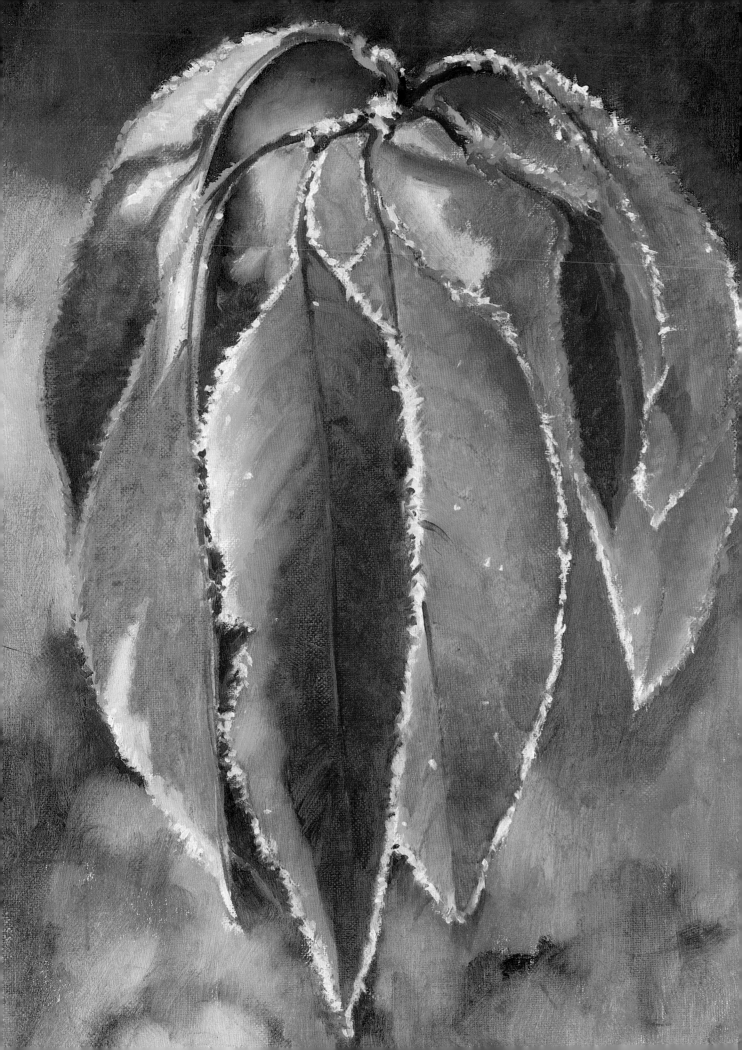

DETAIL *(left)*
The touches of white that indicate the frost look soft and unfocused. When you are working with something ephemeral like frost, don't let your strokes become too strong and definite. Here, for example, the white gently edges the golden oranges and yellows of the leaves. The white strokes become even subtler as touches of bluish gray are introduced to suggest shadows playing over the frost.

DETAIL *(below)*
This soft, diffused background is in harmony with the rest of the painting, in large part because it is painted with the same colors as the leaves. When you are working with an unfocused area in a painting—usually a background—don't make it too dark and be sure to use colors found elsewhere in your painting. It's best not to work with thick paint, however; thin washes of color will downplay the area's importance and let attention focus on the main subject.

ASSIGNMENT
Glazes can unify a painting, add nuance to a plain area, or suggest a particular mood. Experiment with them to learn their power. Choose a landscape with a diffuse background—one that has lots of different things going on in it all at once. Work up the whole surface of the painting, then let it dry. As soon as it is dry to the touch, select an appropriate color—yellow ocher, for example, if you are working with a sun-filled scene—and mix it together with painting medium. Lay in this glaze over the entire background and see how it pulls together all of the different elements in your painting.

Giving Power to a Decorative Closeup

PROBLEM

This complex tangle of leaves has no center of interest. The whole surface is evenly packed with intricate detail. Unless you find something to engage the viewer's eye, the decorative elements may seem boring.

SOLUTION

Search for the patterns formed by darks and lights and by the red, green, and purple tones. Work all over your canvas, accenting individual leaves as you develop the entire scene.

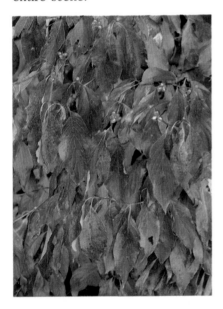

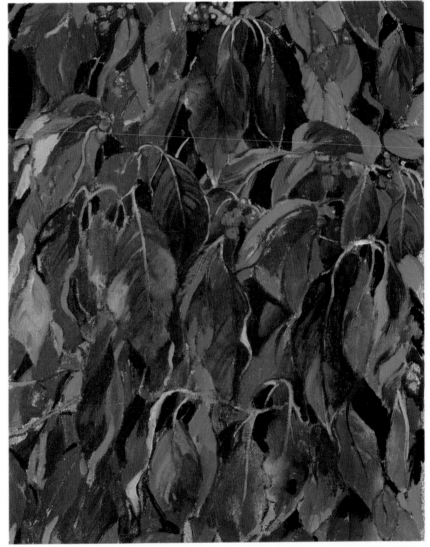

The shiny berries of a flowering dogwood accent the rich pattern of its green and red-tinged leaves.

☐ With charcoal, sketch in the foreground leaves; then spray the drawing with fixative. Now study your subject. Despite the variety of tones, one color—a silvery green—dominates the scene. To establish this color note right away, flood the surface with a wash of alizarin crimson and Thalo green. You'll find that alizarin crimson—a complementary color—grays the green, creating a cool, mysterious hue.

Now build up the surface with thinned color, concentrating on the play of light and dark. Don't get locked into any one corner of the painting—instead, work all over, moving rapidly from one area to the next. Continue to use your mixture of Thalo green and alizarin crimson, adding white to suggest your lights and more green to define your darks.

Next introduce thicker paint. Working back and forth between the near and far leaves, search out the strong patterns created by variations in color and value. Once you are pleased with the result, turn to the details. Take a small sable brush and add the veins of the leaves and the thin branches. Finally, paint the clusters of berries that punctuate the tapestry of leaves.

Highlighting One Element in a Complicated Scene

PROBLEM

Sometimes there can be just too much that attracts the eye in a particular scene. Here the varied textures of the bark, the powerful lines of the tree trunks, and the subtle shifts in color are all intriguing. But no one element stands out clearly.

SOLUTION

To create a center of interest, decide to emphasize one element. Here the purple iris is a logical choice—it's the only color accent in a predominantly greenish scene. To strengthen this color note, play up the red in the purple, in contrast to the cool surroundings.

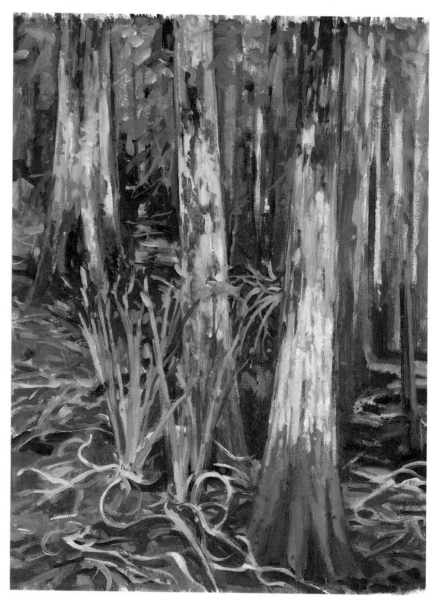

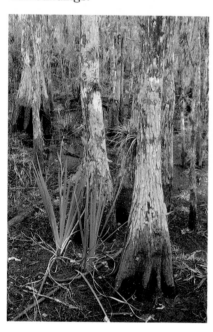

A lone iris springs into bloom alongside the massive trunks of cypress trees.

☐ Draw the cypress trunks, indicating both their contours and their surface texture. Next, sketch the plants that grow alongside. Choose the base colors for your painting—a cool purple, a rich brown, and a green—then go over the lines of your drawing with thinned color. Continue working with thin washes as you lay in strong, vertical strokes to convey the power of the trees. Don't forget to add the browns that create the spaces between the trees. Since the iris is going to be crucial to the finished painting, be sure to note it right away. Then, as you continue to paint, you'll remember its importance.

When you start to lay in opaque color, break up your verticals with short, broken strokes. With a medium-size bristle brush, introduce touches of green and greenish blue to indicate the foliage in the background. Then, with grayish white, gray, and brown, work over the trunks' surfaces to suggest their texture. Try to get across the feeling of roughness, without going into every little

100

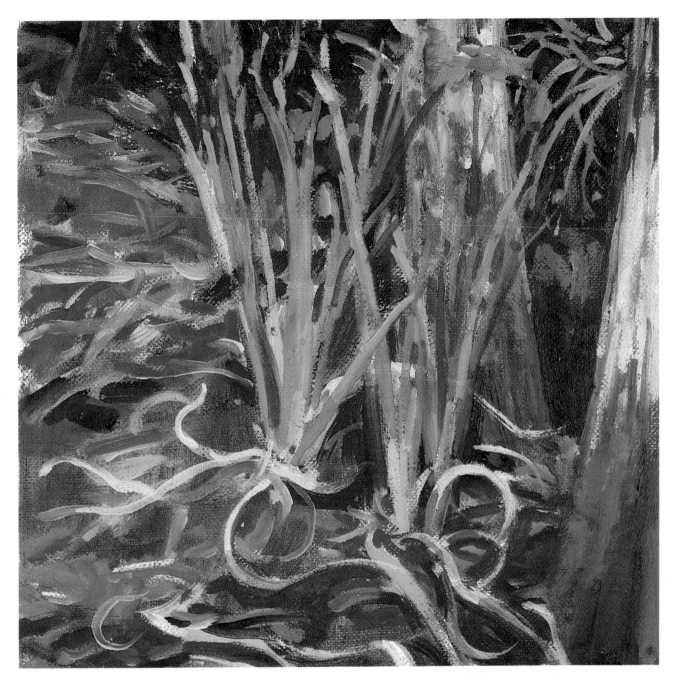

detail. Finally, develop the spaces in between and accentuate the fresh, bright greens of the iris.

Everything comes together in the final stages of the painting. Mix your pigment with a lot of medium to keep it fluid, then start to paint the sinewy roots that spread over the ground. Next, turn to the iris. Accent the bright yellow-greens of its stem, then build up the rosy color of the flower. Finish up your painting by adding touches of bright bluish white to the three major trees.

DETAIL
The swirling lines of these roots, drawn with a brush, give a sense of the swampy location of this scene. Their light color draws attention to the foreground, while their wavy contours direct the viewer's eye to the iris. They also add a lively note to the painting.

Working with Subdued Light

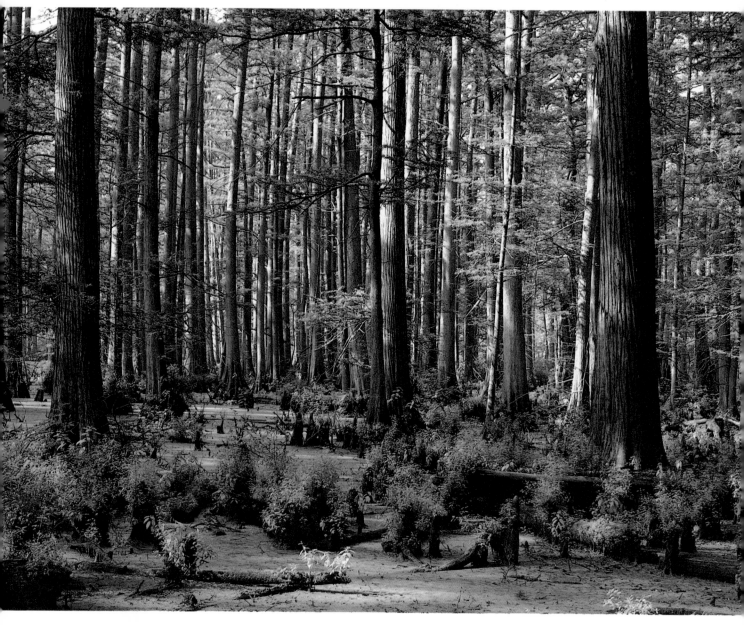

PROBLEM

Massed together as they are, these cypress trees present a difficult challenge: there's little that differentiates one tree from the next. To heighten the challenge, the light filtering in from above creates a rich array of lights and darks.

SOLUTION

To break up the mass of trees, it's very important that you space them correctly. Take special care with your preliminary sketch. When you start to paint, concentrate on value, not color, to capture the pattern of flickering light.

☐ With soft vine charcoal, draw the most prominent trees. Edit what you see—you can't pay equal attention to every trunk. Now reinforce your sketch with a wash of raw umber, using a small, round brush.

Continue working with washes as you set up your lights and darks. Since the scene is infused with greens, put all the ones you'll need on your palette. But don't stop with your tube greens—touches of alizarin crim-

Towering cypress trees rise
out of a southern swamp.

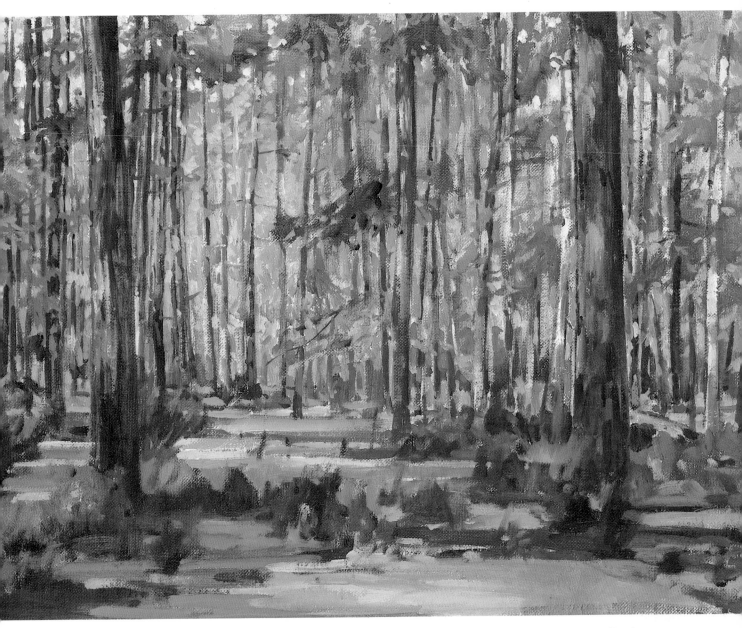

son will gray your greens; touches of brown or yellow, warm them; and touches of blue, cool them. As you lay in your green washes, concentrate on value. Establish the dark brown trunks that shoot up from the swamp and the dark greens that shadow the foreground. Let the white of the canvas represent the brightest areas.

To capture the rhythm of the trees massed together in the background, move back and forth between the trees themselves and the greenish tone around them, adding dabs of blue to suggest the sky breaking through the foliage. Finally, lay in the sunlit patches of brilliant yellow-green that flow across the foreground, with echoes in the middle ground. Use strong horizontal strokes to counter all the vertical lines that run through your composition. To really pull the foreground forward—something that's important when you're working with so much generalized pattern—accentuate the variety of greens.

The finished painting succeeds in giving a sense of depth, with the trees clearly receding into the distance. Note how the background trees are rendered almost entirely with short, broken strokes, while the foreground is treated with much bolder brushwork. Touches like this can make a world of difference in painting.

Conveying the Poetry of a Misty Landscape

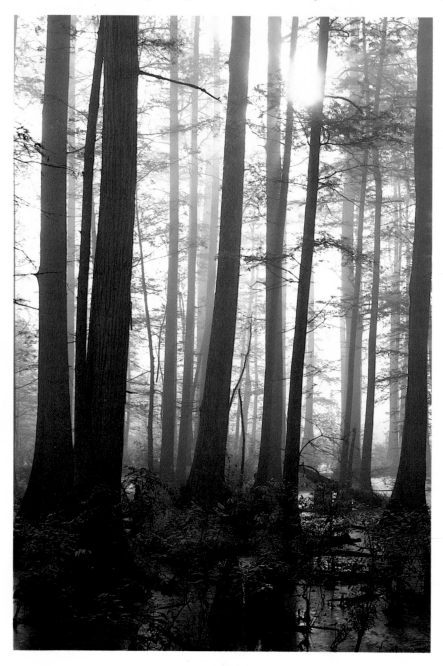

The glow of morning sunlight gently breaks through the veil of mist enveloping a cypress swamp.

PROBLEM

To capture the feel of this scene, you'll have to pay attention to three things: the delicate tracery of the trees, the quality of the morning light, and the atmospheric effect of the mist.

SOLUTION

A careful drawing will establish the profiles of the trees, leaving you free to concentrate on the sunlight and mist. To suggest the warm, enclosed intimacy of the scene—the feeling of a quiet, private moment—first cover the entire surface with a wash of pale yellow ocher.

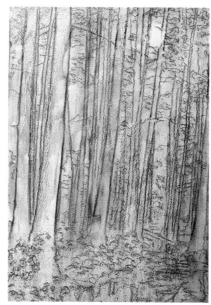

STEP ONE

The milky iridescence of the light matters the most in this scene; nothing, not even the weave of canvas, should interfere with it, so choose a smooth Masonite support. Start by executing a very careful drawing, one that captures the delicate tracery of the tree trunks and the graceful shapes of the foliage. After spraying your drawing with fixative, go over its lines with a small round brush. Finally, tone the entire surface with an uneven wash of yellow ocher.

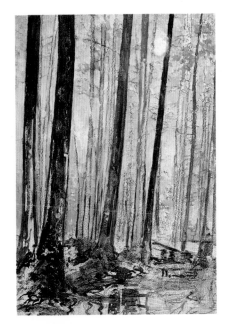

STEP TWO

The yellow ocher wash establishes the mood of the painting. As you lay in the trunks with washes of brown, use uneven strokes, allowing glimpses of yellow to break through. At this stage begin to depict the ground, lay in pale bluish-gray washes over the sky, and indicate the pale yellow sun hovering behind the trees.

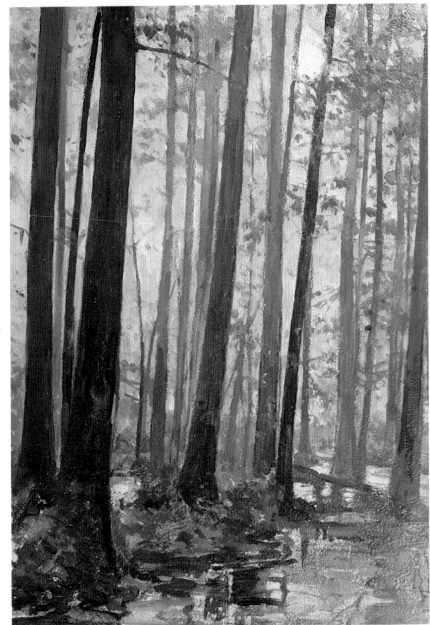

STEP THREE

As you move to thicker paint, don't forget that your goal is to create a mellow, misty feeling. Choose soft, round sable or synthetic brushes rather than stiffer bristle ones, and gently coax the paint over the surface. To indicate the very distant trees, try a pale, cool shade of blue; blue tends to recede, pushing these trees to the back of the picture plane. Conversely, to pull the nearer trees forward, use warmer, purplish-brown and gray hues. Darker, stronger blues come into play in the water in the foreground.

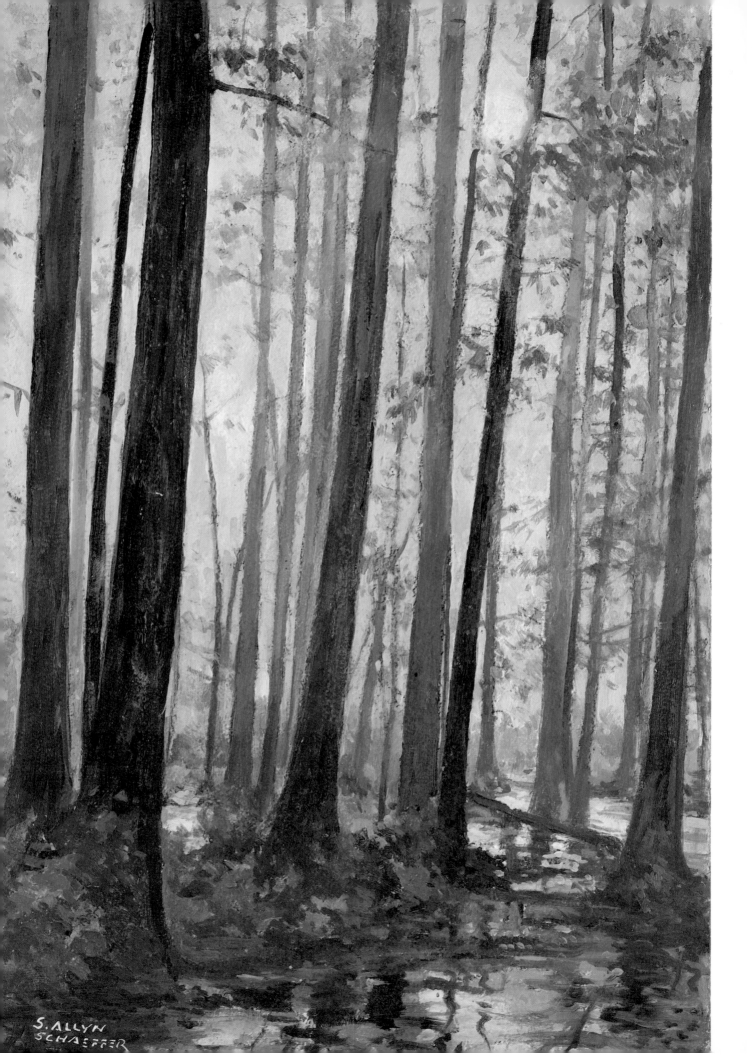

S. ALLYN
SCHAEFFER

FINISHED PAINTING

Refine the colors and values
you've set up, adjusting them in
relation to each other. Are the
trees dark enough against the
sky? Do they recede logically into
space? Is the range of value broad
enough? Critically examine what
you've done and tighten up any
loose areas. Here the ground was
weak; its patterns were clarified
and the reflections in the water
added to strengthen the whole
area. Finally, complete your paint-
ing by adding small accents such
as the tiniest branches and sprin-
kles of foliage.

ASSIGNMENT

Light can dramatically change a
landscape; what looks clear and
fresh early in the morning can
seem mysterious and full of
gloom by late afternoon.

Choose a familiar scene—one
that you often pass—and figure
out at what time of day it is most
appealing. Plan to do a painting
on the site at that particular
time. Arrive at the site, how-
ever, a few hours earlier. Use
those hours to build up much of
your painting. Sketch the land-
scape with charcoal, lay in your
preliminary washes, and start to
work with opaque pigment.
When the hour you've been wait-
ing for comes along, you'll be
ready to focus in on the lighting
conditions that interest you.

If the light changes while you
work, don't try to alter your
entire painting. Instead, stop and
make color notes or quick
sketches. Two options are open:
either finish the picture in your
studio, working from your color
notes and sketches, or return to
the site on another day.

DETAIL

The wash of yellow ocher that
was applied in step one shines
through all the layers of paint that
were added later, warming up the
entire composition. Brushwork
also helps establish the painting's
lyrical mood. Note, for example,
the way the foliage is rendered.
Short, gentle strokes of greens
and grays suggest the delicacy of
the leaves.

Handling a Monochromatic Scene

PROBLEM

You don't often see paintings that depict rich summer foliage, and for a good reason. Working with masses of green presents one of painting's most difficult challenges: How do you create a convincing image when all the colors and values seem basically the same?

SOLUTION

To give your painting a focus, concentrate on just a few of the trees. If you emphasize them and make them appear realistic, the surrounding greens will look convincing as well.

☐ Before doing a drawing, stain the entire canvas with a wash of medium-value green. Setting up a middle tone in this way simplifies your work later. When you add your darks and lights, you'll have something to react against.

As soon as the wash has dried, sketch the scene, concentrating on the trees you've decided to emphasize. Draw them fairly carefully, then loosely sketch in the overall shapes of the rest of the foliage.

Now decide which greens you'll use. It's important to have as

much variety as possible if your painting is going to have any life. For your dark greens, try mixing Thalo green with burnt sienna or alizarin crimson. For the brights, rely on permanent green light mixed with yellow ocher. To create an interesting, silvery blue-green, add a touch of white to Thalo green.

First, work over the entire surface with washes of green, quickly establishing the lights and darks, as well as the bright and dull hues. Introduce opaque pigment as you start to define the trees you are going to emphasize. Lay in their trunks with strong, vertical strokes, then add their foliage with a loose, painterly touch.

Once you've gotten the feel of the most important trees, turn to the rest of the greenery. There's very little concrete visual data to hang onto here; you have to rely on shifts in value as you proceed. Try squinting at the scene—it may help you get a sense of the overall shapes and value differences. Continue to boldly sweep in strokes of green with a large, soft, round brush. To differentiate the foreground from the solid wall of trees, introduce new colors—burnt sienna and yellow ocher, used alone and mixed together. Here a touch of ocher is also added to the center of the painting, drawing the eye into the forest of greens.

Finally, tighten up details. Make sure the trees you've chosen to emphasize stand out clearly against the greens. Add brownish-white highlights in small, delicate strokes to bring out their scraggly branches.

Matching Brushstrokes to a Conifer's Needles

PROBLEM

Once again, you're confronted with a subject that's almost entirely one color. To complicate matters, these spruce needles are packed with intricate detail. How can you convey their individuality, without fussiness?

SOLUTION

Stain the canvas with dark green and make a detailed charcoal drawing. In painting the needles, work from dark to light, searching for the shifts in value. Use your brushstrokes as needlelike lines of color.

☐ These needles are complex enough to demand a large support. Select a canvas that will allow you to paint the needles almost life size. Stain the canvas with a wash of dark green and, once it's dry, carefully sketch your subject with charcoal. Decide at the start to concentrate on the needles' overall appearance; don't get bogged down in detail.

You'll want to paint with long, thin strokes, so add plenty of medium to your pigment. Try, too, using a long-haired, pointed brush. Work from dark to light, carefully stroking the paint onto the canvas. If your drawing gets lost, redraw the needles with a light shade of green, one that will stand out clearly against the darker hues you've already put down.

As you move to the medium-value greens, try to establish as much variety as possible. Also add the brownish branches, again using a long-haired brush. Then introduce the lightest, brightest greens, concentrating them in the center of the painting.

Now, to pull the painting together and to capture the play of light on the needles, work back and forth between your lights, darks, and medium values. Draw the needles with your brushstrokes, letting the lines build in layers, much as the needles do in their clusters. Stop from time to time and evaluate what you've done. As soon as the needles seem focused and logical, slow down; it's easy to push a subject like this one too far and lose the effect you've set out to achieve.

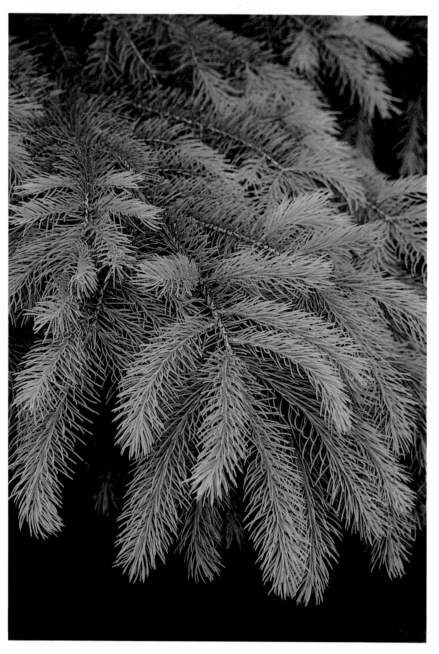

The stiff, sharp needles of a spruce tree pull its branches downward.

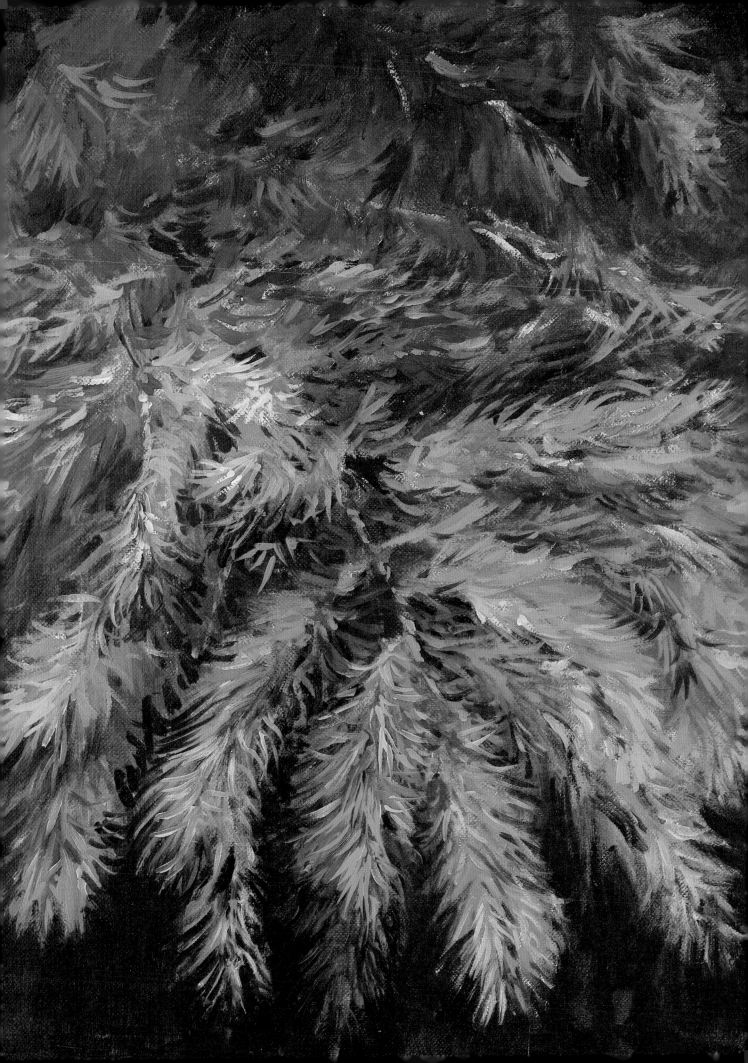

Isolating a Still Life in Nature

PROBLEM

These unusual cones stand out sharply against a dark, unfocused background. The detail that makes them so interesting has to be rendered crisply if you are to capture how they really look.

SOLUTION

Treat the cones just as you might treat a still life. Make the background even darker than it really is and work with opaque pigment right from the start.

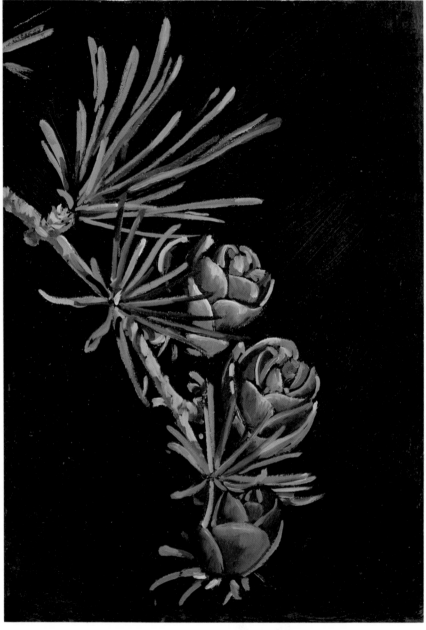

At the end of a larch tree's branch, the cones begin to turn from rose red to golden brown.

☐ Because clear, crisp detail is so important here, work on a small, smooth Masonite panel instead of canvas. Begin by covering the panel with a dark, rich green, using a large bristle brush; then go over the wet paint with a fan brush to remove any obvious brushstrokes. After the panel has dried thoroughly, carefully draw your subject with white charcoal.

Instead of starting with thin washes of color, when you encounter a detailed subject against a dark background, work with opaque color right away. Add a little medium to your pigment to keep it fluid, but not so much that the color is thinned. It's as if you were working with tempera—the color is fluid, but as it's put down, it covers what lies underneath.

Load a small, round brush with plenty of pigment and begin to paint the branch. Moving to the cones, start with the lightest shades, gradually introducing darker hues to sculpt out the

112

shadows. Then, moisten your brush with really dark pigment and paint each cone's contours.

Before you paint the needles, analyze the slight value differences that separate one needle from another. You'll want to exaggerate these differences to show how the needles move forward and backward in space.

DETAIL

The modeling of the pine cones makes them strongly three-dimensional against the dark green backdrop. Careful brushwork and delicate transitions between light and dark convey their rounded shape. Notice how the dark green of the background shows through in places, becoming the line that clarifies the edges of the cone's petals.

ASSIGNMENT

When winter comes, many a landscape artist retreats to the studio, waiting anxiously for warmer, finer weather to come again. You don't have to wait till spring to work with trees.

In late fall, go out into the woods, or even a public park, and collect branches, acorns, leaves, and pine cones that have fallen from trees. At home, set what you've found up in your studio. Try to create a believable backdrop; weathered boards would be great, or a piece of hopsacking tacked to the wall. Arrange the leaves, then take a strong light and shine it on your still life until you get a pleasing pattern of shadows.

As winter drags on, start to introduce other elements into your still lifes—old lanterns, horseshoes, or even a shovel— anything that suggests the out of doors.

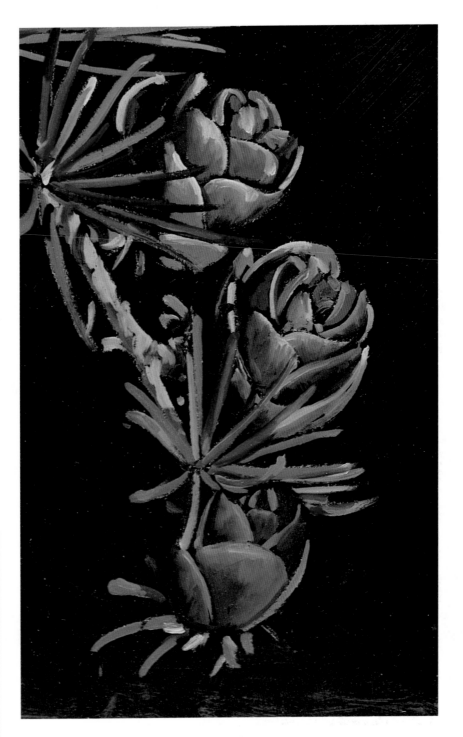

Exaggerating Shifts in Hue and Temperature

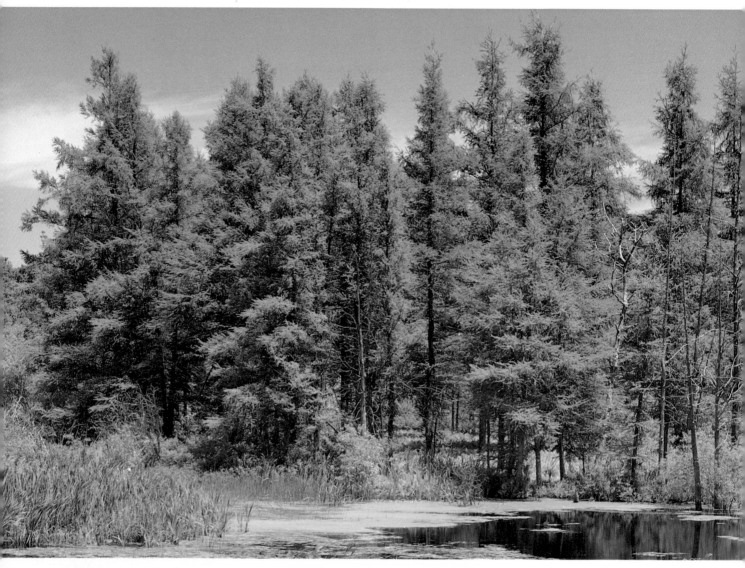

PROBLEM

This scene lacks drama. The trees are almost uniformly green; the sky is an everyday shade of blue; and the algae-covered pond isn't particularly interesting.

SOLUTION

To give your painting punch, play up the small shifts in hue and temperature. Use a variety of greens for the trees; make certain areas of the scene warmer than they really are; and enliven the sky by your choice of blue.

Tall larch trees huddle together beside an algae-covered pond.

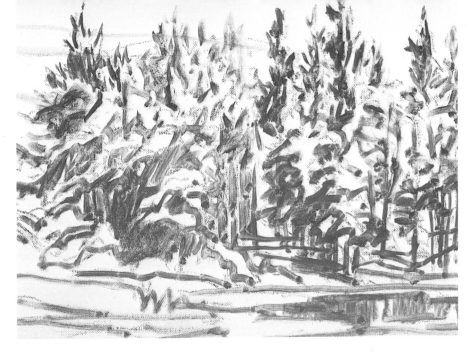

STEP ONE

In your charcoal drawing, concentrate on the shapes of the individual trees; then boldly sketch the horizontals that sweep across the sky and the ground. Now go over your drawing with diluted color. Choose a deep, rich green—the color that dominates the scene—here mixed from viridian and burnt umber.

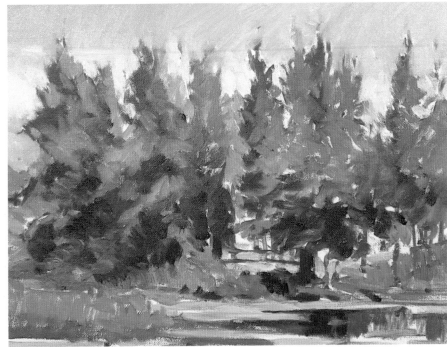

STEP TWO

Working with thin washes, build up the entire surface of your canvas. Use strong, lively strokes to lay in the paint—strokes that suggest the direction each mass of color takes. For the sky, use a warmer blue than the color you see. As you turn to the foreground, separate it from the trees behind by bringing out its bolder color.

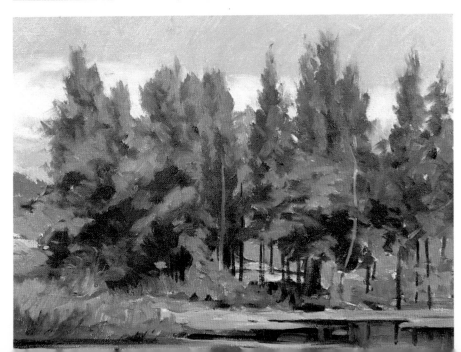

STEP THREE

Continue to exaggerate what you see as you start to use opaque color. Here the bluish-green tone used for the grass in the lower left corner becomes stronger and more arresting as it is overlaid with strokes of an olive green. The algae-covered pond gains in liveliness and interest as more yellowish-green pigment is applied. Finally, turn to the ground right under the trees. If you go for the color you see—which is just about the same color as the trees—it'll be lost in your painting. To distinguish it from the trees, mix a warm yellowish-green hue.

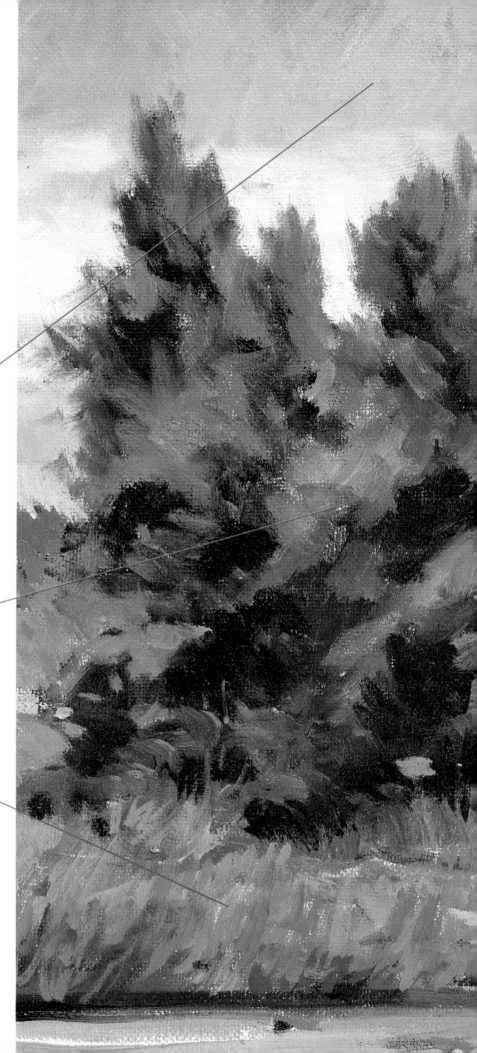

FINISHED PAINTING

Very little remains to be done.
Look at your painting and ask
yourself: Is there enough contrast
between the darks and lights? Do
the trees stand clearly apart from
the ground and the pond? Is the
color of the sky warm enough?
Would more detail help or hurt
your painting?

Here the tree trunks and
branches lacked definition. Work-
ing with a very pale shade of
brown—a shade much paler than
the one that was seen—the
branches and trunks were painted
with thin, delicate strokes.

*A dash of yellow makes the blue
here warmer than the actual sky
and relates it to the colors in the
foreground. This shift in tem-
perature helps establish the overall
mood of the painting. Were the blue
cooler, the entire scene would seem
less vital and dynamic.*

*Vigorous brushwork helps suggest
how the branches of each tree spread
out from the trunk. Some strokes
move upward, some downward—
and they overlap, getting across the
feel of the dense foliage.*

*In the actual subject, the grass is a
cool silvery-green shade. By exag-
gerating its bluish cast, you can
make the grass stand out and set up
a strong foreground—one that will
lead the viewer effortlessly into your
painting.*

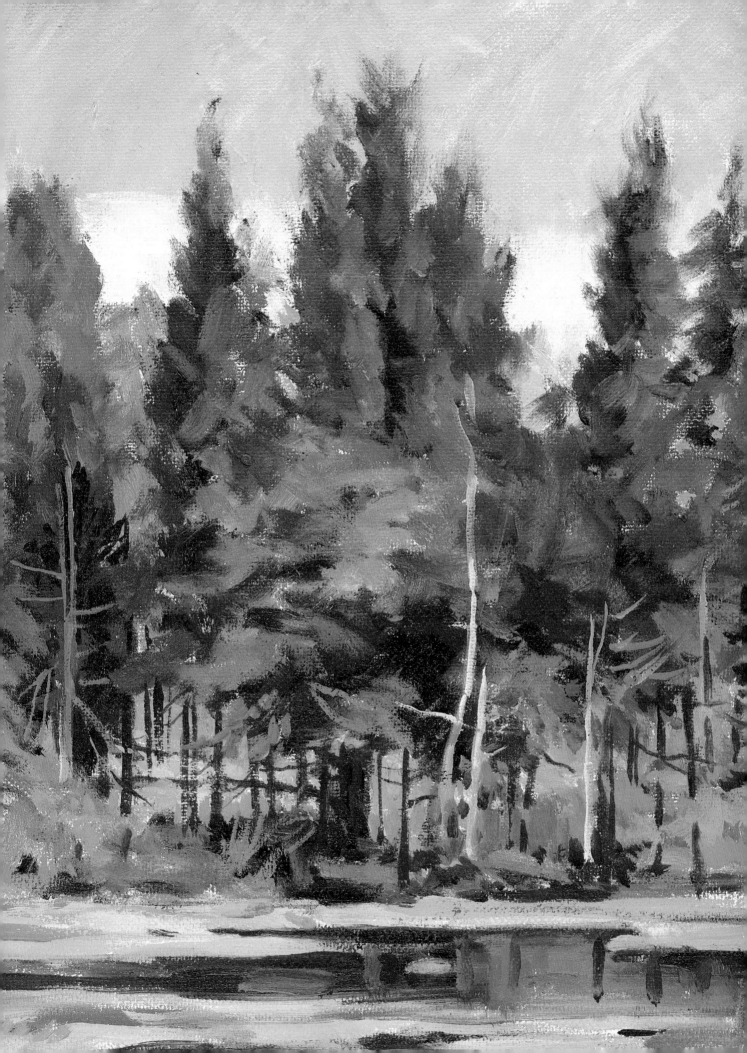

Indicating Broad Vistas and Specifics Simultaneously

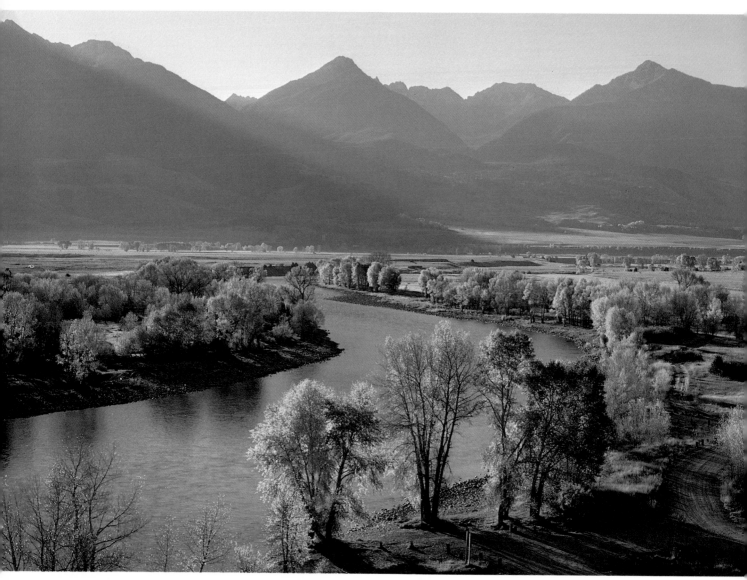

PROBLEM

Broad, sweeping vistas like this one are wonderful subjects. But panoramic views have their own special problems. It can be difficult to convey a clear sense of distance, and it's even harder to balance that distance with the specific references that make the subject unique.

SOLUTION

Use cool colors to push the distant mountains to the back of the picture plane. Warmer hues in the foreground will make the trees spring forward. And try to capture the shapes of the trees accurately; don't get caught up in a predictable pattern.

Golden autumn foliage lines the Yellowstone River in Paradise Valley, Montana.

118

STEP ONE

Indicate the composition on your canvas with vine charcoal, then cover the lines of your drawing with diluted paint. Choose your colors carefully; you want to establish the color theme for each area of the painting at the very start. Blue will set the right note for the hills in the background. Moving forward, in the middle ground, greens gradually give way to browns. The trees in the immediate foreground are rendered in a golden yellow-orange.

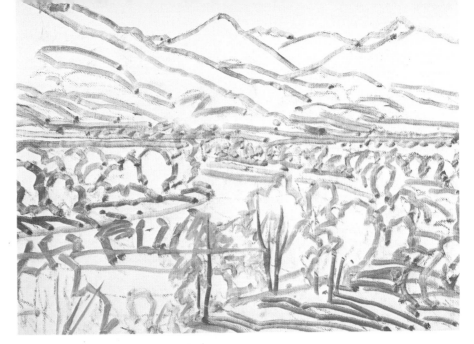

STEP TWO

Now establish the overall effect of light and color as you begin to work with slightly thicker washes. Don't try to define any one area fully; instead, cover the entire canvas with color. As you lay each area in, gauge the effect it has on adjacent areas. The pale blue sky, for example, seems even paler once the darker mountains are laid in. Make any necessary adjustments in color and value before you begin to work with opaque pigment.

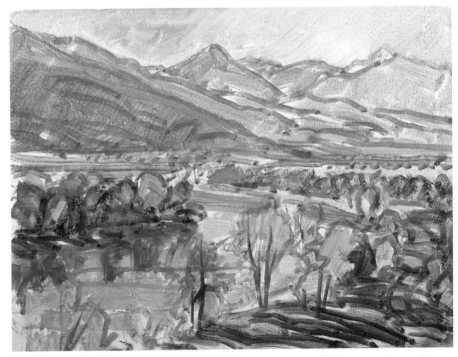

STEP THREE

Working now with opaque pigment, continue to build up the surface of your painting. Start with the distant hills, sharply defining them against the pale blue sky. Don't let the color of the mountains become too dark; remember, the paler the background is, the farther away it will seem. Now turn to the foreground. Refine the shapes of the trees and intensify the blue of the water. Work back and forth between the trees and the water, taking care to indicate the glimpses of water that are visible through the foliage.

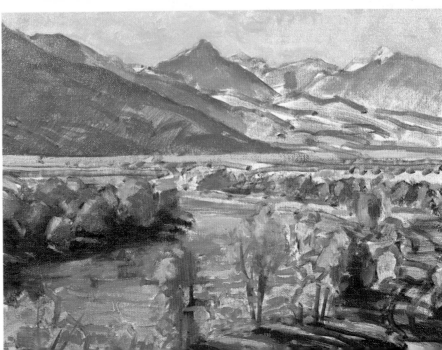

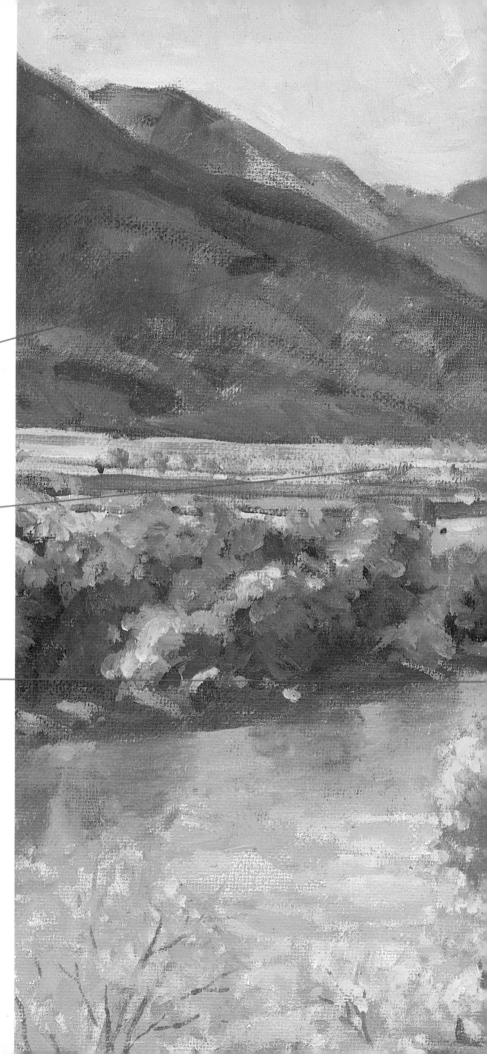

FINISHED PAINTING

It's at the very end that all the small details are added. Brush in a sliver of blue in the middle ground to indicate where the river snakes backward. Then paint the dark shadows that play over the tips of the hills. Finally, turn to the trees. With a small sable brush, gently dab paint onto the canvas to suggest clumps of leaves. Strengthen the shadows cast by the trees, then add touches of cerulean blue to the water to intensify its color.

Painted with cool blues, purples, and greens, these mountains convey the sense of a vast, distant space. Note how the ones farthest back are paler and less distinct than those closer to the river.

Keep the middle ground fairly simple. Too much detail or strong, obvious brushstrokes would interfere with the sense of distance you're trying to convey. Detail tends to bring an area forward—and that's not what you want to happen here.

You need to work back and forth between the trees and the water to capture the feel of the foliage. Note the touches of blue that indicate where the water is visible through the branches. Without them, the trees would look heavy and lifeless.

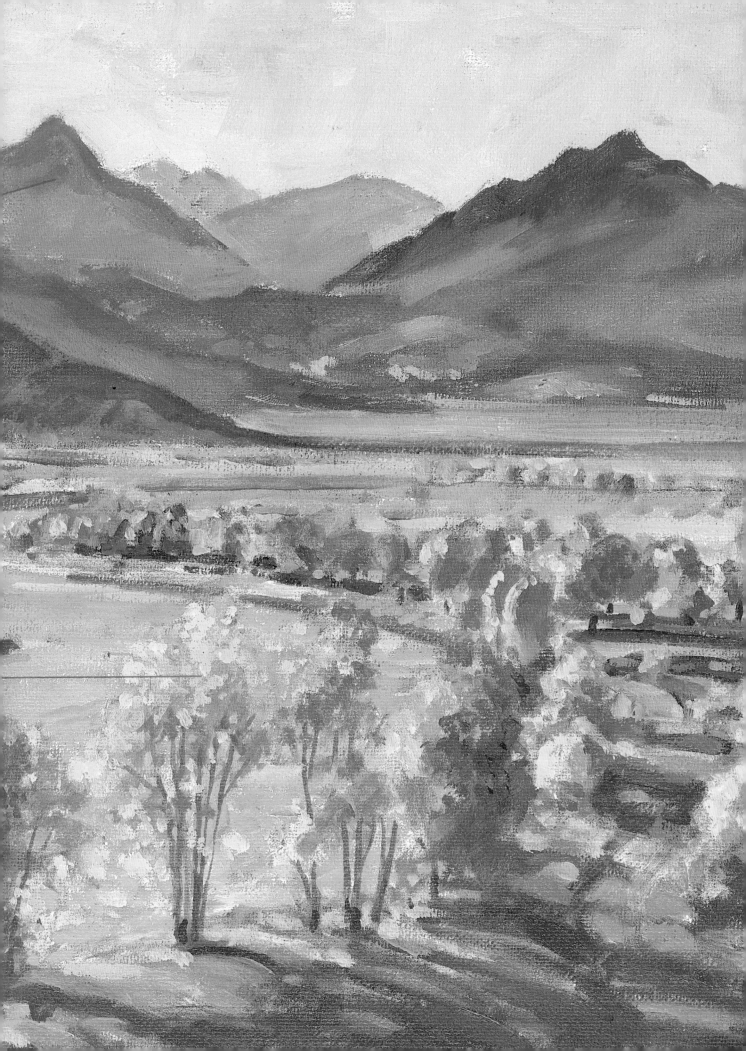

Offsetting Stark, Vertical Tree Trunks

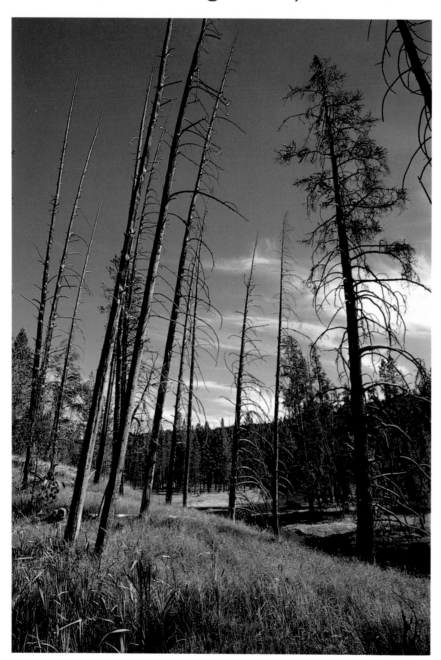

PROBLEM

This composition is dominated by the stark verticals of the tree trunks. In capturing their strong linear quality, you have to be careful that the verticals don't overpower the painting and make it look unbalanced.

SOLUTION

Emphasize all the horizontals in the scene to help balance the composition. Exaggerate the wedge of trees along the horizon and even the clouds that reach across the sky.

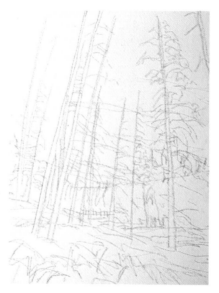

STEP ONE

For your preliminary drawing, try a charcoal pencil instead of the softer vine charcoal. Because it's less fragile, it will be easier to make a fairly detailed drawing, including all the thin, vertical lines of the tree trunks. Be sure to note all the horizontal elements of the composition.

On the West Coast, tall, slender lodgepole pines cut into a cloud-streaked sky.

122

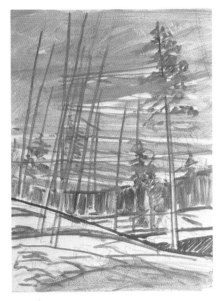

STEP TWO
Working with thinned color, strengthen the overall design of your painting. Concentrate on value, not specific colors, and on the horizontals that stabilize the strongly vertical trees. Use long horizontal strokes to lay in the sky. Next, reinforce the contours of the lodgepole pines. For the trees that run along the horizon, use short, vertical strokes; then flatten the strokes by sharply delineating the horizontal they form against the sky. Finally, establish the planes of the foreground.

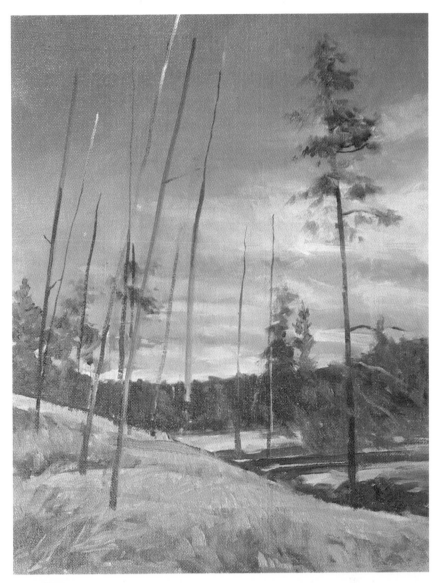

STEP THREE
Now, using heavier color, work from dark to light. Start with the dark line of trees in the background, then turn to the sky. If the dense blues and purple-blues you use to paint the sky cover some of the lodgepole pines, don't worry. Enough of your drawing will show through to guide you as you refine the trunks. Before you turn to the trunks, however, lay in the golden-ocher ground and the shadows that lie across it.

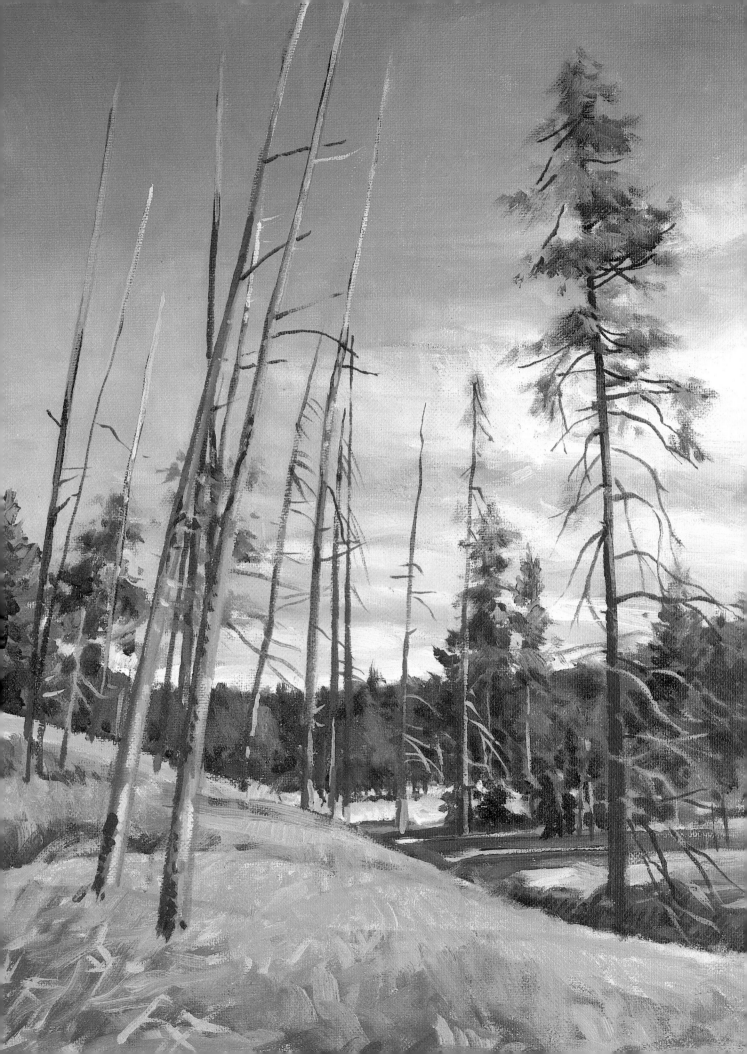

FINISHED PAINTING

In the finished painting, the tall, slender pines stand boldly against the deep purplish-blue sky. Painted at the very end, with fluid, liquid pigment, they glide upward easily. Because of the emphasis placed on the horizontal elements earlier, the strongly vertical tree trunks seem comfortably placed in the rest of the scene.

DETAIL

The rich purplish blue of the sky forms a handsome backdrop for the lodgepole pines. Its color provides a contrast with the bleached tips of the pines, helping them stand out clearly. If you look closely, you can see the smooth blending of the warm sky tones near the top into the cooler hues below, which then lead the eye back into the deep picture space.

DETAIL

In the middle ground, bands of orangish yellow alternate with bands of dark, deep green. These shifts in color not only break up the rolling planes that lie near the front of the picture space; they also lead the eye gradually backward toward the horizon.

Preserving Delicate Trees in Dramatic Surroundings

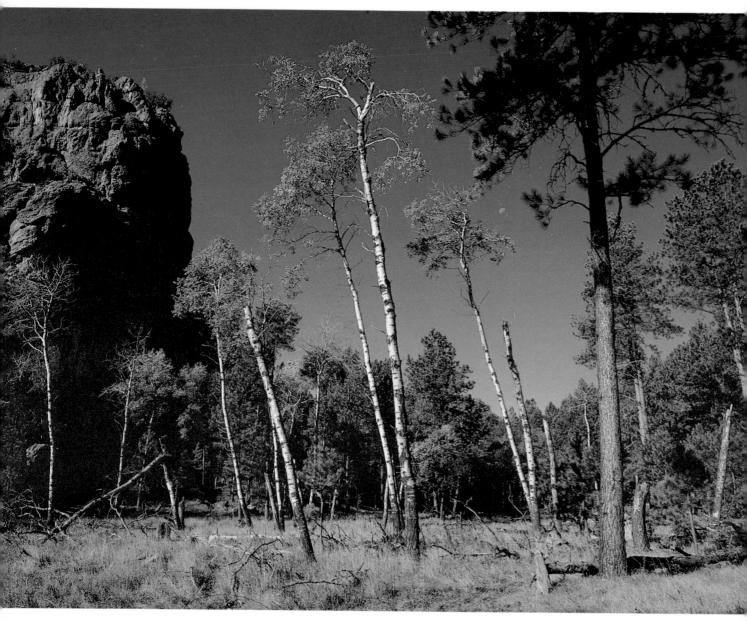

PROBLEM

The threadlike aspens could easily become lost in this dramatic scene. Many elements are competing for attention: the masses of dark foliage in the background, the green-tinged outcropping of rock, even the bright blue sky.

SOLUTION

Minimize the detail in the background and save the aspens for the very end. As you develop the rest of the scene, let the white of the canvas represent the spots where the trees will eventually appear.

☐ Sketch the scene using vine charcoal, with an eye to the major elements—the aspens, the backdrop of foliage, and the tower of rock. Next, reinforce your drawing with diluted permanent green light. Using the same wash of color, begin to lay in the darkest values.

Before you introduce thicker pigment, analyze the overall color scheme. Note the important role that green plays—even the rock is tinged with it. When one color dominates a composition, as it

Alongside a rocky canyon wall, delicate aspens rise proudly from the flat ground.

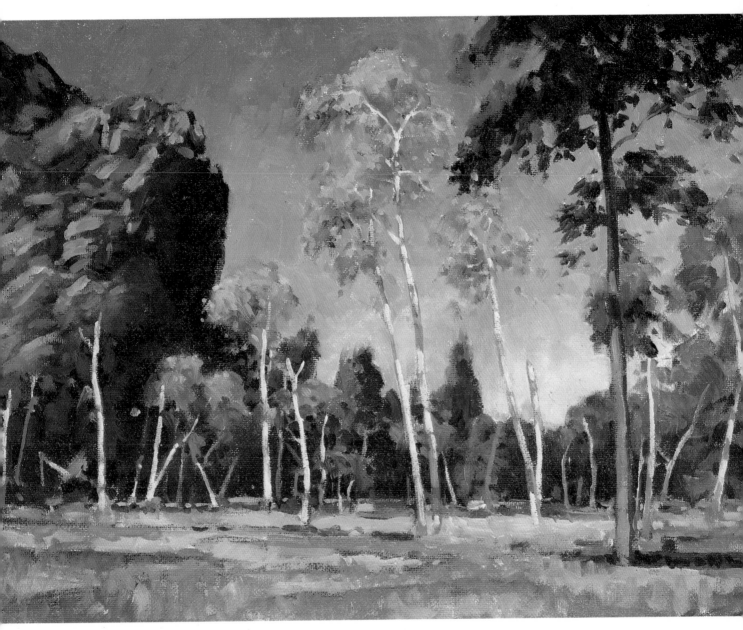

does here, it's vital that you think through your use of color before you start to paint. For your very darkest greens, try mixing Thalo green with alizarin crimson. A combination of permanent green light and cadmium yellow will give you your lighter greens. By adding yellow to this mixture, you can create a rich brownish-green hue for the foreground.

With your colors planned out, start to paint, moving from the sky, to the background trees, and then to the canyon wall. Re-

member as you work to leave areas of white to indicate the placement of the aspen trees. Keep the background trees and the canyon wall as simple as possible—if you add too much detail to them, they'll steal attention from the aspens.

Once the dark and medium tones are down, establish the lights that spill across the foreground. Use short, choppy vertical strokes to break up the bands of light green with slightly deeper color. Now paint the as-

pens. After you've laid in the white of the trunks, add patches of grayish blue to suggest their shadows. To depict the leaves, take a small sable brush and gently dab bits of light and medium-value green onto the canvas. Finally, paint in the pools of shadow beneath each tree.

Take a few minutes to evaluate what you have done. Make sure you've suggested the scene's depth. Here the diagonal bands of color in the foreground lead the eye back into the painting.

Zooming in on Detail

PROBLEM

It's very difficult to move in this close to a subject, especially when it involves so many slender lines. Although you'll need to keep the overall pattern in focus, you'll also have to concentrate on the three-dimensional aspects to give a sense of space.

SOLUTION

After painting the background with a rich, dark green, sketch the needles with white charcoal. Rely heavily on your drawing as you paint; if you lose bits of it, redraw them immediately with a small brush, using light green paint. To position the needles in space, layer them in three different values of green.

Seen up close, the needles of a white pine form a bold, almost geometric pattern.

☐ Choose a smooth Masonite support, cover it with dark green paint, and then remove any signs of brushwork with a fan brush. After sketching the needles with white charcoal, begin to paint. To capture the crisp needles, select a long-haired brush and add plenty of medium to your pigment.

Decide on three basic values of green. Use the darkest first—for the needles farthest away from you. Introduce a slightly lighter green for the needles in the middle ground and, finally, the lightest green for the closest ones. As you move forward, each successive group of needles will overlay those behind, conveying depth.

After enlivening the needles with touches of color, add the cones. Painted accurately, they will clarify the structure—how the needles cling to the branches and how each branch ends in a cone.

Painting the Portrait of a Tree

PROBLEM
On the face of it, this scene is like many others. The composition is simple, with vibrant colors and unambiguous lighting. When you start to paint, however, you'll find that it's not easy to capture the individuality of the red pine that dominates the foreground.

SOLUTION
What distinguishes the pine is its fullness and its buoyant, upward lift, accentuated by the white cones. With only two values, you can bring out the tree's shape. Then let your brushwork highlight the direction of the branches.

Candlelike cones on an aromatic red pine seem to glow against a vivid blue sky.

□ Because the composition is so straightforward, there's no need to reinforce your drawing with thinned color. Instead, use opaque pigment right from the start. First, with a large bristle brush, paint the sky. As you sweep the blue over the canvas, leave bands of white near the horizon to suggest the clouds that gather there. Also blend in a touch of deep blue near the top.

Now turn to the pine in the foreground. First, paint the shadowy green areas; then turn to the middle-value greens. Try mixing the middle tones from viridian and cadmium orange for an interesting olive hue. Let your brushstrokes suggest the way the tree's branches sweep upward.

After you've built up the greens of the pine, lay in the rest of the painting. You'll want to establish a clear sense of depth, so exaggerate the color of the middle ground. Instead of painting it realistically in a middle-value green, use yellow ocher darkened with a touch of green.

At this point, add the trees along the horizon as well as the dark shadow beneath the pine. Then move to the grass in the foreground. As you paint the grass, use thin, upward-sweeping strokes that mimic the way it grows. To break up the plane of greens, introduce touches of yellow ocher and blue.

At the very end, paint the pine cones. Take a small, round brush moistened with yellow ocher and quickly dab the paint onto the tree. Be faithful to what you see: follow the pattern that the cones etch out against the green of the tree and the blue of the sky. Take advantage of their vertical note to accentuate the pine's upward reach.

Intimating the Delicacy of a Blooming Tree

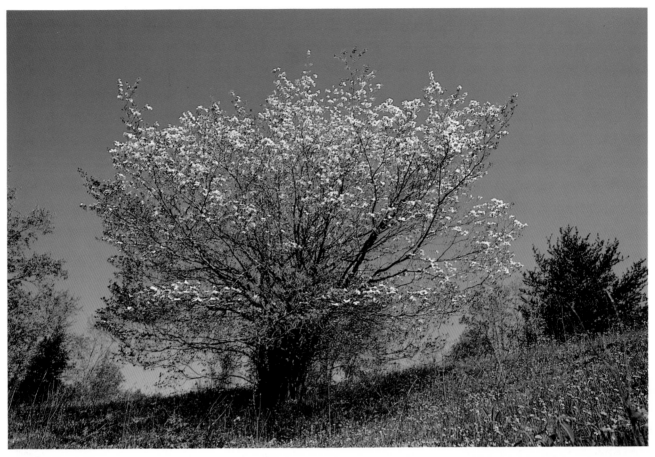

PROBLEM
To capture the spirit of this tree, you have to convey the fragility of the flowers. Since they are massed together, they could easily look heavy.

SOLUTION
Aim for the general effect created by the tree and flowers, rather than concentrating on specific details. Work impressionistically, with gentle, fluid strokes. Throughout, keep all your edges soft and unfocused.

☐ Use your charcoal drawing to place the tree and the horizon line, then go over the lines of your drawing with thinned blue paint. Now brush in the sky with opaque color, working around the tree. Let the white of the canvas represent the tree as you work out the rest of the composition. Keep your brushwork sketchy. Remember that everything—the sky, ground, and trees in the background—must remain soft and unfocused or the flowering dogwood won't dominate in the finished painting.

With a small, round brush, lay in the major branches of the dogwood and its trunk. Use long, fluid strokes for both the trunk

and branches; if they become too heavy, you'll lose the tree's delicate feel. Once you've established this framework, turn to the blossoms. Take a small bristle brush, load it with white paint, then scrub the paint onto the canvas, carefully following the major shapes that the white flowers form. Look for masses of white, not individual blossoms, and don't be afraid to really scrub the paint onto the surface.

Now add detail to the basic white shapes. With a small brush, gently dab white pigment over the areas you have scrubbed with color, then add touches of white tempered with yellow. Introduce strokes of pale olive green to

The spreading branches of a flowering dogwood are fluffed with elegant white blossoms.

131

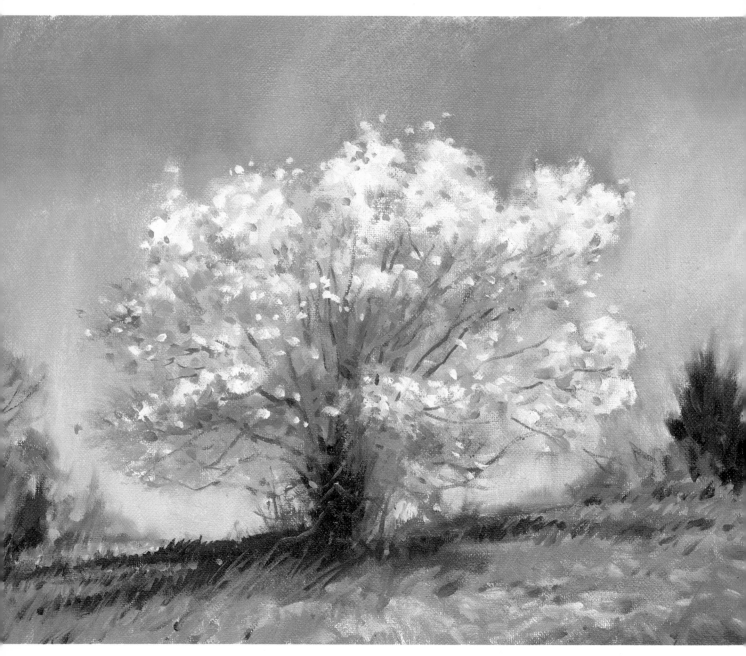

suggest the leaves, and bits of blue to break up the white masses, revealing the sky through the branches. Don't overwork the tree; stop painting it as soon as you are pleased with what you've accomplished.

As you evaluate your composition, look for what will make the painting work. Here bold brushwork was added to make the foreground spring to life. More than that, the strokes direct the eye toward the center of attention—the dogwood. Note also how the shadows under the tree give the work a definite focus.

ASSIGNMENT

Whites often enter into paintings of trees, whether in the blossoms of springtime, the clouds decorating the sky, or the cold snow of winter. If, however, you rely on the pure white from your tube, it may be too brilliant for the other colors in your painting. Tempering the tube white with another color can help you balance the lightest areas.

To discover just a few of the many possibilities, take a tube of white and lay dabs of paint down on one side of your palette. A few inches across from each dab of white, set down a variety of yellowish hues—everything from your yellow ocher to your cadmium orange. Slowly drag the white paint toward the yellow, then pull the yellow across the white. Done carefully, this exercise will show you a gamut of subtle colors. Now repeat it, using your blues.

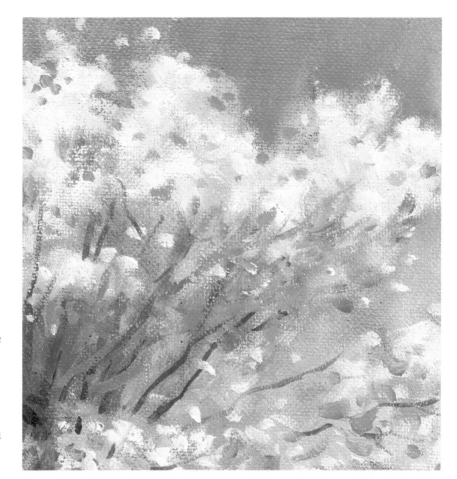

DETAIL

The blossoms that adorn this tree might easily be too thickly painted. When you are working with soft, ephemeral elements like these flowers, try scrubbing your paint onto the surface. Once your basic patterns are down, you can go back and add as much detail as seems necessary.

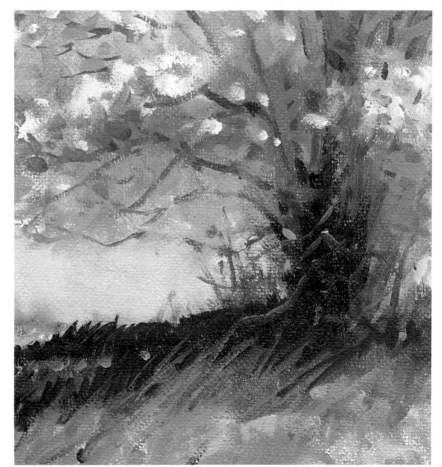

DETAIL

Painted with quick, staccato strokes, the foreground adds a powerful note to what could become too soft and lyrical a painting. Notice how the lines of the brushstrokes converge toward the center, leading the viewer's eye directly to the dogwood tree.

Adding Interest to a Simple Subject

PROBLEM

This subject is extremely simple, consisting of a single tree set against a monochromatic sky. To create a vital, interesting painting you'll have to inject some visual excitement.

SOLUTION

Analyze the tree's foliage. Note how it seems to break apart into small masses of color. When you begin to paint, emphasize these masses to build up a clear sense of volume.

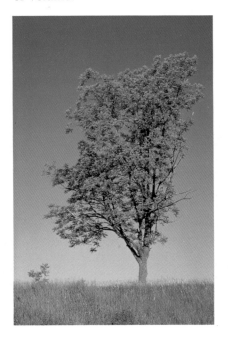

A clear blue sky sets off the asymmetrical crown of a black walnut tree.

☐ With such a simple composition, just draw the scene with a small, round brush dipped in thinned color—here a Thalo green and burnt sienna. To establish the tree's silhouette, also brush in the dark areas.

Now, working wet into wet with opaque pigment, lay in the sky. Start at the top with cobalt blue mixed with a little cadmium red. As you move down, eliminate the red and, near the horizon, lighten the blue with white. To soften the transition from the sky to the tree, let the blue blend gently with the dark greens you've already painted.

After laying in the foreground with thinned green pigment, work on the tree with opaque pigment. For the foliage, use small, short strokes. Reestablish the darks with Thalo green and burnt sienna; then lay in the lights with Thalo green mixed with white. To soften the edges of the crown, softly dab on your greens and then, with a dry brush, scrub them in over the blue.

At the very end, lay in a strip of yellow ocher along the horizon to create a sense of distance. Then, using rapid vertical strokes, define the grass.

134

Building up Volume

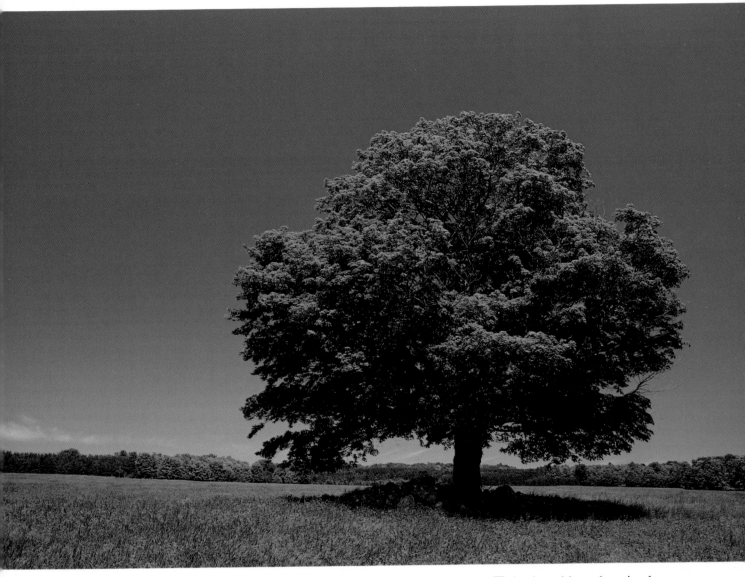

PROBLEM

Thick summer foliage can be difficult to paint, especially when it's set off against a deep blue sky. First, there's little that differentiates one part of the foliage from the next. Second, the blue of the sky and the greens of the tree are closely related in value.

SOLUTION

Use short, curving strokes to render the tree's foliage. With them, you can sculpt out masses of light and dark leaves. To handle the closely related values, exaggerate the deep blue of the sky and the bright green of the tree.

☐ Again, with such a simple composition, there's no need for a careful charcoal sketch. Draw directly with a small brush dipped into a wash of viridian and burnt sienna. Continue working with this dark green wash as you lay in the shadowy portions of the tree and the dark sweep of foliage along the horizon line.

The dense foliage of this sugar maple weighs its branches down, bending them close to the ground.

135

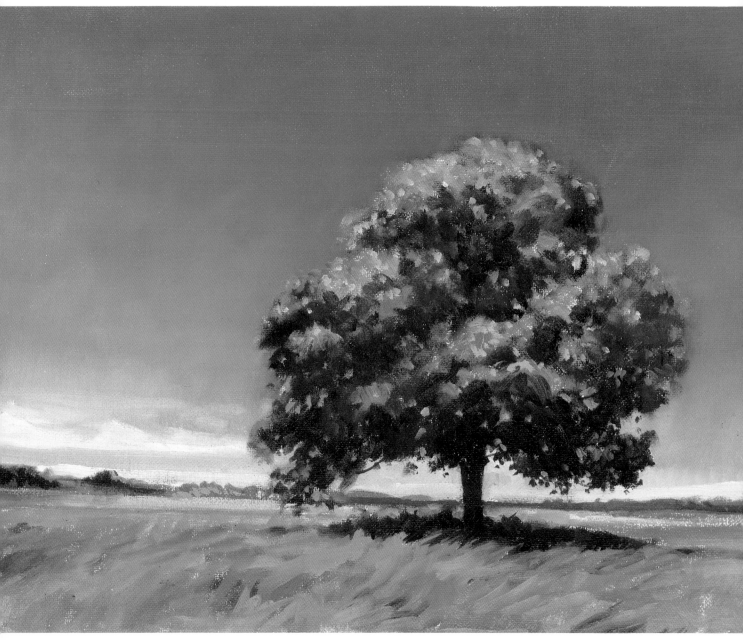

Now, with opaque pigment, re-paint the dark areas of the tree. You'll be reworking the foliage later, so don't pay too much attention to detail now. Once the darks are down, turn to the sky. Try to make it paler and paler as it nears the horizon.

While the sky is still wet, paint the rest of the crown. Because you're working wet into wet, the edges of the crown will look soft and unfocused. If they're too sharp, the tree will look as though it had been pasted onto a deep blue backdrop.

It's time now for your lights. Choose a vibrant green—one

that's a little brighter than the actual green you see—to make the tree stand out against the dark blue sky. Lay the green in with short, curving strokes, suggesting the volume with your gestures. These rounded strokes will indicate how the foliage masses together far better than straight strokes would. With straight strokes, the tree would be flattened and appear much less realistic.

Now paint in the bright green of the foreground, the band of yellow ocher behind the tree, and the strip of dark green along the horizon. Add the deep, dark

shadow cast by the tree as well.

At this point, begin to refine what you have done. Pay special attention to the foliage. You want the short, curving strokes to be visible. The silhouette of the tree is also important in establishing the identity of this particular tree; make sure that it is depicted accurately. Finally, break up the greens in the crown with small touches of deep blue. The blue will hardly be visible from a distance because its value is so close to that of the greens. Up close, though, it will suggest how patches of sky break through the masses of leaves.

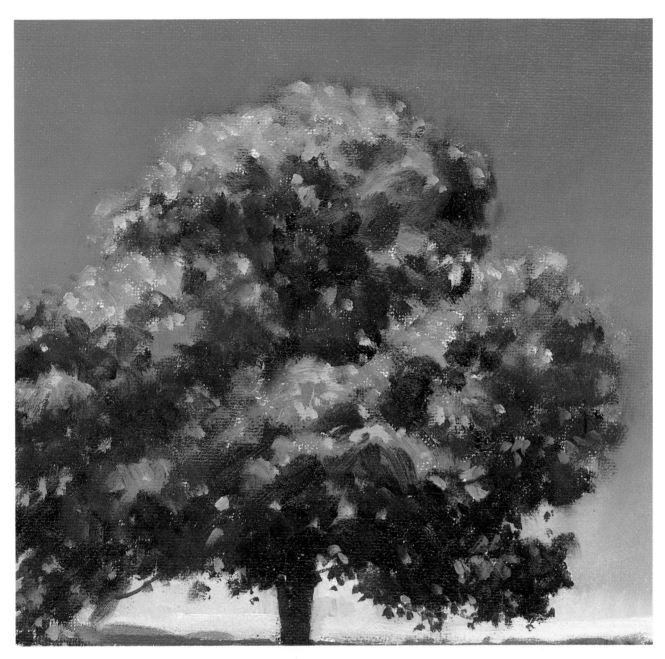

DETAIL

To create the smooth, curving strokes that sculpt out the volume of this tree, work with an almond-shaped bristle brush (a filbert). Load the brush with paint, apply it to the canvas, twist it slightly; then, with a quick gesture, pull it up again. The brush's shape will suggest the volume of the branches; the way you manipulate the brush will convey the masses of leaves that, together, build up the tree's crown.

ASSIGNMENT

It's not easy to put together a powerful composition. In this book, most of the work has been done for you. Masterful color photographs capture dramatic landscapes, ones that are compelling enough for anyone to want to paint.

Now it's time for you to do the groundwork. Get in the habit of carrying a sketch pad with you. Whenever you pass a scene that draws you in, stop and quickly sketch it. Most of the subjects you turn to will remain just drawings, but from time to time, you'll find that you have encountered a scene so powerful that you want to paint it.

Try to figure out what makes one scene arresting and others just mildly interesting. Discover which elements mean the most to you. Once you've gotten a sense of the things that matter the most, concentrate on them. They'll be the key to making the most of your oil paintings.

Expressing the Luminosity of Fog

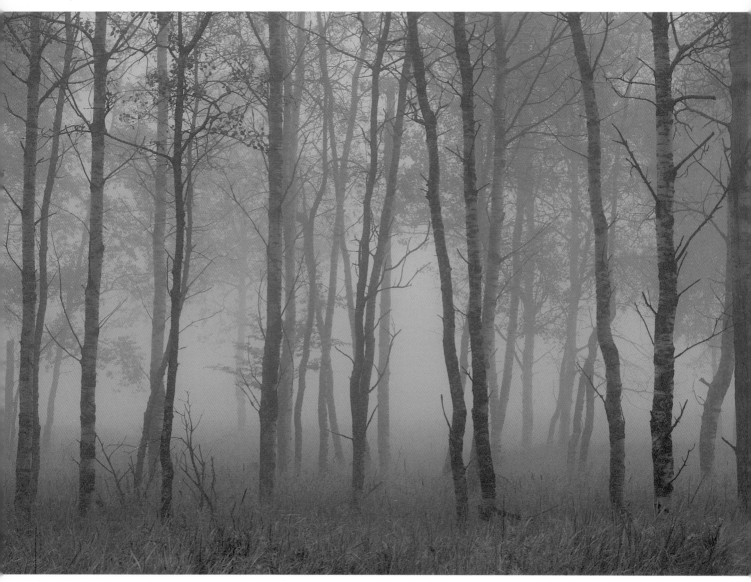

PROBLEM
As we've seen, when fog or mist moves in across a scene, the range of value and color is narrowed. Working within these limitations, you have to discover how the light wends its way through the fog.

SOLUTION
Set the mood of your painting by staining the canvas with an overall wash of warm ocher. To build up the surface, work with thin washes, or scumble layers of thinned paint over one another. The point is to keep the color nearly transparent; you don't want to spoil the mood by introducing heavy passages of pigment.

The stark, thin trunks of aspens create a soft, haunting pattern in the thick blue mist.

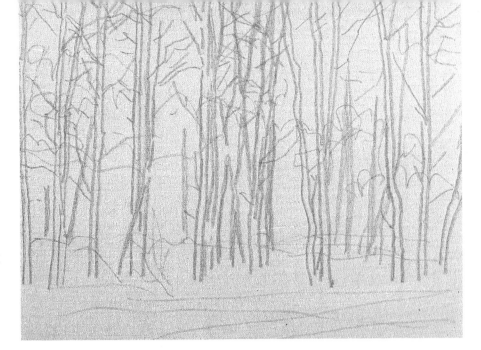

STEP ONE

The first step is to stain the canvas with a warm ocher color. Mix your pigment with a fair amount of turpentine, then apply the wash to the canvas with a rag. If you really soak the rag in diluted paint and then scrub the canvas with it, you'll create an even, undifferentiated flood of color. The effect is a lot different from the look you get by covering the surface with a moistened brush. More than that, the color will dry quickly. When it does, sketch the trees with a charcoal pencil.

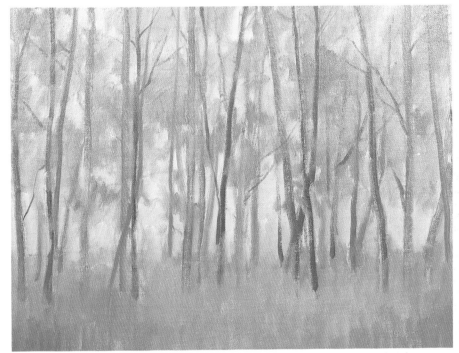

STEP TWO

The charcoal pencil that you used in step one gives you freedom as you begin to develop your painting. Charcoal pencil isn't as fragile as vine charcoal; it clings to the surface longer, allowing you to lay in color without worrying about your drawing. Using thin washes of color, establish the patterns that the trees form and the blurred, misty effect that the fog creates in the sky and on the ground. To keep the shapes soft, work wet into wet with loose, fluid strokes.

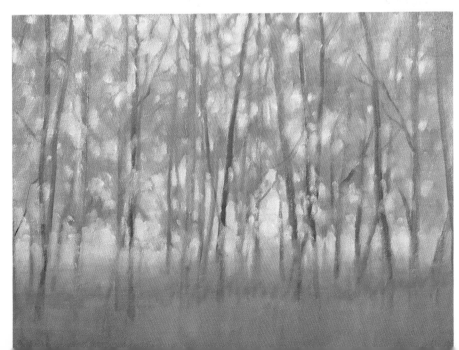

STEP THREE

To develop your forms, you'll want to use opaque color. But don't be tempted to lay it on thickly, or you'll lose the delicacy you're striving for. Thin your paint with just a little turpentine, then scumble the color onto the canvas. Take a bristle brush and dip it into the diluted color, then squeeze the brush until it is almost dry. Now begin to refine the shapes of the trees and branches. The drybrush technique will protect you from laying on your color too thickly and from losing the soft, unfocused effect you've set up.

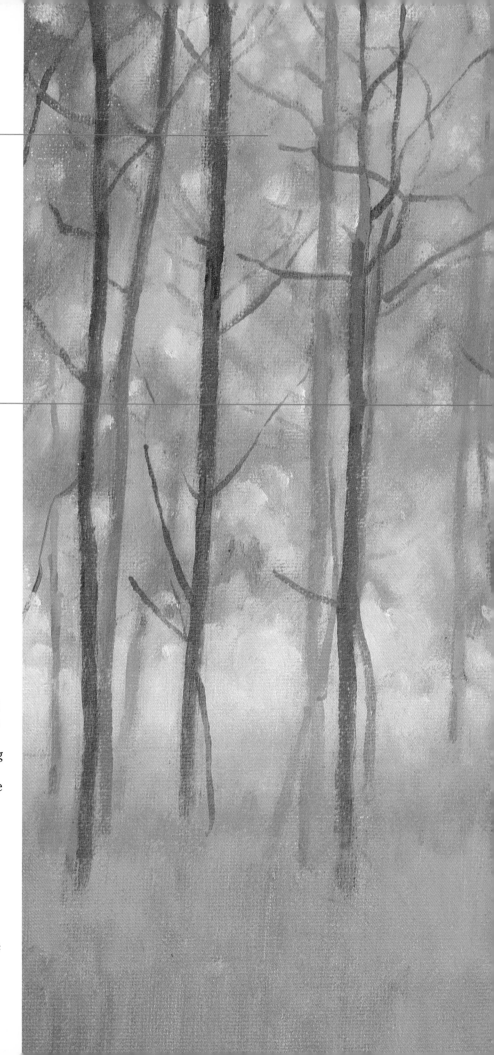

The warm ocher wash that was applied at the very beginning sets up a luminous quality that pervades the entire scene. The ocher shines through subsequent applications of transparent color and is never masked by thick pigment.

To define the shapes of the trees, thinned color is scumbled over the surface of the canvas. The paint is applied with a nearly dry brush, one that has been squeezed until very little paint remains on it. The broken strokes that result let patches of the warm ocher underpainting shine through.

FINISHED PAINTING

When you move in to complete your painting, pay attention to value. So far you've concentrated on laying in soft, unstudied layers of color; now it's time to sharpen up what you've done. Establishing a definite sense of progression into space isn't easy when you are working with hazy color. You'll probably find that you need to sharpen the trees closest to you to make them spring into focus. Don't abandon your original plan of attack, however; stay with thinned color as you rework what you've done. You want to deepen the value of the trees in the foreground without letting intense color disrupt the mysterious, quiet mood of your painting.

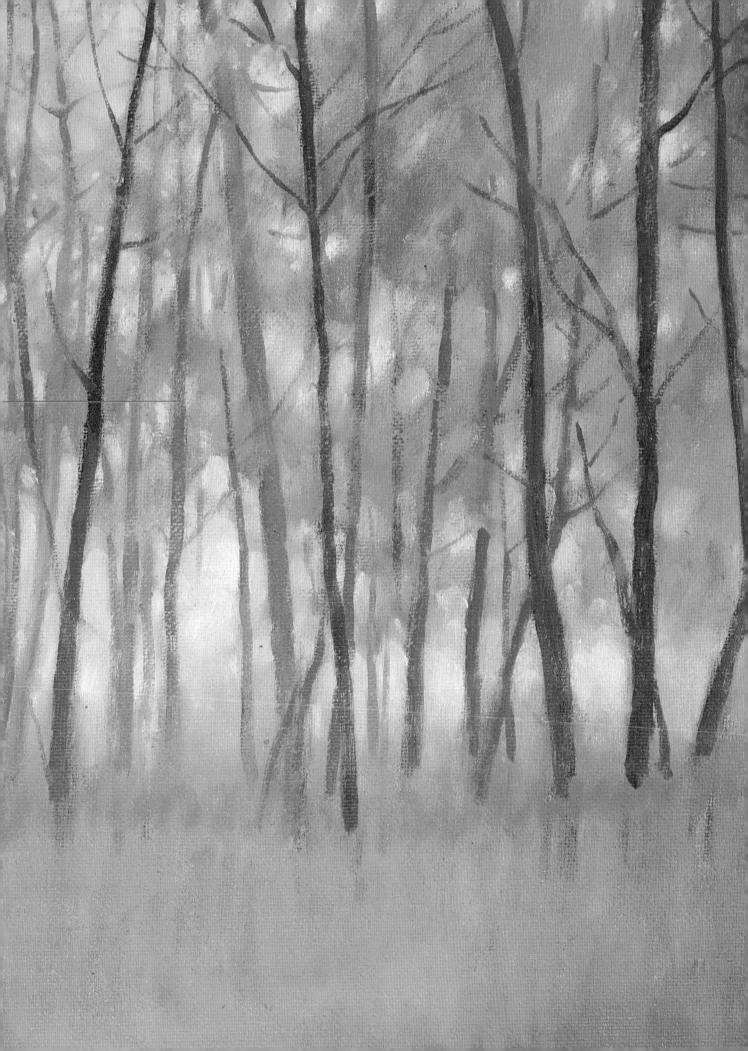

Index